Style and stylistic change are central issues in the study of art and architecture. Over the past hundred years, various important theories of style and its changes have been proposed by scholars in a diversity of disciplines, from the historian Heinrich Wölfflin to the economist Herbert Simon. In this book, a new and innovative approach is developed that not only looks at traditional questions about stylistic change but also sets up a formal model through which to analyze change and to structure innovation. Styles are defined in terms of rule-based, compositional systems called shape grammars. Shape grammars have been used widely in recent years to describe a variety of styles in architecture, landscape design, painting, and the decorative arts. As this book demonstrates, stylistic change is characterized in terms of different transformations of the grammars that define styles.

Transformations in design

Transformations in design

A formal approach to stylistic change
and innovation in the visual arts

Terry W. Knight

CAMBRIDGE
UNIVERSITY PRESS

Published by the Press Syndicate of the University of Cambridge
The Pitt Building, Trumpington Street, Cambridge, CB2 1RP
40 West 20th Street, New York, NY 10011–4211, USA
10 Stamford Road, Oakleigh, Melbourne 3166, Australia

First published 1994

Printed in Great Britain at the University Press, Cambridge

A catalogue record for this book is available from the British Library

Library of Congress cataloguing in publication data

Knight, Terry Weissman, 1952–
Transformations in design: a formal approach to stylistic change and innovation in the visual arts / Terry W. Knight.
 p. cm.
Includes index.
ISBN 0 521 38460 5
1. Design – History – 20th century. 2. Computer-aided design. I. Title.
NK1510.K55 1993
745.4'442 – dc20 92–23445 CIP

ISBN 0 521 38460 5 hardback

CE

Contents

List of illustrations	*page*	viii
Preface		xiii
Acknowledgments		xvii

Part I **Background** 1

1	Style and stylistic change: the tradition	3
2	Languages and transformations: a new approach	24

Part II **Transformations of languages of designs: a formal model** 41

3	Shape grammars: a standard format	43
4	Recursive structures of shape grammars	70
5	Transformations of shape grammars	75

Part III **Examples** 109

6	Transformations of the meander motif on Greek Geometric pottery	111
7	Transformations of *De Stijl* art: the paintings of Georges Vantongerloo and Fritz Glarner	168
8	The transformation of Frank Lloyd Wright's Prairie houses into his Usonian houses	218
	Postscript	243
	Notes	246
	Index	255

Illustrations

2.1 The development of a simple shape grammar *page* 26–27
based on a Greek cross design

2.2 Examples of styles of designs that have been 29–32
described with shape grammars

2.3 A shape grammar defined with Froebel blocks and 33
some designs produced by it

3.1 Shapes 45

3.2 A shape and some of its parts 45

3.3 Two shapes that are equal 45

3.4 Addition and subtraction of two shapes 45

3.5 A sequence of addition and subtraction operations 45
on three shapes

3.6 A sequence of addition and subtraction operations 45
on two shapes

3.7 Euclidean transformations of a shape 46–47

3.8 Spatial relations between a square and an isosceles 48
triangle

3.9 Spatial relations that are the same 48

3.10 Two different spatial relations 49

3.11 Defining and applying shape rules in terms of a 50
spatial relation

3.12 Defining and applying shape rules in terms of a 53
spatial relation

3.13 Using spatial labels to control where a rule is applied 54

3.14 The different transformations involved in matching 55
the left-side of a rule with a shape in a design

3.15 Using spatial labels to control where a rule is applied 55

3.16 Using spatial labels to control where a rule is applied 56

3.17 Using spatial labels to control where and how a rule 57
is applied

3.18	Using spatial labels to control where and how a rule is applied	57
3.19	Using spatial labels to control where and how a rule is applied	58
3.20	Using spatial labels to control where and how a rule is applied	58
3.21	Shape rules for erasing labels	59
3.22	Using state labels to control the sequence of rule applications	60
3.23	Using state labels to control the repetition of rule applications	61
3.24	Applying a shape rule to different initial shapes	63
3.25	Examples of shape grammars	64–66
3.26	A shape schema that defines a family of rectangles	67
3.27	A spatial relation schema that defines a family of spatial relations	68
3.28	A shape rule schema that defines a family of shape rules	69
4.1	Defining the recursive structure of a grammar	72
4.2	Defining the recursive structure of a grammar	73
5.1	Rule addition and rule deletion	77–78
5.2	A shape grammar	79
5.3	Rule change: changing state labels	80–83
5.4	Rule change: changing state labels	84
5.5	The recursive structure of a grammar and the recursive structures of transformations of the grammar	85
5.6	A shape grammar	86
5.7	Rule change: changing spatial labels	87
5.8	Changing spatial relations in designs by introducing new shapes	89–90
5.9	Changing spatial relations in designs by rearranging shapes	92–93
5.10	Changing spatial relations in designs by transposing shapes	94
5.11	Metathesis	95
5.12	Rule change: introducing new shapes	97
5.13	Rule change: repositioning shapes	98–99
5.14	Rule change: transposing shapes	101
5.15	A shape grammar	103
5.16	Change rules	103
5.17	A transformation of a grammar that preserves the recursive structure of the grammar	103
5.18	A transformation of a grammar that does not preserve the recursive structure of the grammar	104
5.19	The different ways of transforming a shape grammar	105
5.20	Combining an addition rule and a subtraction rule into a single rule	106

6.1	Greek Geometric pottery	114–131
6.2	Meanders used in the different stages of the Geometric and by the different regional schools	133–136
6.3	Workshop variations of Late Geometric meanders in Attica	137
6.4	Workshop variations of Late Geometric meanders in the Argolid	138
6.5	An Early and Middle Geometric grammar	139
6.6	Derivations of designs by the Early and Middle Geometric grammar	140
6.7	The underlying construction of Late Geometric complex meanders	140–141
6.8	All possible relationships between adjacent rows of running meanders	142–143
6.9	Defining shape rules for Late Geometric complex meanders	144–145
6.10	Changing the spatial labels in the Early and Middle Geometric grammar	147
6.11	A Late Geometric Attic grammar and some designs generated by it	148–149
6.12	A Late Geometric Argive grammar and some designs generated by it	150
6.13	A Late Geometric Rhodian grammar and some designs generated by it	152–153
6.14	A new Late Geometric grammar and some designs generated by it	154
6.15	All possible triple meanders composed of running meanders (excluding reflected variations) that can be generated by Late Geometric grammars	156–157
6.16	Quadruple and quintuple meanders generated by the Late Geometric Attic grammar	158
6.17	A derivation of a spiraling meander by a Late Geometric grammar	159
6.18	Two Late Geometric Attic vases with complex meanders formed by increasing both the height and the depth of the running meander	160
6.19	Changing the spatial labels in an Attic or Argive grammar	161
6.20	A Hirschfeld grammar and some designs generated by it	162
6.21	A Birdseed grammar and some designs generated by it	163
6.22	A right-running Argive grammar and some designs generated by it	164
6.23	A Post-Geometric grammar	165
6.24	Meander designs in Goethe's sketchbooks	166
6.25	Le Corbusier's variation of the meander, called a *redent*, and his use of *redent* designs in the "Radiant City"	167
7.1	Early *De Stijl* paintings	169

7.2	Shape grammars representing the seven stages in the development of Vantongerloo's paintings	172–174
7.3	Stage I Vantongerloo paintings	175
7.4	A derivation of a stage I design	177
7.5	A stage II Vantongerloo painting	178
7.6	A derivation of a stage II design	179
7.7	Stage III Vantongerloo paintings	180–181
7.8	The different results of making perpendicular divisions and parallel divisions to the areas formed by a pinwheel	182
7.9	A derivation of a stage III design	184
7.10	Stage IV Vantongerloo paintings	185–186
7.11	Stage V Vantongerloo paintings	187
7.12	A derivation of a stage V design	188
7.13	A stage VI Vantongerloo painting	189
7.14	The four different pinwheel configurations comprised of curved lines that are produced from a pinwheel comprised of straight lines	190
7.15	A derivation of a stage VI design	191
7.16	Stage VII Vantongerloo paintings	192–193
7.17	A derivation of a stage VII design	193
7.18	Paintings by Vantongerloo produced after stage VII	194
7.19	Stage I, II, III, V, VI, and VII designs	195
7.20	Shape grammars representing the five stages in the development of Glarner's paintings	196–199
7.21	Paintings by Glarner produced before stage I	200–201
7.22	Stage I Glarner paintings	202
7.23	The six possible relationships between two obliquely divided rectangles that form a larger rectangle	203
7.24	A derivation of a stage I design	205
7.25	Stage II Glarner paintings	206
7.26	A derivation of a stage II design	208
7.27	Stage III Glarner paintings	209
7.28	Stage V Glarner paintings	212
7.29	Subdivisions and color relationships in stage V paintings	213
7.30	A derivation of a stage V design	215
7.31	Stage I, II (or IV), III (or IV), and V designs	216
8.1	The plans of five Prairie houses designed by Wright	220
8.2	The main stages of the derivation of a new Prairie-style house (the "Stiny" house) using the Koning and Eizenberg shape grammar	221
8.3	The plans of six Usonian houses designed by Wright	223
8.4	A Prairie house grammar and a Usonian house grammar	225–231
8.5	The basic composition of the Robie house, the basic composition of the Roberts house, and the basic composition of the Henderson, Willets, and Baker houses as generated by the Prairie house grammar	232

8.6 Changing Prairie spatial relations into Usonian spatial 234–235
 relations
8.7 Usonian basic compositions 238
8.8 A derivation of the Garrison house 240
8.9 The final designs of the Jacobs, Lusk, Newman, Rosen- 241
 baum, and Pope houses
8.10 Other spatial relations between living and bedroom 242
 zones produced by changing the spatial relations
 between living and bedroom zones in a Prairie house

Preface

Style and stylistic change are central and traditional issues in art and architecture. Various theories of style and its changes have been proposed by historians and theorists as well as by practicing architects and artists, most notably over the past hundred or so years. These theories have served both as models for understanding the evolution of styles and as guides for creating new styles. The historian Wölfflin, for example, applied his well-known principles of stylistic change to understand the transformation of Renaissance architecture into Baroque architecture. The architect Durand, on the other hand, used his theories of building types and styles to develop a compositional system for creating entirely new architectural designs.

In this study, a new approach toward modeling stylistic change and innovation is proposed. A formal model is developed that addresses traditional questions about stylistic change yet departs significantly from traditional answers in the manner in which change is represented, in the formal rigor of this representation, and most important, in the power it provides for both analyzing change – the task of the historian – and structuring innovation – the task of the designer.

Styles are defined in terms of formal systems called *shape grammars*. Shape grammars were introduced in the early 1970s by George Stiny and James Gips as a way of describing and creating *languages of designs*. A language of designs was seen as a formal equivalent of the traditional notion of a style. Shape grammars could be used to characterize designs and styles in a way that was at once more precise than ways proposed within the established fields of art and architectural history, and more intuitive than ways proposed within the newly emerging fields of computer science and design methodology.

In the 1970s, however, the notions of grammars and languages were not new. In the visual arts, these terms had been used as

informal metaphors for style for some time. In logic, mathematics, and linguistics, more formal and technical definitions of grammars and languages had been developed by the 1950s. The development of these formal grammars was made possible by research into the foundations of mathematics beginning at the turn of the century. Shape grammars, though, were one of the earliest, most complete, and most successful generalizations of formal grammars for one-dimensional logical or natural languages, to formal grammars for two- or three-dimensional spatial languages.

The mechanisms underlying shape grammars and the formal grammars from which they originate are analogous in many ways. Formal grammars in logic and related areas are systems of rules for characterizing the structure or, as it is more popularly termed, the "syntax," of sentences in natural and artificial languages. Similarly, shape grammars are systems of rules for characterizing the composition or "syntax" of designs in spatial languages. However, the rules of a grammar in logic or linguistics are expressed with one-dimensional symbols, letters, or words, whereas the rules of a shape grammar are expressed with two- or three-dimensional drawings. The nonverbal, graphic medium in which shape grammars are expressed is like the medium in which designers and artists conceive and express their work.

Since their introduction twenty years ago, shape grammars have been used widely to explore questions of composition and style. In 1978, George Stiny and his colleague, William Mitchell, wrote of the characterization of architectural style:

Ideally this characterization has three main purposes: (1) it should clarify the underlying commonality of structure and appearance manifest for the buildings in the corpus; (2) it should supply the conventions and criteria necessary to determine whether any other building not in the original corpus is an instance of the style; and (3) it should provide the compositional machinery needed to design new buildings that are instances of the style. If the characterization of a particular architectural style is to have any explanatory or predictive value, it must satisfy these descriptive, analytic, and synthetic tests of adequacy.[1]

Shape grammars have since demonstrated their ability to satisfy these tests, not only for the elucidation of architectural styles but for styles of landscape design, painting, furniture, and ornamental design as well. They have been used to study a broad spectrum of designs, from precise, "geometric" designs which might seem obviously amenable to analysis by a shape grammar – for example, the plans of Mughul gardens – to more amorphous, "organic" designs which might seem to defy formal understanding – for example, the Prairie houses of Frank Lloyd Wright.

This ongoing work on style is expanded in this book to look at questions of stylistic change – how different styles are related to one another across time and space, and how new styles emerge

from existing ones. With styles defined in terms of shape grammars, stylistic change is characterized here in terms of *transformations* of the grammars that define styles. Transformations are formally defined operations that specify how the components of grammars are modified to form new grammars, and from them, new styles – or languages – of designs. Transformations are defined in a straightforward, general way so that they may be applied to model change and innovation in any area of visual design. In some ways, the grammatical transformations described here are comparable to the operations that linguists use to describe historical changes in spoken languages. Here, though, operations are defined for spatial, rather than verbal, material with all of the nuances that spatial designs present.

This work on style and change is, like most research, incomplete and exclusive, with a definite focus and obvious limits. It is explicitly concerned with form and composition and not, at least directly, with social, cultural, functional, personal, or other meanings and determinants of styles. While limits are a necessary part of research, the limitations of form studies are sometimes criticized as reductive, even dangerous: such studies may credit form with a status it does not have or deserve, and diminish the role of other, more important dimensions of design. The most basic response to such criticism is that without a form, either real or imagined, there would certainly be no other dimensions of a work of art or architecture to discuss, and without a good understanding of form, discussion of anything beyond form would likely be ill-founded. Further, despite conventional distinctions between form and other concerns, a fundamental part of the purpose and expression of a design is its form. Form has interesting, nontrivial meaning in and of itself. Artists and architects do invent and play abstract design games, and one of the challenges of understanding styles and their evolutions is confronting and understanding the rules of these games. Thoughtful investigations into form can open up new issues and questions concerning other, equally important aspects of style, and even help provide or justify answers to these or other, outstanding questions.

In the same time that the ideas on which this book is based were being developed, work in a related field – that of computer-aided design – was also experiencing rapid growth. Although the formalisms underlying grammars and computer technology have common origins in early twentieth-century logic, and although grammars and computer-aided design have some common goals, the two fields have had less interaction than is often assumed. Developments within the two fields have been more or less independent. All of the theoretical work and most practical applications of shape grammars have been done without the aid of computers. Conversely, much of the work in computer-aided

design is unrelated, and sometimes antithetical, to the motivations behind shape grammars. The coming years may see more, mutually beneficial interchange between these two areas, with computers being used to implement shape grammars more rapidly and easily, and shape grammars providing a formal basis for some computer-aided design systems.

The book is in three parts. In the first part, *Background*, the origins and development of concepts of style and stylistic change within art and architectural history and theory are reviewed. The formal model for style and change is then sketched informally and considered in relation to the other, traditional approaches discussed. In the second part, *Transformations of languages of designs: a formal model*, the formal model is presented in detail and is illustrated with numerous simple examples. In the third and last part, *Examples*, the model is applied to describe in depth three historical cases of stylistic transformations: one in the decorative arts, one in the fine arts, and one in architecture.

Although the work presented here is formal in that it attempts to be rigorous and precise, no formal, technical, or mathematical background is assumed on the part of the reader. Indeed, it is those readers without mathematical backgrounds, but with scholarly, professional, or general interests in style, art, and design, that may be most interested in this work and may ultimately be the best judges of it. With this in mind, most material is explained verbally and informally, with visual examples conveying the important ideas. In a sense, the conventional roles of text and illustrations are reversed here: once the reader is familiar with grammars, these can be "read," and if unclear, the writing may be looked to for explanation. The real text of this book, and the basis on which it should be judged, are the grammars themselves.

Acknowledgments

This book is based in large part on my doctoral dissertation, *Transformations of Languages of Designs*, completed at the University of California, Los Angeles in 1986. In the expectation of a wider, partly nonacademic readership, many of the technical details of the dissertation have been omitted here, some parts have been rewritten, and new material has been added. However, the substance of the original work remains the same and I would like to thank once again the members of my doctoral committee, Professors Marvin Adelson, Lionel March, William Mitchell, John Neuhart, and Paul Schachter, for supporting and encouraging this work. In the rewriting of the dissertation, Lionel March continued to be an invaluable reader and critic, and an enthusiastic supporter. To George Stiny, I owe a very special and great debt. He has worked for many years to establish and develop the field on which this book is founded. His readings and criticisms of the manuscript and our many conversations and many arguments have contributed in countless different ways to this book.

My deepest appreciation also goes to Nirva Fereshetian and to James Michael Brown for their fine work in preparing many of the drawings. I am indebted as well to Alexander John Rollo for his diligent and patient work in obtaining permissions to reproduce the many works of art and architecture illustrated in the figures. The institutions and individuals who kindly gave their permissions to reproduce works are named in the figure captions. For figures 7.7b, 7.7d, 7.10a, 7.10b, 7.10d, 7.16c, 7.16e, 7.18a, 7.21a, 7.22b, 7.25b, 7.25c, 7.25d and 7.27a, however, the ownership of the works shown is uncertain or unknown. Despite many efforts to contact owners, the present whereabouts of the works remain unverified or unknown.

Earlier versions of chapters 3, 4, 5, 7, and 8 of this book were published in the journal, *Environment and Planning B*, by Pion Limited, London. An earlier version of chapter 6 was published in the journal, *Design Computing*, by John Wiley and Sons, New York.

Part I Background

Theories of style and stylistic change are introduced in the following two chapters. In chapter 1, the traditions within which concepts of style and change emerged and were employed are reviewed. In chapter 2, a new approach to understanding stylistic change is outlined.

1 Style and stylistic change: the tradition

The significance of the concept of style

The concept of style is used basically as an ordering principle. It allows the vast domain of individual artifacts and phenomena to be structured – it allows order to be created out of an otherwise chaotic world. To talk of individual things or events would be virtually meaningless without first grouping or classifying these things, according to some distinguishable properties, into "styles."

Although usually associated with the arts, the concept of style is often used in a broad sense to characterize phenomena within fields as diverse as the social sciences, the life sciences, and the physical sciences. The anthropologist A. L. Kroeber, for example, has used the notion of style to describe cultural activities, from ways of eating and dressing to ways of scientific thinking. He has further speculated on the possibility of using style to characterize entire cultures or civilizations.[1] What Thomas Kuhn calls "paradigms" in science are, in essence, styles of scientific research or practice.[2] In archaeology, classificatory concepts analogous to style have been used since the nineteenth century to organize artifacts of primitive and early historical cultures. Style has its counterpart in the life sciences, too. Biological classification depends on the notion of hierarchical "styles" of plants and animals, that is, the species within the genus within the family, and so on.

Within the arts, the concept of style is typically used to describe consistencies among works that are the products of an individual, school, culture, time period, or geographic region. Once stylistic categories are established, these are turned to predictive purposes to identify works of unknown origins; in the words of the philosopher Nelson Goodman, to "help answer the question: who? when? where?"[3]

The grouping of works of art into styles is a prerequisite for studying stylistic change. Once defined, styles can be ordered and arranged according to temporal, geographic, or other criteria to establish a larger network of relationships between individual styles as well as between individual works. Of particular concern to the historian are the relationships between successive styles in time which enable him or her to study change. Fundamental to the study of change is the assumption of some continuity of forms through time against which changes can be measured. This continuity is usually understood to be the result of the constraints placed on the artist by the tradition in which he or she works. Tradition provides the artist with a repertory of forms and conventions which he or she may then vary to produce new forms and styles. Were it possible for the artist to transcend the tradition he or she inherits and invent a completely new style from scratch, the results would likely be unintelligible and incommunicable. As the art historian, Heinrich Wölfflin observed, "not everything is possible at all times."[4] The only possibilities that exist are those that are given by the styles of current or previous periods.

Against these conceptions of style and stylistic change, is posited the "romantic" view of art which stresses the uniqueness and individuality of the artist and the work of art. The philosopher Benedetto Croce, champion of this view, described the work of art as a unique "intuition pure of every abstraction, of every conceptual element."[5] Accordingly, individual artistic creations can never be related to one another or grouped in any meaningful way into abstract or universal classes or "kinds."[6] The notion of a style, or worse, a history of styles is senseless since, as a fellow romantic, Aldous Huxley, put it, "every artist begins at the beginning."[7] Fortunately, these sentiments are not shared by the majority of past and present historians and theorists without whom it would have been impossible to build the body of knowledge of style and stylistic change that exists today.

The origins of the concept of style

The term *style* comes from the Latin term for a writing instrument, *stilus*.[8] In antiquity, the term was used to characterize the manner of writing peculiar to a person and, later, by extension, a particular manner of speaking or rhetoric. In the visual arts, the term *genus* gave the closest approximation to the modern idea of style. Both Pliny and Vitruvius referred to the Doric, Ionic, and Corinthian *genera* in architecture. *Genus* was also used to designate biological classes; this is the meaning of the term that has continued through to modern times. Its association with the arts has been retained as well through the derivative French word *genre*.

In the arts, it was the original idea of style as manner which was

carried through to the Renaissance. Giorgio Vasari used the term *maniera* to describe the individual styles of artists, nations, and periods.[9] With reference to the individual arts, *maniera* was the habitual, characteristic way of drawing, painting, or sculpting; it still referred to the "signature" aspect of the work of art implicit in the Latin *stilus*.

The term *style* as applied to the arts gradually began to be used in the late sixteenth and the seventeenth centuries. It was not until the eighteenth century, however, that it finally became fixed as an art historical term, replacing the term *manner*. In J. J. Winckelmann's *History of Ancient Art*, style is treated for the first time, not as the personal habit of the artist, but as the artistic expression of an entire culture during a particular period of development.[10] Following Winckelmann's lead, style in the next century was used increasingly to designate successive period styles in the history of art. Many of the names for these styles were evaluative. Styles were judged according to their acceptable adherence to classical standards or their unacceptable departure from them. Thus, *gothic, baroque, rococo, romanesque,* and *mannerism* were all originally terms of ridicule or contempt. It was not until the nineteenth and twentieth centuries that each style in turn was cleared of the charges against it.

Development of theories of style and stylistic change in art history

After Winckelmann, theories of style and stylistic change developed rapidly. Common to most all of them was the attempt not merely to describe the various period styles in history, but to uncover patterns of relationships between them; to show not only how, but why, style changed the way it did through time. These theories were based on one shared supposition: style and change must be driven by some force outside the conscious, free will of the artist. Theories can be divided roughly into two types. The first type of theory derives style from sources, either abstract or material, which are external to art. The second type of theory derives style from sources internal to art. Both types of theories can be further subdivided according to how changes in styles were patterned. Again, there were basically two views: change was either a long-term evolutionary process or a cyclical process.[11]

Evolutionary theories of change originated essentially with Aristotle. In the Aristotelian picture of evolution, all living forms are arranged in a hierarchy from simple to complex. Evolution from simple to complex forms, which did not occur across time but across fixed species, was a teleological process predestined toward a single, final goal. Cultural artifacts were also subject to this process. Aristotle's ideas were forwarded through the centuries and, at the time of Winckelmann's book, were being studied once again. Later, in the nineteenth century, interest in

evolutionary concepts was stimulated further by developments in biology, in particular, the work of Charles Darwin.

Cyclical theories of change, like evolutionary ones, originated in ancient Greece and Rome. According to one ancient theory, all of mankind had gone through and was continuing to go through repeating cycles of existence. Cyclical theories in antiquity and up to the eighteenth century were variously conceived. The most widespread and enduring theory was that based, like evolutionary theories of style, on a biological analogy: the life cycle of birth, adolescence, maturity, and decay. In Vasari's *Lives of the Artists*, for example, the art of the Renaissance is depicted as progressing through the stages of infancy, adolescence, and maturity corresponding to the works of Cimabue and Giotto, then Donatello, Masaccio, and Brunelleschi, and, last, Leonardo, Raphael, and Michelangelo.[12] Vasari wisely avoided making any predictions about a final, less glorious stage.

J. J. Winckelmann, often referred to as the father of art history, was the first to give a systematic exposition of the "external" type of stylistic theory.[13] Winckelmann applied the metaphor of life cycles to the art of ancient Greece to describe its four stages: its origins, perfection, decline, and fall. Each stage was a consequence of the Greek "spirit," rather than of the will of the individual artist. Winckelmann's determinist view of the development of Greek art and his conception of a collective spirit determining that art were subsequently elaborated and generalized in the romantic philosophical system of G. W. F. Hegel.

Hegel elevated Winckelmann's concept of group spirit into a fully metaphysical, idealist concept. In Hegel's view, "the Spirit of the Age," the notorious *Zeitgeist*, controlled not only the style of art of a nation or people, but all aspects of its cultural achievements. Hegel replaced Winckelmann's cyclical view of development with a new, but equally determinist, combined cyclic-evolutionary theory: the "Spirit" passes through cycles of thesis-antithesis-synthesis in a continuous evolution toward ever higher states. Although much of Hegel's philosophy was rejected by succeeding generations of art historians, his *a priori*, idealist forces, his holistic conception of the relatedness of all aspects of a society, and his search for large-scale patterns of development strongly influenced subsequent external, as well as internal, theories of style and change.[14]

Like Hegel, the architect and theorist Gottfried Semper also looked outside of art to find its origins. Semper, however, did not pursue Hegel's grand, idealist speculations. Instead, he focused quite narrowly on architecture and the applied arts using a more empirical, naturalistic approach. Semper found the source of style not in the heavens but in more tangible sources such as the function of the work of art and the techniques and materials available to the artist. Along these lines he gave the very concise

formula for style: $U = C(x, y, z, t, v, w ...)$, where U is one of a number of possible styles of an object; $x, y, z, t, v, w ...$ are variable influences on style including purpose, materials, and techniques, local factors such as geography, climate, and culture, and the personal choices of the artist; and U is a mathematical function C of $x, y, z, t, v, w ...$[15] The specific value or style U assigned to an object by the function C is determined by the specific values given to $x, y, z, t, v, w ...$

Semper pictured the development of forms as a continuous, evolutionary process reaching back into the remote past. Current thinking in biology and comparative linguistics clearly inspired his ideas on the history of forms. In *Der Stil*, he describes the origins and transformations of art and compares this process with that of language:

Art has its particular language, residing in formal types and symbols which transform themselves in the most diverse ways with the movement of culture through history, so that in the way in which it makes itself intelligible, an immense variety prevails, as in the case of language. Just as in the most recent research into linguistics, the aim has been to uncover the common components of different human linguistic forms to follow the transformation of words through the passage of centuries, taking them back to one or more starting points where they meet in a common *Urform* ... a similar enterprise is justified in the case of the field of artistic inquiry.[16]

There was no determinism in Semper's evolutionism in the sense that each step in the evolution was a necessary consequence of the preceding one. He saw instead a continuity of forms developing from previous forms where each step in the development was the result of changes in materials, techniques, or the general cultural and geographic environment.

Under the spell of Darwinism, followers of Semper soon turned his theories into simplistic, materialist doctrines. It was partly against these "Semperians," rather than against Semper himself, that Alois Riegl introduced one of the earliest "internal" theories of style and change. In his first book, *Stilfragen*, Riegl systematically traced the transformation of decorative motifs from ancient Egyptian to ancient Greek to Roman, Byzantine, and then Islamic art over a period of some five thousand years.[17] This development was explained as a purely internal, autonomous process in which forms are transformed into new forms by artistic factors alone. More particularly, changes in form are the manifestation of more deep-seated changes – changes in the *Kunstwollen*, the unconscious aesthetic urge or "Will-to-Form" which directs the artists of a particular culture during a particular period in time.

In a following book, *Die Spätrömische Kunstindustrie*, Riegl combined his Kunstwollen theory with a new psychological theory of perception in order to reveal the pattern underlying all of artistic development.[18] The history of art, according to this more

comprehensive theory, is the history of the evolution of the *Kunstwollen* from a "haptic," or tactile, to an "optic," or visual, mode of perception; from representation based primarily on touch which depicts an object as tangible, permanent, and objective to representation based primarily on vision which depicts an object in a more impressionistic and subjective manner.[19]

Riegl's grand attempt to systematize the internal development of style was rivaled by the work of his close contemporary Heinrich Wölfflin. Like Riegl, Wölfflin based his theories on detailed, visual studies of works of art. He produced several major works, revising his position with each one.

In one of his early works, *Renaissance and Baroque*, Wölfflin described the change in style from Renaissance architecture to Baroque (now referred to as Mannerist) architecture.[20] He employed the metaphorical categories of "painterly," "massiveness," and "movement" to characterize the Baroque style as opposed to the Renaissance style. In considering the causes of the change, he rejected the two most common theories of the time: the architect Adolph Göller's psychological hypothesis that new forms are generated as the result of a visual "form fatigue,"[21] and the Hegelian "Spirit of the Age" theory. In their place, Wölfflin proposed a physiognomic theory of style – a type of empathy theory by which the people of a particular age project their "corporeal essence," their "particular habits of deportment and movement," in short, their *Lebensgefühl* or attitude toward life, onto architecture.[22] Wölfflin's *Lebensgefühl* comes close to Hegel's "Spirit" and an external explanation of style. In later writings, however, the *Lebensgefühl* becomes only a backdrop against which the internal dynamics of stylistic change are explored.

In a subsequent work, *Principles of Art History*, Wölfflin elaborated his study of the Renaissance and the Baroque and defined five opposing pairs of categories which could be applied to distinguish, not just the architecture, but all of the arts of the two styles.[23] "Linear" is opposed to "painterly," "plane" to "recession," "closed" to "open," "multiplicity" to "unity," and "absolute clarity" to "relative clarity." The first term of each of these pairs describes the Renaissance style; the second describes the Baroque style. Although Wölfflin claims his "categories are only forms" and "have no expressional content in themselves,"[24] it is only by means of lengthy verbal descriptions of numerous works of art that the reader can sense, but never actually see, the qualities he describes.

Somewhat analogous to Riegl's changing modes of perception theory, Wölfflin suggests that the change from the first set of qualities to the second set was an inevitable development resulting from a change in the artist's mode of vision. This change was

the progress from a tactile apprehension of things in space to . . . the mere

visual impression, in other words, the relinquishment of the physically tangible for the sake of the mere visual appearance.[25]

The specific changes in style which accompanied the change in seeing were dependent upon the artist's familiarity with the forms of the previous style. For example, on the development of Baroque art, Wölfflin writes:

The development ... will only fulfill itself where the forms have passed from hand to hand long enough or, better expressed, where the imagination has occupied itself with form actively enough to make it yield up its baroque possibilities.[26]

Wölfflin believed that his model of stylistic change could be applied to many historical periods to describe similar cyclical patterns of development. He compared, for instance, the "linear" High Gothic with the "painterly" Late Gothic.[27] Wölfflin's categories have since been applied with some success to other styles of art as well as to styles of literature and music. Many studies, however, have shown his model to be patently invalid across all of art history.

Wölfflin's ideas of stylistic polarities and cyclical change were taken up by Paul Frankl. Frankl's *Principles of Architectural History* was his answer to Wölfflin's writings.[28] Frankl's notion of stylistic change, like Wölfflin's, was firmly embedded in the German idealist tradition:

The *development* of style is an intellectual process over-riding national characteristics and individual artists ... the greatest genius is no more than the servant of this intellectual process.[29]

Further, this process is internally motivated:

He [the artist] begins to want *that* which he does not have and to work for that unattainable satisfaction by means not previously explored. So I certainly do not mean that a kind of "form fatigue" hurries on the new phase. Rather, this is the result of the feeling that all the problems of the prevailing movement have been solved ... The formal elements are changed by internal causes, then, and this change is sealed by external causes, by the new intention.[30]

Focusing only on architecture, Frankl proposed four categories for its analysis: "spatial form," "corporeal form," visible form," and "purposive intention." Spatial form referred to composition; corporeal form to mass and surface articulation; visible form to optical appearance suggested by light and color; and purposive intention to social function. Within each of these categories, four phases of architectural history were examined. Frankl considered spatial form to be the most significant of the four categories. He declares:

Anyone for whom geometric descriptions are tedious and irksome is fundamentally unsuited for research in the history of architecture: he

should confine himself to the remaining chapters [on corporeal form, visible form, and purposive intention].[31]

Accordingly, it is spatial form which receives the most extensive treatment. Under spatial form, Frankl introduces two polar concepts to distinguish between the Renaissance and the Baroque: "spatial addition" and "spatial division." In spatial addition,

each of its [a building's] members is ... a detachable, clearly defined entity, an addend.[32]

In spatial division, on the other hand,

the components of spatial form are no longer complete, isolated addends, but fractions of a pre-existent whole. The space does not consist of many units; it is *one* unit divided into parts or fractions.[33]

What is exceptional about these categories is that Frankl takes them beyond the suggestive stage where Wölfflin stopped with his categories. Frankl demonstrates spatial addition with careful geometric analyses of the various compositional types of Renaissance architecture. Taking the lead from Leonardo's study of central-plan churches, he shows how Renaissance plans can be generated by starting with very basic spatial forms and systematically combining one form with another to produce more complex compositions. Thus, "the creation of spatial forms becomes a matter of scientific combination."[34] What is most original about Frankl's analysis, within the field of art history, is his introduction of constructive principles for understanding style.

Frankl later applied his polar categories to distinguish between Gothic and Romanesque church architecture in his book, *Gothic Architecture*.[35] Since then they have been appropriated by numerous authors to characterize opposing styles of architecture and even opposite methods of designing.[36]

Concerns with the formal analysis of style were continued during the 1930s with the so-called *Kunstwissenschaft* (science of art) school of Viennese art historians.[37] The best known of this group, Hans Sedlmayr, distinguished two levels of the science of art.[38] The first level was basically empirical; it was concerned with the collection and classification of information about works of art. The second level was more theoretical. Drawing upon evidence collected in the first level, the second science aimed at discovering the underlying structure and principles which governed the art of a particular style. Gestalt psychology was appealed to as a working method for this second science. To discover the hidden principles of a style, the historian-scientist must possess the "correct mental set" by which to observe and gain insight into his or her specimens. Although the weaknesses of the *Kunstwissenschaft* school were numerous, several impor-

tant studies emerged from it, in particular, the writings of Emil Kaufmann on the Neoclassical style of architecture.

In France, the internal view of style and change was carried on by Henri Focillon. In his book, *The Life of Forms*, Focillon asks himself "What, then, constitutes style?" He answers:

First, its formal elements ... which make up its repertory, its vocabulary ... Second, although less obviously, its system of relationships, its syntax.[39]

Focillon did not concern himself with detailed characterizations of particular styles. He was intrigued more by the internal development or "life" of styles in general. He writes:

the life of forms is not the result of chance. Nor is it ... called into being by historical necessities. No; forms obey their own rules – rules that are inherent in the forms themselves, or better, in the regions of the mind.[40]

He resurrected the early schema for cyclical development, defining stages called "experimental," "classic," "refinement," and "baroque," yet rejected a deterministic view toward this development which would "isolate works of art from human life, and condemn them to a blind automatism and to an exactly predictable sequence."[41]

Focillon's theory is heavy with contradictions; his poetic style of writing makes it difficult to know whether his declarations should be interpreted literally or metaphorically. His one clear contribution to the study of style was his repudiation of the holistic conception of style initiated by Hegel, which he replaced with the idea of stylistic plurality. In any particular period of time, Focillon wrote, there is not necessarily just one style or group of related styles. Instead:

several styles may exist simultaneously within neighboring districts, and even within the same district ... styles develop differently in accordance with whatever technical domain they may occupy.[42]

In the United States, George Kubler took up Focillon's idea of coexistent, continually changing styles. In *The Shape of Time*, Kubler rejected static, synchronic models of style and proposed instead a purely diachronic model of change.[43] Works of art and other man-made artifacts are interpreted only in terms of their position in "formal sequences" of "linked solutions." Kubler's very informally defined formal sequences are meant to replace "any idea of regular cyclical happening on the pattern of 'necessary' stylistic series by the biological metaphor of archaic, classic, and baroque stages."[44]

Kubler's ideas on style and change, as well as those of other recent historians and theorists, will be returned to later.

Development of theories of style and stylistic change in architectural theory

As in art history, speculation on the nature of style and stylistic change in architectural theory was basically a nineteenth-century development. In architectural treatises from antiquity to the Enlightenment – from Vitruvius to Villard de Honnecourt to Alberti to Laugier – the question of style and change was never problematic. There was always only one acceptable, valid style of architecture for the day, usually some version of the "classical" style. Within the classical style, the different orders constituted the various substyles or genera within which the architect could work. Since the style of architecture was generally fixed, the description and classification of architectural forms developed out of a different concept – that of *type*.

From its original meaning in Greek as "impression" or "figure," the term *type* was applied to impressions of coins and, eventually, to the blocks for printing characters of the alphabet. It was through this last association with "character" that the term became associated, in later, more general usages, with the purpose, function, intention, or *character* of a building or other man-made or natural form.

Significantly, the term *character* was originally related to the etymon of style, *stilus*. *Character*, which originally meant "impress," "engraver," or "minter of coins," was later used by Aristotle to characterize the different aspects of human nature. Following Aristotle, Greek rhetoricians concerned with finding the suitable style for expressing a specific aspect of human nature, used *character* to mean "appropriate style."[45]

Although the word "type" was not used explicitly in architectural theory until the eighteenth century, it was the idea of type as function or purpose which was used most often as the basis for classification systems in architecture from Vitruvius on. In Vitruvius's *The Ten Books on Architecture*, for example, rules for the design of buildings are separated according to whether the building is a temple, forum, basilica, treasury, prison, theater, and so on.[46]

In the eighteenth century, the notion of type took on new and significant meaning. Laugier's idea of a "primitive hut"[47] gave rise to the idea of an *archetype* – an actual or conceptual type from which architecture had evolved and upon which new architecture could be based. The archetype embodied principles of form as well as principles of character. Like theories of style emerging at the same time, theories of archetypes were justified on either naturalistic or idealistic grounds. Laugier's primitive hut was founded in Nature; it was the actual origin of architecture. Quatremère de Quincy's "wooden hut,"[48] on the other hand, was an *a priori*, ideal type. In either case, it was the underlying principles or laws of

architectural form that Laugier and Quatremère claimed to have discovered, just as their fellow historians were claiming to discover the underlying principles of style.[49]

Interest in the origins of architecture was not fortuitous. The establishment of archaeology as an academic discipline in the eighteenth century brought a new awareness of the buildings of the past as well as of the diversity of contemporary building types and styles into which they seemed to have evolved. The classification questions which this vast assortment of new data posed were paralleled by similar classification problems faced in the natural sciences. With rapidly growing discoveries of fossil species and new living species, the development of classification systems in biology progressed quickly. Although early systems, such as those of Linnaeus and Buffon, were based on similarities of form rather than of function, they still served as models for the classification of building types.[50] The idea of "a general prototype for each species on which each individual is modeled," which Buffon proposed,[51] was paralleled by the idea of a general building type upon which the individual building could be modeled. J.-F. Blondel, in his *Cours d'Architecture*, for example, gave descriptions of each of the major contemporary building types – the theater, library, cemetery, college, hospital, hotel, factory, and so on – which the architect could refer to in designing an instance of a particular type.[52]

Probably the most interesting consequence of biological taxonomies, from an architectural point of view, was the thought that through the ordering of all the species, transformational rules or principles could be deduced which would not only show the relationships between known species but could also be used to construct new, hypothetical or undiscovered species. The best elaborated theory of this kind was Goethe's theory of a plant archetype called the *Urpflanze*.[53] Similar in concept to an architectural archetype, the *Urpflanze* was the theoretical plan of all possible plants. Goethe illustrated the *Urpflanze* in detail and described a permutational system which could be used to transform the *Urpflanze* into all varieties of existing and imaginary plants.[54]

As incredible as Goethe's ideas may sound today, the idea of a theoretical plan for living forms was not abandoned. In the 1940s, the biologist J. H. Woodger developed a highly formalized and convincing treatment of the biological transformations of different species.[55] Woodger was able to demonstrate affinities between various species through the "morphological correspondences" of their *Bauplans* or "building plans." The *Bauplan* of a particular species was the abstract system of spatial relations between the different parts of any member of that species.

The idea of taking classification systems beyond analysis and using them to derive synthetic or generative principles for creating new forms, was to distinguish the architectural approach to

style most strikingly from the art historical approach discussed earlier. The architectural approach begins to be treated systematically in the work of J. N. L. Durand at the beginning of the nineteenth century.

Durand's system of architectural composition described in his *Leçons d'Architecture*[56] evolved out of his earlier taxonomic studies of building types in his *Recueil et Parallèle des Edifices*.[57] In the *Leçons*, Durand sets up a compositional system for generating new variations of building types that is similar to Goethe's permutational system for generating new variations of plant types. Compositions are constructed by first establishing a basic axial schema, called a *parti*, and then placing different architectural elements such as walls, columns, arches, and so on, within the *parti* according to implicit rules of combination and allowable symmetries.

The nineteenth century following Durand saw the conflation of theories of type with theories of style, theories of function with theories of form. This was nowhere more evident than in the work of Gottfried Semper.

Some ideas in Semper's major work, *Der Stil*, were discussed briefly in the previous section. In an earlier essay, *The Four Elements of Architecture*,[58] Semper proposed a classification system for architecture based on four archetypal elements – the hearth, platform, roof, and enclosure – which together constituted the archetypal building or *Urhutte* (a probable reference to Goethe's *Urpflanze*).[59] The evolution of architecture is reducible to the transformation, either singly or together, of the four elements of the *Urhutte*. The formal properties of any object serving a particular function, for example, any one of the four archetypal elements, Semper called *types* or *motifs*. Types are transmitted through evolving functional elements. Thus, if a building originally had textile enclosures and these evolved into masonry walls, then the formal patterns of the textile enclosure will be found, in a modified form, on the masonry walls. It was through this transmission of types that the symbolic content of functionally evolving forms was preserved through time.[60]

In *Der Stil*, Semper devised a new classificatory system in which his four architectural elements are subordinated to, and evolved from, more fundamental elements of the industrial arts. The hearth is linked to ceramics, the platform to masonry, the roof to carpentry, and the enclosure to textiles. What is significant about this classification system is that it was based explicitly on the new and controversial, functional classification system of the anatomist Georges Cuvier, rather than on older systems based on resemblance of form.[61] In a lecture, Semper spoke with reverence of Cuvier's work:

In this magnificent collection ... we perceive the *types* for all the most

implicated forms of the animal empire ... A method, analogous to that which Cuvier followed, applied to art, and especially to architecture would at least contribute towards getting a clear insight over its whole province and perhaps also form the base of a doctrine of *style* and a sort of *topic* or method, how to invent.[62]

Note Semper's allusion to the possibility of deriving generative methods from analytic ones.

Although Semper has in the past been accused of a Darwinian type of evolutionism, the core of his theories was formulated before Darwin's *The Origin of Species* was published.[63] Semper later read Darwin and saw certain analogies with his own theories. He maintained, however, that Darwin's theory of natural selection, particularly the hypothesis that sudden leaps never occur in natural evolution, was not directly applicable to the evolution of the arts where sudden leaps do, in fact, occur.[64] He also pointed out the nondeterministic, free choice aspect of an evolution contrived by man as opposed to an evolution contrived by Nature:

We must consider the free will of the creative mind of man as the most important factor in the problem of the origin of building styles. It was naturally controlled by certain higher laws, which were traditional, of the requisite and the necessary, but it appropriated and utilized them through free, objective conception and application.[65]

Semper's association of style with function and materials in his classification schemes was given greater force in the so-called "rationalist" theories of his contemporary, Viollet-le-Duc. In response to the increasing awareness of the assortment of historical styles of architecture and the attendant stylistic eclecticism in building, Viollet-le-Duc proposed a theory by which a new architecture for the new age could be derived.

Viollet-le-Duc first distinguished between two uses of the term *style* – one descriptive, the other normative.[66] The first use referred to "the styles" – the many period styles then being "discovered" and catalogued by art historians. The second use referred to his own conception of "style" – a supreme and invariable quality which inheres in just those forms constructed according to certain *a priori* laws or principles. Echoing Durand, Viollet-le-Duc believed that the study and classification of "the styles" were a necessary prerequisite for discovering the principles by which to design architecture with "style." He found these principles in the relation, or *unité*, of function, material, and technique with form. A thing has style:

first, because it exactly indicates its purpose; second, because it is fashioned in accordance with the material employed and the means of fabrication suited to this material; third, because the form obtained is suitable to the material ... and the use for which it is intended.[67]

To create architecture with style, the architect must bring to bear his or her faculties of imagination and reason.[68] The "passive imagination" or memory is presented with the facts of a situation – an architectural program, for instance. The "active imagination" then applies logical reasoning to the contents of the passive imagination. Guided by principles of function, structure, and materials, the active imagination selectively recombines, unites, and synthesizes forms in the memory to generate new forms.

Viollet-le-Duc's emphasis on remembered or known forms as an integral aspect of creative activity was reflected in his evolutionary and teleological approach to stylistic change and innovation. He pictured change essentially as a sequence of modifications and perfections of older forms. For example, speaking of the development of the Greek temple, he writes:

Thus, by how many successive modifications of the Doric order was that perfection attained which is exhibited in the Parthenon![69]

While Viollet-le-Duc here attributes change to final goals, more immediate, material causes were also invoked. Of the progression of the Greek to the Roman to the Gothic style, he says that if "the structural method changes ... the form must necessarily alter."[70]

Regardless of causes, the impact of tradition is paramount in Viollet-le-Duc's reasoning on change and innovation. Addressing the call for a style of the day, he declares:

There is no invention; we can only submit to analysis elements already known, – combine and adapt these, but not create: ... we must necessarily have recourse to the past in order to originate in the present.[71]

The rationalist philosophy of Viollet-le-Duc was reformulated at the end of the nineteenth century by Auguste Choisy in his *Histoire de l'Architecture*.[72] The *Histoire* is a record of the development of architecture from prehistory through the nineteenth century. This development is always subject to one underlying rationale: form is logically determined by technique, structure, and function, in short, what Choisy called "the logic of the circumstances." Choisy more or less reiterates Viollet-le-Duc's stand on stylistic change:

Style does not change according to the caprice of more or less arbitrary fashion [a possible reference to the alleged caprices of Art Noveau], its variations are nothing but those of processes ... and the logic of methods implies the chronology of styles.[73]

Both Viollet-le-Duc's and Choisy's main argument for their rationalist doctrines – the Gothic rib – was effectively refuted some years later by the engineer Pol Abraham who showed that the rib lacked the structural significance they claimed for it. However, their basic attitudes toward form and structure, toward the cultivation of style, and their teleological/evolutionary view

of stylistic change were carried forward into the modern movement of this century.

In a reaction against the succession of stylistic revivals of the nineteenth century, the modern movement rejected any notion of adapting a period style for the new century. In *Towards a New Architecture*, Le Corbusier proclaimed: "Architecture has nothing to do with the various 'styles'."[74] Instead, a new style will be determined by, and evolve out of, the new era of technology. This new style will possess style (in Viollet-le-Duc's sense), that:

unity of principle animating all the work of an epoch, the result of a state of mind which has its own special character.[75]

The new style is manifested through the various *objet-types* – ordinary objects such as pencils, typewriters, pipes, and so on – which are continuously evolving toward an ideal, universal form under a "Law of Mechanical Selection."[76] As theories of styles and types are carried from the nineteenth into the twentieth century, it is interesting to note how Laugier's idea of the type and its evolution has been turned on its head. For Laugier, evolution diverged from an ideal type lying somewhere in the distant past; for Le Corbusier, evolution converged on an ideal type somewhere in the distant future.

Recent theories of style and stylistic change

Reacting against the large-scale, comprehensive theories of the nineteenth and early twentieth centuries with their soon discernable flaws, twentieth-century art historians retreated into the safety of more limited, empirical studies. Despite a general, antitheoretical atmosphere, though, a number of theories of style have been advanced in recent years. Recognizing the complexity and idiosyncrasies of style and change, these theories tend to be nonjudgmental, nondeterministic, and more generous in acknowledging the role the individual artist plays in determining style. Style is generally seen, not as an abstract thing to be found in Nature or in the heavens, but as an artificial construct devised by the historian. Nevertheless, there has been considerable debate over definitions of style, in particular, over what aspects of works of art or design constitute style. Unfortunately, none of these deliberations have been accompanied by extensive, detailed examinations of particular styles of the sort carried out in earlier times.

From the mid-twentieth century and on, definitions of style usually focus on features specific to individual works of art. Meyer Schapiro, in his renowned review of style theories of the past, defines style as:

the constant form – and sometimes the constant elements, qualities, and expression – in the art of an individual or a group ... the description of a

style refers to three aspects of art: form elements or motives, form relationships, and qualities (including an all-over quality which we may call the "expression") ... these three aspects provide the broadest, most stable, and therefore most reliable criteria [of style].[77]

Elaborating on his three aspects of art, Schapiro says:

Form elements or motives ... are not sufficient for characterizing a style ... In order to distinguish ... styles, one must also look for features of another order and, above all, for different ways of combining these elements.[78]

Further, one cannot "do without the vague language of qualities in describing styles."[79]

In a similar definition of style, James Ackerman proposes that:

Conventions of form and symbolism yield the richest harvest of traits by which to distinguish style.[80]

Recalling Focillon's definition of style, Ackerman says that conventions are:

an accepted vocabulary of elements – a scale of color, an architectural order, an attribute of a god or a saint – and a syntax by which these elements are composed into a still life, a temple, or a frieze.[81]

Thus, style is

a kind of language, within which symbolic and formal conventions are organized into coherent constructs similar to a grammar.[82]

In slightly different ways, both Schapiro and Ackerman make elements of form and elements of content ("qualities" or "symbolism") and the way they are combined, integral to style. Both are also dismissive of rationalist theories of style; neither techniques nor materials are viewed as adequate determinants of style (as Riegl had claimed some sixty years before). Schapiro admits that technique, material, as well as subject matter:

may be characteristic of certain groups of works and will sometimes be included in definitions; but more often these features are not so peculiar to the art of a period as the formal and qualitative ones. It is easy to imagine a decided change in material, technique, or subject matter accompanied by little change in basic form. Or, where these are constant, we often observe that they are less responsive to new artistic aims.[83]

He astutely observes that:

Where a technique does coincide with the extension of a style, it is the formal traces of the technique rather than the operations as such that are important for description of the style.[84]

Ackerman similarly notes that:

aspects of the work of art as a material object change so little in the course of history that they might appear almost anywhere at any time[85]

and so convey little of style. Technique is acknowledged as a more sensitive gauge of style than material, but not so sensitive as conventions of form and symbolism:

> To say that a temple is constructed of doweled ashlar blocks and that its trussed roof rests on lintels supported by columns is to reveal more of its style than to say that it is built of marble, wood, and iron; but it does not distinguish a Greek temple from a Roman or Neoclassic one.[86]

While form and content have generally been agreed upon by Schapiro, Ackerman, and others as the best indicators of style, the separation of form and content and the use of form or content or both in the description of style has provoked further controversy. This issue, like so many others, can be traced back to the Aristotelian opposition of matter (content) and manner (form), to the distinction between *what* was said and *how* it was said. We have seen how style has traditionally been associated with manner. In antiquity, style or *stilus* literally meant manner. In much later, nineteenth-century developments, the most successful theories of style – those of Riegl, Wölfflin, and Frankl – were still being formulated on the basis of form or "how" rather than on the basis of content or "what."

The issue of the separation of form and content was rekindled in the twentieth century with Stephen Ullmann's well-known "synonymy" theory of style.[87] According to Ullmann, style is the "how" as opposed to the "what." It is the result of a choice between synonymous forms; it is the picking out of one among many alternative forms for expressing the same content or meaning. Speaking primarily of literary style, Ullmann claims:

> There can be no question of style unless the speaker or writer has the possibility of choosing between alternative forms of expression. Synonymy, in the widest sense of the term, lies at the whole root of the problem of style.[88]

Soon after, the art historian Ernst Gombrich argued for a similar theory of style, applicable to all of the arts, in his classic encyclopedia essay on style. "The term 'style'," he says, "is thus used descriptively for alternative ways of doing things."[89]

The synonymy theory of style was quickly called into question. One powerful counter to Ullmann's argument was given by Nelson Goodman.[90] Goodman insisted that form and content are not opposed to one another in the definition of style. Style, in fact, consists of only those features that function symbolically in a work of art. Thus:

> Style is not exclusively a matter of how as contrasted with what, does not depend either upon synonymous alternatives or upon conscious choice among alternatives, and comprises only but not all aspects of how and what a work symbolizes.[91]

Goodman's view is now accepted among many aestheticians and philosophers. Although it may be difficult to deny that both form and content play a part in style (this is essentially Schapiro's and Ackerman's view) and that they interact very closely, it is usually expedient to separate one from the other in describing style and stylistic change. Relations between form and content are not invariant and may change independently of one another. As Ackerman put it (in a restatement, basically, of thoughts previously expressed by Focillon):

The distinction [between form and content] not only is permissible but necessary for description, because the life of symbols and the life of forms has not been everywhere coexistent in history. Some symbols ... pass through varied forms, while formal conventions ... are applied to symbols of different, even conflicting significance.[92]

Kubler, in an analogy of art with language that is reminiscent of Semper, also observed the independence of form and content through time:

The structural forms [of art] can be sensed independently of meaning. We know from linguistics in particular that the structural elements undergo more or less regular evolutions in time without relation to meaning, as when certain phonetic shifts in the history of cognate languages can be explained only by a hypothesis of regular change ... Similar regularities probably govern the formal infrastructure of every art.[93]

For those who agree to the separation of form and content for descriptive purposes, form is considered the foremost index of style. Form precedes meaning. To quote Kubler again:

No meaning can be conveyed without form. Every meaning requires a support, or a vehicle, or a holder. These are the bearers of meaning, and without them no meaning would cross from me to you, or from you to me, or indeed from any part of nature to any other part.[94]

Further, form changes more frequently than meaning and is a more accurate measure of stylistic change. Ackerman, in a discussion of the dependence of style on form, observes that:

formal conventions remain the pre-eminent style indicators because they tend to change continually and because, as the creation of artists alone, they are less subject to external influence than techniques or symbols ... Accordingly, the most influential theories of style have been morphological.[95]

Ackerman then goes on to cite as evidence the great formal studies of style by nineteenth-century scholars such as Riegl and Wölfflin.

While aspects of form appear to be the most reliable indicators of style, there is no consensus on which aspects of form count as "stylistic" and which do not. The identification of style by statistical measurements of different properties of form – for example,

in literary style by statistics of word choice, length of sentences, frequency of specific words, and in musical style by statistics of frequency of certain tonal series[96] – may be successful, but there is some feeling that these measurements are not genuine, are accidental, or do not capture the essence of a style. The computer scientist Herbert Simon has decried such measurements as "artificial"; they are only symptoms or "accidental byproducts" of deeper, more fundamental aspects of style.[97] Gombrich, while cautiously approving of "statistical morphology," believes that the "underlying Gestalten" of a style cannot be captured by such studies; it is something that can only be intuited by the experienced connoisseur.[98] Nelson Goodman has attempted to discriminate between stylistic and nonstylistic features of a work of art by distinguishing between those properties which function symbolically and those which do not.[99] Still, it is not at all obvious how to determine the symbolic function of some property.

Most contemporary theories of style, such as those described above, locate style in some aspects of the work of art or design. Some theories, however, avoid the art object altogether. The most common theory of this kind locates style in the process or activity of making art. Kendall Walton suggests that "styles of works of art are to be understood in terms of the notion of styles of action."[100] Richard Wollheim has argued similarly for a "generative conception of style" where "generative" refers to the processes or operations of the artist in making his or her art.[101] In another variant of the process theory, Herbert Simon sees design as a problem-solving activity.[102] Style, according to Simon, results from the process by which the designer searches and selects from among the many possible solutions to a design problem. He says, "A style is *one way of doing things*, chosen from a number of alternative ways."[103] (Simon here acknowledges the similarity between his theory and the synonymy theory of style. Simon's theory of style is predicated on synonymous processes; Ullmann's theory on synonymous forms.) Although these theories may have the "psychological reality"[104] their authors claim for them, as theories of style they suffer from serious flaws, one of which is noted by Simon:

> We ordinarily do not have direct access to the program [process] and can therefore identity it [the program or process for some style] only by its products.[105]

More crucially, many of the definitely stylistic aspects of a work of art or design may not be directly attributable to any particular design process.

Closely related to process theories, and subject to the same criticisms, are the so-called "signature" theories of style.[106] In signature theories, style is one step further removed from the art

object than it is in process theories. Style is now attributed to the unique, idiosyncratic workings of the artist's character or personality; style is the predisposition of the artist to paint, sculpt, design, write, or compose in a particular way. The signature theory of style of the twentieth century is, in essence, a reincarnation of the signature theory of antiquity.

Although recent theories of style tend to be much narrower in scope than nineteenth-century ones, the problem of explaining the behavior and causes of style and, more especially, stylistic change, has not been forgotten. Determinist theories, of the type which predominated in the nineteenth century, have generally been discredited and given up. While some patterns or causes of change may appear self-evident in retrospect, there have been no conclusive arguments that any particular development was inevitable. The development of style has instead been viewed broadly as the result of conflicting factors of stability and change.[107] The conservative pressures of society tend to promote stability; the individual inclinations of the artist and what Gombrich sees as pressures of competition[108] tend to promote change. More specific developments of style have been explained in terms of the concept of the "logic of the situation" – a liberal version of Choisy's "logic of the circumstances." The logic of the situation approach to change was originally applied to the development of science by the philosopher Karl Popper.[109] It has since been offered by art historians and theorists as a "rational" explanation of change in the arts.[110] So-called "situational logic" is closely tied to the problem-solving conception of design mentioned briefly in connection with Herbert Simon above.

According to the situational logic theory, the artist or designer is engaged, at any particular moment in time, in the solution of some problem. He or she rationally and consciously considers the choices offered by the "logic" – the cultural, political, technological, and other constraints – of the situation to provide a solution. This solution causes a change in the initial problem, so creating a new problem which is answered by a new solution, and so on. Thus, a style, as Ackerman describes it, "may be thought of as a class of related solutions to a problem" and stylistic change may be thought of as "a succession of steps away from one or more original statements of a problem."[111] Where similar patterns of development have occurred at different times or places – for example, the development of increasingly refined illusionistic styles in both Greek antiquity and the Renaissance – this is explained as a consequence of similar problems being considered at each time or place.

While situational logic theories avoid some of the determinism of previous theories, by their avoidance of determinism, they do not offer any real explanation of style or change. They simply relate styles, now called answers to problems, in some indefinite

way with the constraints of the context in which they arise. While
the constraints placed on the artist by the logic of the situation
may be enormous, there is still as great an enormity of choices of
solutions or styles open to the artist. The particular choices the
artist makes remain unaccounted for. If any progress is to be made
in explaining these choices and if, in fact, such explanations are
possible, it will probably depend on first adopting more sophisti-
cated methods for describing the purely formal aspects of style
and change.

2 Languages and transformations: a new approach

Let us return to design. The first condition in effective design is to know what we wish to do. To know what we wish to do is to have an idea; to express that idea, we require principles and a form, that is to say, rules and a language.[1]

Style as language

With the evidence of nineteenth-century formal studies of styles and types before them, contemporary theorists of style from Focillon to Kubler to Ackerman and Schapiro have recognized the primacy of form and its counterpart, meaning, in defining style. The frequently made analogy with natural language, also replete with forms and meanings, seemed to capture best the common view of style. The structure of natural language with its vocabulary and rules of combination or syntax became a familiar model for describing the structure of style. But the language analogy always stopped at the metaphorical stage. Possibly fearful of making the mistakes of the grandiose but flawed stylistic theories of the nineteenth century, or possibly thinking it too difficult or, worse, too obvious, the proponents of the language analogy never attempted to formalize their intuitions or to offer any detailed analyses of styles to test them.

While the words "vocabulary," "rules," "syntax," "grammar," and "language" were being used only suggestively in connection with art and design, they were being developed into rigorous, formal constructs in logic, mathematics, linguistics, and computer science. Procedures equivalent to grammars were first defined by logicians in the 1920s to characterize abstract languages, most notably languages such as the predicate calculus. Continued work on grammars, languages, and similar kinds of formal systems later provided the basis for the first abstract computing

machines. Today, grammars are essential to the definition of computer programming languages. It was through a rather different field, however, that the notions of grammar and language were popularized. In the 1950s, the linguist Noam Chomsky presented a new model for characterizing natural languages called a *generative grammar*.[2] Since then, grammars have been associated most commonly with Chomsky's work. Chomsky gave the now conventional definition of a grammar: a vocabulary of symbols or words, together with a set of rules that specify how elements in the vocabulary may be combined to form strings of symbols, or sentences, in a language.

In the following decade, grammars were studied extensively to determine their abstract properties and practical applications. Of some relevance to art and design was work on grammars for describing languages of two- or three-dimensional patterns or pictures, rather than the usual one-dimensional strings of symbols or sentences. Commonly called "syntactic pattern recognition," much of this work was directed toward developing grammars for computer-automated recognition and analysis of various classes of images. Even though these grammars were touted as multi-dimensional, most in fact were (and still are) defined in terms of one-dimensional symbols or words, and produce rather complex and unwieldy symbolic rather than graphic representations of patterns. Most also had very limited applications constrained to one particular class of patterns or mode of description.[3]

Following closely on the heels of this work, were studies begun by the architect and theorist Christopher Alexander. Alexander's well-known "pattern languages" consisted of informal, verbal rules for generating architectural and urban designs.[4] Although Alexander's model was devised for generative rather than analytic or recognition purposes, it espoused virtually the same restricted view of the syntactic organization of designs as did pattern recognition grammars.[5] Similarly, his rules were essentially verbal rather than pictorial. However, Alexander's pattern languages lacked the formal precision and rigor toward which pattern recognition grammars aspired and which would be necessary to make these languages truly practicable.

It was a return to earlier, more fundamental grammatical models for language that provided the basis for the first successful and comprehensive formal model for languages of two- and three-dimensional forms. In the early 1970s, *shape grammars* that generate *languages of designs* were developed by George Stiny and James Gips to characterize what in art and design has been traditionally called *style*.[6]

Where grammars in logic and related areas manipulate symbols, shape grammars manipulate *shapes*. Following classical tradition, a shape is defined as an arrangement of *lines*, either in two or three dimensions. A shape grammar is founded on a vocabulary of

shapes and a set of *spatial relations* that correspond to different arrangements of shapes in the vocabulary. A set of *shape rules* defined in terms of these spatial relations, together with a starting or *initial shape* made up of shapes in the vocabulary, comprise a shape grammar. The shape rules of a grammar are applied repetitively or *recursively* to the initial shape and to shapes produced from it to generate designs in a *language*. The vocabulary of shapes and the set of spatial relations underlying a language generated by a grammar correspond to the familiar constituents of style: to Focillon's "formal elements" and "system of relationships," for example, or to Schapiro's "form elements or motives" and "form relationships," or to Ackerman's "vocabulary of elements" and "syntax by which these elements are composed."

The development of a very simple shape grammar is illustrated in figure 2.1 The starting point for the grammar is a Greek cross design – a simple scheme that underlies many architectural and other designs. A typical Renaissance church design based on the Greek cross is shown in figure 2.1a. The basic cross plan of this church can be described in a variety of ways, for example, as two overlapping rectangles of proportions 2×1. These two shapes constitute a vocabulary of shapes that is shown in figure 2.1b. To produce the Greek cross, the shapes in the vocabulary are put together or arranged to form the spatial relation in figure 2.1c.

The vocabulary of shapes and the spatial relation of figures 2.1b and 2.1c are used to define the shape grammar illustrated in figure 2.1d. The initial shape of the grammar is a shape from the vocabulary. The shape rule is based on the spatial relation. It allows a wide variety of new and complex designs to be built up entirely in

2.1
The development of a simple shape grammar based on a Greek cross design.
a. Santa Maria delle Carceri, Prato by Guiliano da Sangallo.
b. Vocabulary of shapes.
c. Spatial relation.
d. Shape grammar.
e. Derivation of a design.
f. Designs in the language.

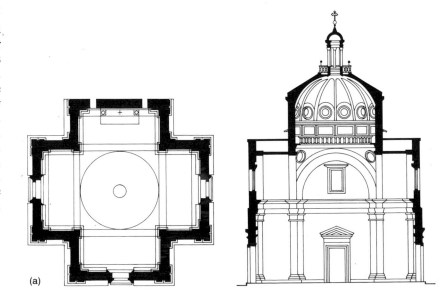

(a)

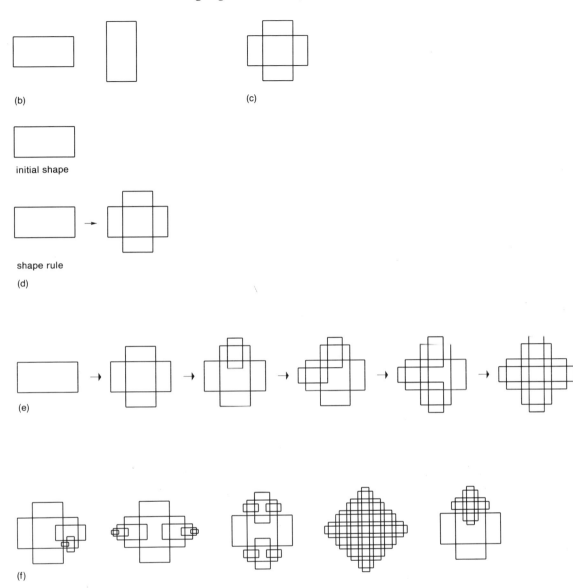

(b)

(c)

initial shape

shape rule

(d)

(e)

(f)

terms of one simple relation. Basically, the rule says that if a 2×1 rectangle – the shape on the left-side of the rule – can be found in any size or orientation in a design being generated, then another 2×1 rectangle can be overlaid on top of it as shown on the right-side of the rule. By applying this rule repeatedly, starting with the initial shape, different designs all based on the Greek cross can be produced. Figure 2.1e shows the production or *derivation* of one such design.

The derivation begins with the initial shape. In the first step of the derivation, the shape rule is applied to produce the Greek cross. The Greek cross has in it four smaller 2×1 rectangles that form the arms of the cross. The rule may apply next to any of

these rectangles. In the following four steps, the rule is applied in turn to each rectangle. The final design of the derivation is a more elaborate version of a Greek cross, also a scheme for numerous architectural designs. Figure 2.1f shows some of the many other designs that can be generated by the shape grammar. Different designs are produced by applying the shape rule in different ways to different parts of designs as they are generated. All of these designs are in the language defined by the grammar.

The grammar of figure 2.1d is elementary – it has one rule of composition and it generates a very diverse and general style of designs. Over the past two decades, many more detailed and specialized shape grammars have been developed to address two fundamental concerns in design: the description and analysis of past or present styles of designs, and the creation of completely new and original styles of designs.

Defining a shape grammar to describe a known style involves essentially the same steps taken to define the grammar in figure 2.1: first, a vocabulary of shapes and a set of spatial relations common to designs in the style are distinguished; next, shape rules that fix the occurrences of spatial relations in designs are defined; next, an initial shape to begin the generation of designs is given; and last, a shape grammar is specified in terms of the shape rules and initial shape. The shape grammar thus defined generates known designs as well as new designs in the same style. Different interpretations of the composition of designs in a certain style are always possible. These may lead to different vocabularies and spatial relations, different grammars, and different languages. Each of these different grammars and languages provides a different understanding or theory of a style.

Numerous styles of designs have been defined in this way in recent years. These include styles of architecture, landscape design, painting, furniture design, and ornament. Figure 2.2 shows some examples of this growing body of work. Grammars have been defined to generate and understand languages of Chinese ice-ray lattice designs, Palladian villas, Mughul gardens, Hepplewhite chairs, Japanese tearooms, Frank Lloyd Wright Prairie houses, Queen Anne houses, among other kinds of designs.[7]

Shape grammars can also be defined to generate completely new styles or languages. Generally, this involves making up from scratch a vocabulary of shapes and a set of spatial relations between these shapes, then defining initial shapes and shape rules based on the vocabulary and spatial relations. The shape rules can then be combined in various ways with one another and with the initial shapes to form shape grammars. A detailed program for developing new shape grammars and languages in this manner has been outlined by George Stiny.[8] Stiny's approach is illustrated using the building blocks of the educator Frederick Froebel. Froebel devised his system of building blocks or "gifts" in the

2.2
Examples of styles of designs that have been described with shape grammars. Each shape grammar generates known designs in a style as well as new designs in the same style.

Chinese ice-ray lattice designs

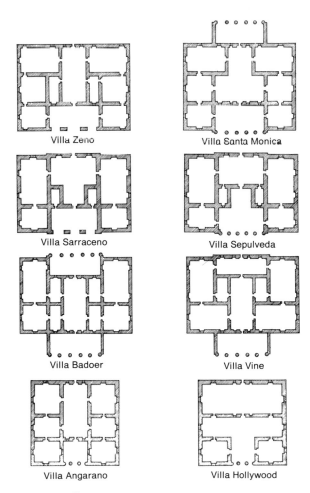

Villa Zeno

Villa Santa Monica

Villa Sarraceno

Villa Sepulveda

Villa Badoer

Villa Vine

Villa Angarano

Villa Hollywood

Palladian villas

Mughul gardens

Hepplewhite chairs

2.2 continued

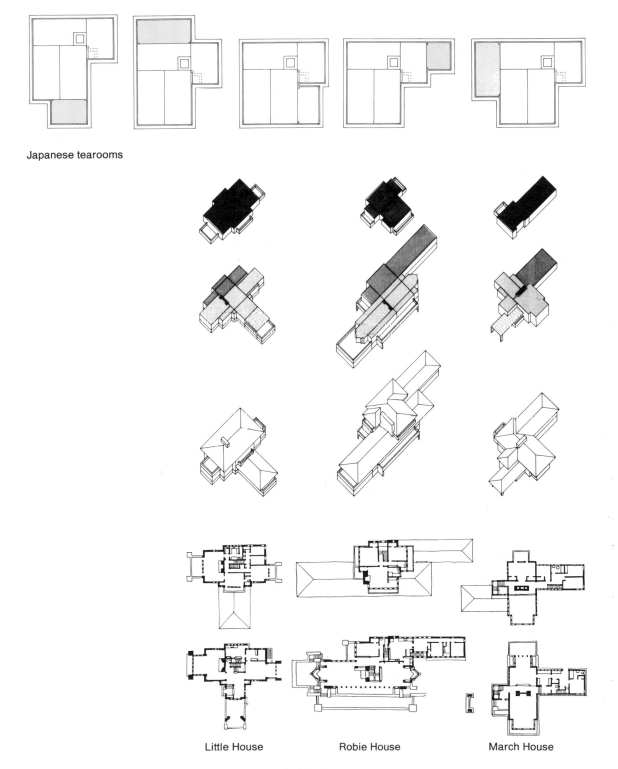

Japanese tearooms

Little House Robie House March House

Frank Lloyd Wright Prairie houses

Queen Anne houses

2.2 continued

nineteenth century as part of his new kindergarten method of education. Today, Froebel's kindergarten method is best known among designers through Frank Lloyd Wright's testimonials to his Freobel training as a child and the alleged impact this training had on his design philosophy and work. Stiny has shown how Froebel's educational method for children, which resembles in many ways the studio method of architectural education, can be exploited in a more structured and sophisticated program for inventing and exploring new and original shape grammars. Many of the new design languages created with these grammars challenge the imagination of the best of designers creating in the traditional studio manner. Figure 2.3 shows a very simple example of a shape grammar defined with Froebel blocks. The grammar is based on a vocabulary consisting of oblong blocks. The one rule of the grammar is defined in terms of a spatial relation between two blocks placed at right angles to one another. Some designs generated by the grammar are also illustrated.

 Shape grammars alone define style in terms of form. The counterpart of form – content or meaning – can be specified in terms of a *description scheme* associated with a shape grammar.[9] A description scheme is a type of grammar that generates a *language of descriptions*. It links the way designs in a style are

2.3
A shape grammar
defined with Froebel
blocks and some designs
produced by it.

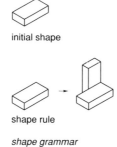

initial shape

shape rule

shape grammar

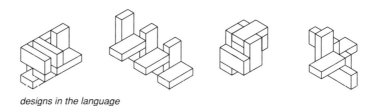

designs in the language

described spatially with the way they are described in terms of other properties such as meaning, function, materials, expression, and so on. It links designs with, for example, Ackerman's "conventions of symbolism," Schapiro's "qualities" of "light and color," "cool and warm, gay and sad,"[10] Riegl's "haptic" and "optic," Wölfflin's "linear" and "painterly," Frankl's "addition" and "division," or any other properties that can be used to talk about form.

A description scheme is defined in parallel with a shape grammar for either a known or new style. It consists of a set of rules expressed in terms of words, symbols, or even pictures. Each rule of the description grammar is linked to a rule of the corresponding shape grammar. Whenever a rule in the shape grammar is applied to generate a design, the corresponding rule in the description scheme is applied to generate a description of that design. Thus, every design in the language generated by the shape grammar is accompanied by its description in the language generated by the description scheme.

Just as the spatial aspects of a style are open to varying interpretations with a shape grammar, so too are its descriptive aspects. A single language of designs can be linked with many languages of descriptions, and many different languages of designs can be linked with the same language of descriptions. In either case, the way designs in a language are described is relative to the way in which they are interpreted spatially.

Shape grammars and description schemes thus accord with most contemporary understandings of style. Both form and content are accounted for and, as Ackerman required, both are "organized into coherent constructs" that are separate but interdependent. Together, a grammar and a description scheme elucidate nontrivial aspects of form and content. A grammar goes beyond the superficial, statistical measures of features of designs dismissed by Herbert Simon and others; it describes deeper-seated commonalities of structure and composition. A grammar formalizes what Gombrich described as the connoisseur's intuitions of the "underlying Gestalten" of a style. Along with a description scheme, a shape grammar may also help to distinguish between what Goodman termed stylistic and nonstylistic features by explicitly linking features of designs (given in terms of shape rules) with their symbolic interpretations (given in terms of description rules).

Grammars and description schemes also accord with both the analytic and synthetic components of traditional architectural theories of style. In the manner of Durand, for example, a grammar developed for the analysis of a style (in Durand's case, a schema developed for a type) may also be employed to create new instances of that style. For the historian, these new designs provide valuable tests for a theory of a style: if the new designs are not credible, the theory is unlikely to be so. For the designer, these new designs provide a repertory of new ideas with which to work.

The idea of languages of designs and descriptions is consistent, too, with contemporary relativistic views of style. While early theorists were preoccupied with discovering fixed, absolute essences underlying styles, most recent writers have adopted a pluralistic approach to style. Today, the characterization of a style is generally considered an hypothesis – a construct invented by the historian that may be changed, accepted, or rejected according to the particular purpose for which it is used. As Gombrich has remarked: "like all language, it [style classification] is a man-made thing which man can also adjust or change."[11] The language view of style presented here is equally relativistic. Stiny and March have aptly summarized this view:

Our view of design is a licentious and pluralistic one. There are many languages of designs, many languages of descriptions, and many ways of going from one to another. The languages we use in design and the translation schemes we choose to move between them are neither self-defining nor given to us fixed and ready-made; we introduce them ourselves according to our own interests and purposes, and they depend on our immediate commitment to culture and history as a record of our past experience and the source of our present goals. The designed world is one of our own making, and its making is our responsibility alone.[12]

While the grammatical approach to style satisfies most contemporary intuitions of style and carries forward the nineteenth-

century tradition of formal studies of style, it clearly goes much
further in the manner and extent to which style is captured and
formalized.

To begin with, styles are defined with generative or algorithmic
devices rather than with the more usual descriptive device of char-
acterizing selected, paradigmatic designs in a style. A generative
description of a style, such as a shape grammar, can be given
independently of the designs it produces. It encapsulates the often
complex underlying structure of designs by giving explicit yet easy
rules for constructing these designs. Taken singly, the rules of a
grammar isolate simple spatial relations common to designs in a
style; taken together, they give a straightforward procedure that
describes how these spatial relations combine to make designs.

Traditional formal studies of style, such as those of Riegl and
Wölfflin, also describe spatial properties of styles. But these prop-
erties, for example, "linear" and "painterly," are understandable
only with reference to the individual designs from which they
were abstracted – a rather circular definition of style. And, while
they may direct the way that designs are perceived, they say
nothing of the construction of these designs. Where descriptions
of styles do elucidate constructive principles, such as those of
Frankl and Durand, these principles are mostly implicit rather
than explicit. Again, they can be understood only with reference
back to individual designs.

Traditional descriptions of style rely on words. This accounts in
part for their circularity and ambiguity. Frankl attempted to cir-
cumvent this problem with his spatial categories for distin-
guishing between Renaissance and Baroque. In a move to surpass
Wölfflin's more evocative categories, Frankl defined his cate-
gories of spatial addition and spatial division with reference only
to geometrical, spatial aspects of forms. Nevertheless, these cate-
gories were still vague enough for Emil Kaufmann, some forty
years later, to reverse their intended application. According to
Kaufmann, Renaissance architecture was an exemplification, not
of spatial addition as Frankl had claimed, but of spatial division.
Of Brunelleschi's Foundling Hospital, he says:

> the main point is not the 'added up' arcade, but the vertical subdivision of
> the front into differentiated stripes and the less conspicuous, but very
> significant, horizontal subdivisions by doors and windows into compart-
> ments.[13]

Shape grammars employ purely pictorial means of description,
thus avoiding some of the difficulties of verbal descriptions. The
medium used to describe and interpret designs in a style – namely,
lines – closely approximates that in which these designs are given
to us. Other ways of describing style – for instance, in terms of
natural or symbolic languages – can then be associated with these
pictorial descriptions using parallel generative devices such as
description schemes.

Change as transformation

Traditional studies of stylistic change presupposed the existence of an ongoing tradition or continuity of forms through time which allows successive styles to be related and compared. From the architects Semper and Viollet-le-Duc to the historians Riegl, Wölfflin, Frankl, and Focillon, the innovation of forms and styles has been pictured consistently as the recombination, modification, or transformation of forms given to the artist or designer by tradition. Given this view, even seemingly radical changes in style can be traced back through successive transformations in time to some historical precedent. Discontinuities in tradition are rare and when they do occur they are usually attributed to some catastrophic social, political, or natural upheaval over which the artist has no control. The randomness, as well as the rarity, of such events makes them of little interest to the historians and theorists considered here.

As with style, the language analogy has been invoked to characterize stylistic change. The transformation of word forms and meanings through time has been compared quite explicitly by Semper, Focillon, Kubler, and others to the transformation of forms of art and design. The recently developed shape grammar and description scheme formalisms capture basic intuitions of the language analogy for style while advancing previous formal studies of style. But they describe synchronic aspects of style only; the issue of stylistic change is not addressed. Frankl has observed that "to study stylistic change in architecture ... we must focus upon the comparable elements in the art of building."[14] If languages of designs and descriptions are taken as a model for style, how then can these languages be compared in order to study stylistic change?

In a partial response to this question, a formal model for defining changes or *transformations* of languages of designs is presented in Part II of this book. The model may be used both to analyze relationships between past languages as they have evolved over time (the task of the historian), and to develop completely new and original languages on the basis of existing or known ones (the task of the designer). Transformations thus unite the two design issues that shape grammars, alone, address separately – the understanding of known styles and the creation of new ones; transformations begin with the known and from it build something new. However, transformations are not defined by directly transforming individual designs in languages; rather, they are defined indirectly by transforming the shape grammars that underlie and determine languages. These underlying grammatical transformations specify how the comparable elements of grammars – shapes, spatial relations, and rules – are modified to derive new grammars and from them new languages of designs.

As a preliminary to the comparison and transformation of languages of designs via the grammars that define them, a standardized format for expressing the rules of grammars is developed. This format makes explicit the basic determinants of the composition of designs in a language: spatial relations between shapes in a vocabulary, and the ways in which different spatial relations are employed, as shape rules, to generate designs. These constructive mechanisms are used to specify each rule in a grammar. The underlying system of spatial relations encoded in a grammar, called its *recursive structure*, is also characterized.

Transformations of grammars consist of three operations called *rule deletion, rule addition*, and *rule change*. Rule deletion subtracts rules from a grammar, rule addition adds rules to a grammar, and rule change changes the rules of a grammar by changing the constructive mechanisms underlying rules. These three operations are analogous in some respects to the linguistic operations of rule loss, rule addition, rule change, and rule reordering which are used to explain historical changes in grammars for spoken languages. (The operation of rule change defined here for shape grammars encompasses both the operations of rule change and rule reordering defined for grammars in linguistics.) Rule deletion, addition, and change apply to a shape grammar to produce one or more new shape grammars. Each new grammar then defines a new language of designs.

Transformations may be restricted so that while new grammars can incorporate a diversity of changes, they still have the same recursive structure as the original grammar from which they were derived. This approach to the transformation of styles is similar to the biologist Woodger's earlier approach to the transformation of biological species in terms of "morphological correspondences." Woodger's morphological correspondences are mappings between individual forms in different species; style transformations are mappings between grammars defining individual forms in different styles. In the former, transformations preserve the *Bauplan* or structure of spatial relations in forms. In the latter, transformations preserve the structure of spatial relations in grammars and thus indirectly in the forms they produce.

Applications of the transformation model to describe historical examples of stylistic change are given in Part III. In one such application, for example, the model is used to analyze the relationship between two well-known architectural styles of Frank Lloyd Wright. Starting with a shape grammar for Wright's Prairie houses, grammatical transformations are applied to transform systematically the rules of the Prairie grammar into rules of a grammar for Wright's later Usonian houses. Each rule transformation not only elucidates a transformation in form but also can be correlated with some transformation in social and housing

norms from the early 1900s to the late 1930s when the earlier and later styles were developed.

Like previous formal studies of stylistic change, the approach to change taken here is concerned mostly with the abstract, logical structure of change, rather than with the actual historical events of change. However, the transformation model of stylistic change, like the language model of style on which it is based, is more pluralistic in approach than previous models. Different interpretations of designs in a style and different interpretations of which features of these designs change and which features remain invariant can lead to different characterizations of a transformation. Defining a transformation is thus relative, first, to the definition of grammars for specifying styles and second, to the definition of grammatical operations that transform one grammar into another. If, however, the definition of grammars for specifying styles sometimes appears arbitrary, then this impression is considerably weakened when grammars are linked, via transformations, to one another. The plausibility of a particular grammar as a description of a style is both confirmed and enhanced by locating it in a network of other grammars from which it has emerged and toward which it contributes.

The transformation model of change accommodates both the analytic requirements of the historian and the synthetic requirement of the practicing designer or artist. From the viewpoint of analysis, the model characterizes change in a more rigorous yet more subtle way than previous ones.

First, transformations are based on generative, rather than paradigmatic, descriptions of style. They are based on changes in the grammatical structure of a style, not on changes in the visible appearance of designs in the style. Thus, styles which show no superficial, readily observable similarities in form or composition may show surprising similarities in the rules used to construct them. Where styles do show obvious similarities in surface appearance, similarities in grammatical structure usually follow.

Second, transformations, like the styles they relate, are defined pictorially rather than verbally; the rules deleted, added, or changed in the transformation of one grammar into another are given entirely in terms of drawings, not words. The advantages of pictorial descriptions as opposed to more ambiguous, verbal descriptions which were discussed earlier, are equally observable here.

Last, when analyzing the relationship between two styles, transformations may be defined that not only transform the first style into the second, but also transform the first style into a variety of other, possibly nonexistent, but related styles. Transformations thus formalize Goethe's permutational scheme for transforming his plant type or *Urpflanze* into known as well as undiscovered or theoretical species of plants. This more powerful

and creative conception of change offers valuable additional criteria – whether hypothetical species or hypothetical styles – for judging a particular theory of change, just as grammars offer additional criteria – new, hypothetical designs – for judging a theory of style.

From the viewpoint of synthesis, the transformation model provides an alternative to traditional, informal approaches to the creation of new designs. And within the more formal languages of designs approach, it provides an alternative to the "start from scratch" program for the creation of new grammars, proposed by Stiny. The transformation model combines the formal rigor of shape grammars with the traditional "form follows form" view of innovation, by allowing new languages to be constructed on the basis of known ones. However, this approach to design departs from traditional ones in a number of important ways.

First, representing known styles of designs in terms of grammars, or sets of rules, lays bare possibilities for change that could not be visualized otherwise, for example, by just looking at individual designs in these styles. Second, transformations are easily realized by making simple alterations to rules. Because rules are generally easier to understand than the designs they generate, the consequences of altering rules are easier to understand and control than alterations made directly to more complicated designs. Third, because transformations themselves are expressed in terms of easy to understand operations, the intentions and ideas of the designer can be externalized and clarified more readily. Last, transformations can be used to construct not just one new design, or even one new language of designs, but a multiplicity of new languages of designs. A whole new range of design possibilities or choices may be opened up in a few steps.

Clearly, the transformation model proposed here does not address all questions of stylistic change. Changes in the content or meaning of forms, for example, are not considered. However, it is easy to imagine a more complete system in which the transformations that operate on the rules of a shape grammar are linked to similar transformations that operate on the rules of a corresponding description scheme. Such a system would not only elucidate the changes in form and the changes in meaning of designs – what Focillon called, the "life of forms" and the "life of symbols" – but also elucidate the relationships and reciprocities between the two. Building up a store of knowledge about style and change in this way may also provide the foundation for new insights and more systematic answers to other broader and more elusive questions concerning the behavior and causes of style.

Part II Transformations of languages of designs: a formal model

A formal model for defining transformations of languages of designs is presented in the following chapters. In chapter 3, a standardized format for shape grammars is described. This format distinguishes the different spatial and nonspatial determinants of the composition of designs in a language. A formal property of a grammar called its *recursive structure* is discussed in chapter 4. The recursive structure of a grammar describes the way the rules of the grammar interact in the construction of designs. In chapter 5, the operations for transforming a grammar are defined. These are *rule addition*, *rule deletion*, and *rule change*. Each operation can be applied to a grammar to transform it into one or more new grammars. Each transformation of a grammar into a new grammar determines a transformation of the corresponding language into a new language. Of particular interest are those transformations that preserve the recursive structure of the original grammar. Very simple, tutorial examples of grammars and transformations are presented.

3 Shape grammars: a standard format

To facilitate the comparison and construction of languages of designs in terms of the grammars that generate them, a standard format for expressing the initial shape and rules of a shape grammar is defined here. This format allows different shape rules of different grammars to be compared in a systematic way. It simplifies the presentation of rules and isolates the basic determinants of the composition of designs that rules generate: spatial relations and the places and order in which spatial relations are used to construct designs. The format also allows different transformation operations to be defined and applied in a general way to any shape rule of a grammar. Although this format restricts the ways that rules are expressed, it does not in any way restrict the kinds of designs that can be generated. In other words, the generative power of a shape grammar defined in the standard format presented here is equivalent to that of a shape grammar defined in the format originally given by Stiny.

The development of a "standardized" shape grammar has six stages. It is an elaboration of Stiny's earlier program for defining a shape grammar that was described in the previous chapter.

A vocabulary of shapes

A *shape* is an arrangement of lines in two or three dimensions. The lines in a shape can be connected or disconnected, they can overlap or intersect; in other words, lines can be arranged in any conceivable way to form a shape. The number of lines in a shape can be few, several, or many; in other words, shapes can be as simple or as complicated as imaginable. A special shape that has no lines in it, corresponding to a blank space, is called the *empty shape*. The empty shape is denoted by the symbol s_\emptyset.

Every shape has a definite location, orientation, and size in some two- or three-dimensional coordinate system. However,

coordinate systems are usually not shown in drawings of shapes except when the exact position or dimensions of a shape are important. Examples of different shapes in two dimensions are shown in figure 3.1.

Shapes can be compared and manipulated in various ways using elementary *relations* and *operations*. Each of these relations and operations has a formal definition but can be explained and understood intuitively using informal definitions based on the manual operations of drawing and erasing shapes with a pencil and an eraser.

Two relations that allow shapes to be compared are the *part of* or *in* relation (denoted by ≤) and the *equality* relation (denoted by =). A shape A is a part of, or in, a shape B whenever the result of drawing one of these shapes and then drawing the other shape is the shape B. A shape A is equal to a shape B whenever the result of drawing one of these shapes and then drawing the other shape is the shape A as well as the shape B. In other words, two shapes are equal whenever each shape is a part of the other shape. Figure 3.2 shows an example of shapes that are parts of another shape. Figure 3.3 shows an example of two shapes that are equal.

Three operations that allow shapes to be manipulated to create new shapes are *shape addition* or *sum* (denoted by +), *shape subtraction* or *difference* (denoted by −), and the *euclidean transformations* (each denoted by t).

With shape addition, a shape B is added to a shape A to create another shape A + B. The new shape A + B is simply the shape produced by drawing one shape and then drawing the other shape. With shape subtraction, a shape B is subtracted from a shape A to create another shape A − B. The new shape A − B is the shape produced by drawing one shape, drawing the other shape, and then erasing the shape B. In other words, the shape A − B is the shape A with all of its parts that are also parts of B, erased. Figure 3.4 shows examples of shape addition and shape subtraction.

Shapes can be combined to produce new shapes in sequences of addition and subtraction operations. Figure 3.5, for example, illustrates three shapes, A, B, and C that are combined in the sequence (A + B) − C. Figure 3.6 illustrates two shapes A and B that are combined in the sequence (A + B) − B. Because lines in B overlap lines in A, subtracting B after adding it to A does not give back the shape A. This result, while at odds with ordinary number addition and subtraction, corresponds exactly to what happens when drawing and erasing shapes with a pencil and eraser.

A third operation for producing new shapes from given ones involves the *euclidean transformations*. A euclidean transformation t takes a single shape A and creates a new one t(A) by changing A's location, orientation, handedness, size, or some combination of these changes. Formally, these changes correspond to the transformations of *translation, rotation, reflection,*

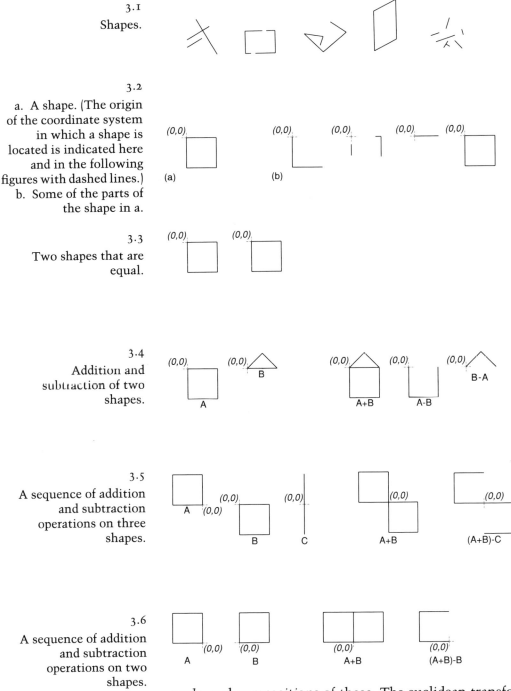

3.1
Shapes.

3.2
a. A shape. (The origin of the coordinate system in which a shape is located is indicated here and in the following figures with dashed lines.)
b. Some of the parts of the shape in a.

3.3
Two shapes that are equal.

3.4
Addition and subtraction of two shapes.

3.5
A sequence of addition and subtraction operations on three shapes.

3.6
A sequence of addition and subtraction operations on two shapes.

scale, and *compositions* of these. The euclidean transformations change a shape into another shape that is *similar* to it. If scale is not included in a transformation, then a shape is changed into another shape that is *congruent* to it. Transformations are considered to be the same whenever they leave every line in a

A shape

Translations of the shape

Rotations of the shape about different points in the coordinate
system in which the shape is located.

Reflections of the shape across different axes.

shape in exactly the same location and with exactly the same
orientation, handedness, and size; otherwise they are different. A
special transformation that leaves every line in a shape in its
original location with its original orientation, handedness, and
size is called the *identity* transformation. For example, a 360°
rotation of a square about its center is an identity transformation.
So is a 0° rotation, scaling by a factor of 1, or any other trans-
formation that does not change the shape in any way. Figure 3.7
gives examples of various euclidean transformations.

A set of shapes constitutes a *vocabulary*. Usually, a vocabulary
is assumed to include all of the euclidean transformations of all
the shapes in it. The shapes in a vocabulary are building blocks for
designs. Because shapes can be formed from lines in almost limit-

Scalings of the shape by different factors (.5 and 1.5) and with respect to different points.

Composition of two reflections of the shape.

A transformation of the shape that is the same as the transformation above.

less ways, vocabularies for constructing designs are not fixed or preordained in any way.

A vocabulary of shapes by itself, however, does not determine designs; it merely determines the pieces from which designs may be made. To actually construct designs, the ways that shapes in a vocabulary can be combined with one another must be specified. The operations of shape addition, shape subtraction, and the euclidean transformations provide very general ways for combining shapes in a vocabulary. However, without restricting the ways these operations are used, all vocabularies of shapes are equivalent – all can be used to produce every design, or shape, made up of any number and any arrangement of lines. More particular ways of combining shapes in a vocabulary are necessary. These more particular combinations of shapes are given with spatial relations.

Spatial relations

A *spatial relation* is an arrangement of shapes. Just as lines can be arranged in any conceivable way to form a shape, shapes can be arranged in any conceivable way to form a spatial relation. The shapes in a relation can touch or not touch, they can overlap, one can be inside the other, and so on. A spatial relation can have any number of shapes in it. Again, like shapes, spatial relations can be as simple or as complicated as imaginable. Example of spatial relations between two shapes – a square and an isosceles triangle – are shown in figure 3.8.

The spatial relations in figure 3.8 are all different. In each relation, the arrangement between the square and the triangle differs. Spatial relations can also be the same. A spatial relation is the same as another spatial relation whenever the arrangement of shapes in one relation is a translated, rotated, reflected, or scaled version of the arrangement of shapes in the other relation. The spatial relations between squares and isosceles triangles in figure 3.9, for example, are all the same. Although the positions, orientations, or sizes of the square and the triangle in each relation are different, the relationship between the square and the triangle in each relation is identical: the square and triangle are always adjacent and the square always shares a side with the base of the triangle.

When defining a spatial relation, it is important to specify the individual shapes in the relation as well as the arrangement between these shapes. If the shapes in a relation are not distinguished (either graphically or verbally), then spatial relations that are different may be taken for the same. Figure 3.10, for instance, shows two spatial relations. The arrangement of shapes in each relation looks the same, yet the two relations are different. The spatial relation in figure 3.10a is between a square and a triangle; the spatial relation in figure 3.10b is between a pentagon and a line.

3.8
Spatial relations between a square and an isosceles triangle.

3.9
Spatial relations that are the same.

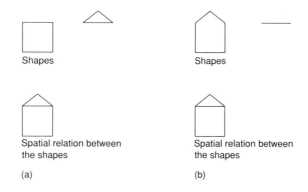

Shapes

Shapes

Spatial relation between
the shapes

Spatial relation between
the shapes

(a)

(b)

Spatial relations are compositional ideas for making designs. They provide different contexts for either adding shapes in a vocabulary to one another or subtracting these shapes from one another, to create a design. In more traditional terms, they fix the ways that shapes may be either drawn or erased as a design is made. These two basic actions of adding (drawing) and subtracting (erasing) shapes in accordance with spatial relations can be specified more precisely with shape rules.

Shape rules

Spatial relations are the basis for rules of composition called *shape rules*. For the sake of simplicity, only rules defined on the basis of spatial relations between two shapes will be considered here. However, the definitions given can easily be generalized to relations between any number of shapes.

Given two shapes A and B that are arranged to form a spatial relation, denoted by A + B, four shape rules can be determined. Two of these rules correspond to the operation of adding a shape, two correspond to the operation of subtracting a shape:

addition rules: (1) A → A + B
 (2) B → A + B

subtraction rules: (3) A + B → A
 (4) A + B → B

Addition rule (1) says that if the shape A is in a design being generated, then the shape B may be added to the design to form the spatial relation A + B. Similarly, addition rule (2) says that if the shape B is in a design being generated, then the shape A may be added to the design to form the spatial relation A + B. Subtraction rule (3) says that if the shapes A and B, arranged in the spatial relation A + B, are in a design being generated, then a shape may be subtracted from the design, to leave the shape A. Similarly,

subtraction rule (4) says that if the shapes A and B, arranged in the spatial relation A + B, are in a design being generated, then a shape may be subtracted from the design, to leave the shape B. In each of these different rules, the spatial relation A + B controls the way that a shape is added to or subtracted from a design as it is being made. The shapes in each rule are assumed to have the same locations, orientations, and sizes as the shapes in the spatial relation from which each rule is defined.

Figure 3.11 gives an example of how shape rules are defined in terms of a spatial relation. A spatial relation between two squares is illustrated in figure 3.11a. In the relation, the smaller square is one-half the size of the larger square and is centered inside of it. Figure 3.11b shows the four rules that can be defined from this one relation. Rule 1 adds a larger square around a smaller one. Rule 2 adds a smaller square inside a larger one. Rule 3 subtracts the larger of two squares. Rule 4 subtracts the smaller of two squares. Although all four rules are based on the same spatial relation, each rule specifies a distinctly different compositional action.

Shape rules apply *recursively*, in a step-by-step fashion, to construct designs. In each step of the construction, or *derivation*, of a design, a shape rule applies to a design to change it into another

3.11

Defining and applying
shape rules in terms of a
spatial relation.

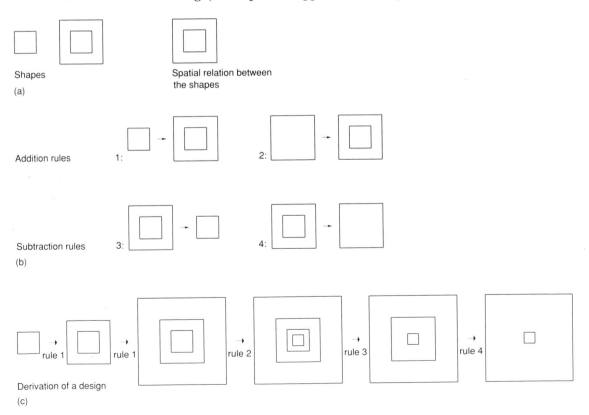

Shapes
(a)

Spatial relation between
the shapes

Addition rules 1: 2:

Subtraction rules 3: 4:
(b)

rule 1 rule 1 rule 2 rule 3 rule 4

Derivation of a design
(c)

one. A rule can be applied to a design whenever the shape (or arrangement of shapes) on the left-side of the rule "matches" a shape (or shapes) in the design. A shape matches another shape whenever there is a euclidean transformation that makes the first shape equal to the second shape. If a rule is applicable to a design, then the transformed or matched version of the shape on the left-side of the rule is erased from the design and replaced with the shape (or arrangement of shapes) on the right-side of the rule, similarly transformed. More formally, a shape rule (either an addition rule or a subtraction rule) denoted by *left-side → right-side* applies to a design whenever there is a euclidean transformation t such that $t(left\text{-}side) \le$ design. The new design produced by applying the rule is equal to: [design $- t(left\text{-}side)] + t(right\text{-}side)$.

Shape rules apply to generate designs *nondeterministically*. That is, in each step of a derivation, there may be a choice of rules that apply to the current design. Further, there may be a choice of euclidean transformations under which a rule can be applied. These different transformations match the left-side of a rule either with different parts of a design or with the same part in different ways. Applying different rules to a design may lead to different results; applying the same rule under different transformations may do likewise.

Figure 3.11c shows a derivation of a design using the shape rules in figure 3.11b. In this derivation and all others, the design in each step has a fixed location, orientation, and size with respect to some coordinate system. The coordinate system may be shown explicitly or simply assumed as in the figures here. The location, orientation, and size of the design in the first step of a derivation fix the locations, orientations, and sizes of the designs in succeeding steps.

The derivation of figure 3.11c begins with a single square. In the first step, either rule 1 or rule 2 can be applied to the square. Each rule can also apply under any one of several different transformations that match the square on the left-side of the rule with the square in the first step of the derivation. However, in this case, applying a rule under any of these different transformations produces the same result. In the step that is shown, rule 1 is applied to add a larger square around the first one. (More formally, following the definition for rule application given above, the square on the left-side of rule 1 is subtracted from the starting square leaving the empty shape, then the two squares on the right-side of the rule are added.) In the second step of the derivation, any one of rules 1 through 4 can be applied to the second design. In the step shown, rule 1 is applied again to add a third, larger square. To apply this rule, the square on the left-side of the rule is matched with the square added in the first step of the derivation. The rule could have been applied under a different transformation to match the

first square once again, adding the second square back again. Choices of rule applications continue in the following steps. In the third step, rule 2 is applied to add a smaller square inside the first square. In the final two steps, rules 3 and 4 are applied to subtract squares. The final design is one of many possible designs that can be generated with the four shape rules.

Figure 3.12 gives another simple example of a spatial relation, the shape rules defined in terms of that relation, and a design generated by the rules. Figure 3.12a shows the Greek cross relation between two rectangles illustrated in the preceding chapter. Figure 3.12b shows the four shape rules determined from this relation. Unlike the previous example, the two addition rules defined from this relation are equivalent compositionally, as are the two subtraction rules. Both addition rules apply to a rectangle of any size and orientation to overlay another rectangle on top of it. Both subtraction rules apply to a Greek cross of any size and orientation to subtract either one of the two rectangles in it. In general, two addition rules or two subtraction rules are equivalent whenever the shapes A and B in the defining spatial relation are congruent, and the disposition of the shape A with respect to the shape B in the spatial relation is the same as the disposition of the shape B with respect to the shape A. Figure 3.12c illustrates a derivation of a design using the rules in figure 3.12b, beginning with a single rectangle.

Shape rules defined from spatial relations specify the ways that shapes in a vocabulary can be added and subtracted to generate designs. Nevertheless, shape rules defined this way may not be precise enough to control exactly *where* or to what parts of designs, *how* or under what euclidean or matching transformations, and *when* or how many times and in what sequence, rules apply to create designs. Rule 1 in figure 3.12b for example, applies in many different ways to produce a wide variety of designs. To generate a more exclusive set of designs, for example, designs with particular kinds of symmetries, applications of the rule would need to be restricted in definite ways. As it is given now, the rule has no such restrictions.

To limit the ways that rules apply, additional mechanisms called *labels* are necessary. Labels are letters, numbers, or other symbols that are attached to rules. By associating labels with rules, the applications of rules are restricted, thereby restricting the kinds of designs produced by them.

Two kinds of labels may be used with rules: *spatial labels* and *state labels*.

Spatial labels control *where* and *how* rules apply to designs by distinguishing spatial aspects of rules and designs. Like a shape, a spatial label has a definite location, marking a particular point, in some coordinate system. Unlike a shape, the orientation and size of a spatial label is inconsequential.

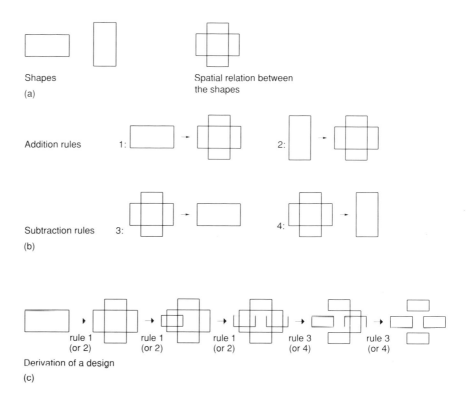

Shapes

(a)

Spatial relation between the shapes

Addition rules 1: 2:

Subtraction rules 3: 4:

(b)

Derivation of a design

rule 1 (or 2) rule 1 (or 2) rule 1 (or 2) rule 3 (or 4) rule 3 (or 4)

(c)

3.12

Defining and applying shape rules in terms of a spatial relation.

State labels, on the other hand, control *when* rules apply to designs. More specifically, they control the sequence and repetition of rule applications. State labels do not distinguish spatial aspects of rules or designs, rather they distinguish the stage or state a design is in as it is being generated. State labels have neither a particular location, a particular orientation, nor a particular size with respect to some coordinate system: they are completely nonspatial.

The use of spatial labels is illustrated in figures 3.13 through 3.20. All of these examples are based on the Greek cross addition rule 1 of figure 3.12b.

Figure 3.13a shows the Greek cross rule with spatial labels added. A dot marks the center of the rectangle on the left-side of the rule; a dot also marks the center of the smaller, top rectangle of the cross on the right-side of the rule. These labels identify where, or to what parts of a design, the left-side of the rule may be matched in order to apply the rule. To apply a labeled rule, such as this one, the shape and all labels on the left-side of the rule must match a shape and labels in a design.

A derivation of a design using the rule of figure 3.13a is illustrated in figure 3.13b. In each step of the derivation, the dot on the left-side of the rule and the dot in the current design restrict matching the rule to exactly one rectangle in a design. Applying

3.13
Using spatial labels to
control where a rule is
applied.
a. Shape rule.
b. Derivation of a
design.
c. Other designs.

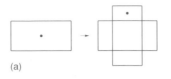

(a)

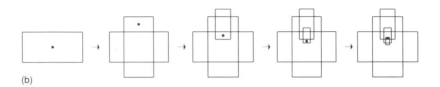

(b)

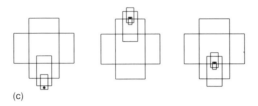

(c)

the rule creates a new, smaller Greek cross with either its top arm
or its bottom arm labeled with a dot, depending on what matching
transformation the rule is applied under. Four different trans-
formations are possible. One transformation involves a reflection
across a vertical axis passing through the center of the rectangle
on the left-side of the rule, one involves a reflection across a
horizontal axis, one involves a 180° rotation, and one may involve
only the identity transformation. These four transformations are
illustrated in figure 3.14. All four transformations may also
involve translation or scale transformations in the different steps
of a derivation. Applying the rule under a transformation that
involves a rotation or a horizontal reflection places a dot on the
bottom arm of the new cross; applying the rule under any other
transformation places a dot on the top arm of the new cross. The
final design of the derivation shown in figure 3.13b is thus one of
many designs that can be produced with the rule. Different
designs are produced by applying the rule under different trans-
formations in the steps of a derivation. Nonetheless, this rule
generates a smaller, more exclusive set of designs than its
unlabeled version: only bilaterally symmetric designs with
successively smaller Greek crosses placed along a vertical axis of
symmetry are produced. Figure 3.13c shows some other designs
determined by the rule.

3.14
The different
transformations
involved in matching
the left-side of the rule
of figure 3.13a with a
shape in a design.

vertical reflection horizontal reflection 180° rotation identity

The rule of figure 3.13a allows exactly one Greek cross of any size to occur in a design; that is, it applies to create a cross from either the top arm or the bottom arm of the previously formed cross in each step of a derivation. To create a cross from the top arm, the bottom arm, or both the top and bottom arms of the previously formed cross, the rule is labeled as shown in figure 3.15a. Spatial labels now mark both the top and bottom arms of the cross on the right-side of the rule. A derivation of a design using this rule is illustrated in figure 3.15b. In each step of the derivation, the rule applies to create a cross with both its top and bottom arms labeled, regardless of which transformation the rule is applied under. In any subsequent step, the rule may be applied to create a new, smaller cross from the top, bottom, or both top and bottom arms of any previously formed cross. The rule need not apply everywhere it is possible to do so. Thus, designs generated by the rule may have either one or two Greek crosses of any size placed along a vertical axis of symmetry.

3.15
Using spatial labels to
control where a rule is
applied.
a. Shape rule.
b. Derivation of a
design. (The notation →
... → indicates steps in
the derivation not
shown in the figure.)

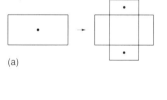

(a)

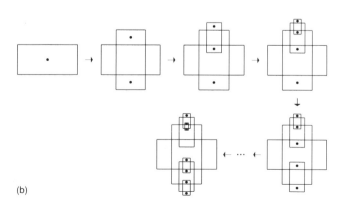

(b)

In figure 3.16a, the rule is relabeled to produce very different kinds of designs. Spatial labels now mark the left and right arms of the cross on the right-side of the rule. This rule generates designs in which successively smaller crosses are created alternately along a vertical axis (from the top and/or bottom arms of a previously formed cross) and along a horizontal axis (from the right and/or left arms of a previously formed cross). A derivation of a design is given in figure 3.16b. In this derivation, crosses are formed everywhere it is possible to do so, that is, from both the right and left arms or from both the top and bottom arms of previously formed crosses in a design.

With each of the labeled rules presented so far, there is a choice of four different transformations under which a rule can be applied to a part of a design in each step of a derivation. With the rule of figure 3.13a, this choice determines two different results. To eliminate this choice, that is, to produce designs in which new crosses are always created from the top arm of each previously formed cross or always created from the bottom arm of each previously formed cross, the rule must be labeled differently. One possible labeling is shown in figure 3.17a. The dots in the rule are now located at the top centers of rectangles. These labels still identify those rectangles to which the left-side of the rule may be matched in order to apply the rule; however, matching is now restricted to just two transformations – the transformations that involve either a horizontal reflection or a 180° rotation are excluded. Thus, the spatial labels in this rule identify not only *where*, or to what parts of a design, the rule can be matched but also *how*, or under what euclidean transformations, the rule can be matched with the identified parts. A derivation of a design

3.16

Using spatial labels to control where a rule is applied.
a. Shape rule.
b. Derivation of a design.

(a)

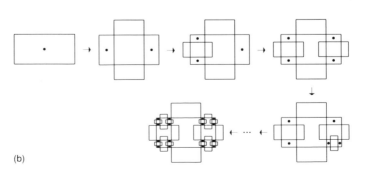

(b)

3.17
Using spatial labels to
control where and how
a rule is applied.
a. Shape rule.
b. Derivation of a
design.

(a)

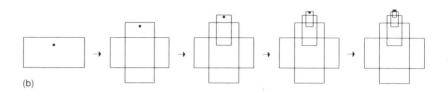

(b)

3.18
Using spatial labels to
control where and how
a rule is applied.
a. Shape rule.
b. Derivation of a
design.

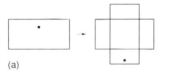

(a)

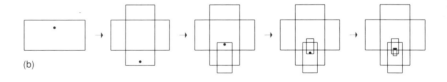

(b)

using the rule is illustrated in figure 3.17b. The rule generates a
subset of the designs generated by the rule of figure 3.13a. Only
designs with successively smaller Greek crosses created from the
topmost arms of previous formed crosses are produced.

The Greek cross rule can be labeled with spatial labels in
numerous other ways to determine designs with special prop-
erties. Figure 3.18a, for example, shows the rule labeled so that
successively smaller crosses are created alternately from the top
and bottom arms of previously formed crosses. A derivation of a
design is given in figure 3.18b.

Figure 3.19a shows the rule labeled so that successively smaller
crosses are created in repeating cycles from the right, bottom, left,
and top arms of previously formed crosses. The spatial labels in

3.19

Using spatial labels to
control where and how
a rule is applied.
a. Shape rule.
b. Derivation of a
design.

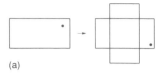

(a)

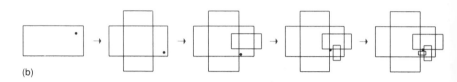

(b)

the rule are now located in the corners of rectangles so that the
transformations under which the rule can be applied are restricted
to just one. A derivation of a design is shown in figure 3.19b.
Successively smaller crosses spiral clockwise around the right
arm of the largest cross.

Figure 3.20a shows still another labeling of the rule. This rule
creates crosses alternately from the right and top arms of pre-
viously formed crosses. Figure 3.20b shows a derivation of a
design.

The final designs of the derivations of figures 3.13b through
3.20b have labels associated with them. To erase labels from a
design in the final step or any other step of a derivation, an *erasing
rule* may be used. The rule shown in figure 3.21a, for example,
applies to erase dots from the centers of rectangles. It can be used
to erase labels from the designs shown in figures 3.13b, 3.15b, and
3.16b. The rule shown in figure 3.21b applies to erase labels from
designs illustrated in figures 3.17b and 3.18b; the rule shown in
figure 3.21c applies to erase labels from designs illustrated in

3.20

Using spatial labels to
control where and how
a rule is applied.
a. Shape rule.
b. Derivation of a
design.

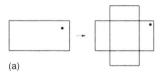

(a)

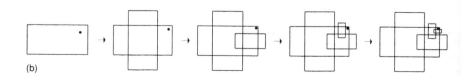

(b)

3.21
Shape rules for erasing
labels.

(a)

(b)

(c)

figures 3.19b and 3.20b. Rules, like these, that erase labels while neither adding nor subtracting shapes may be viewed as special cases of either addition or subtraction rules that are defined in terms of spatial relations consisting of just one shape. Rules that introduce new labels, while neither adding nor subtracting shapes, may be viewed in the same way. Examples of these kinds of rules may be found in the grammars in Part III.

The use of state labels is illustrated in figures 3.22 and 3.23. These examples are based on rules 1 and 4 of figure 3.11b.

Figure 3.22 shows how state labels can be used to control the sequence in which rules are applied. Two rules with state labels are illustrated in figure 3.22a. A state label, or more simply, a state, *1* is associated with the left-side of rule 1; a state 2 is associated with the right-side. States are reversed in rule 2: a state 2 is associated with the left-side of the rule and a state *1* with the right-side. Rules with state labels, such as these, apply in a similar way as do rules with spatial labels. To apply a rule, the shape on the left-side of the rule (including any spatial labels) must match a shape in a design in the usual way. In addition, the state on the left-side of the rule must match, or be identical to, the state of the design. Applying the rule replaces a shape in a design with another shape in the usual way. At the same time, it replaces the state of the design with the state on the right-side of the rule.

The state labels associated with the rule of figure 3.22a limit applications of these rules to a definite sequence. Limiting the rules in this way allows only particular kinds of designs to be generated. A derivation of a design is illustrated in figure 3.22b. The derivation begins with a single square in a state *1*. In the first step, rule 1 is the only applicable rule. It applies to produce a design in a state 2. In the next step, only rule 2 is applicable. Rule 2 then applies to produce a design in a state *1*. In the following step, only rule 1 is applicable. Rule applications continue to

Transformations in design

3.22

Using state labels to
control the sequence of
rule applications.
a. Shape rule.
b. Derivation of a
design.

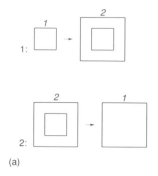

(a)

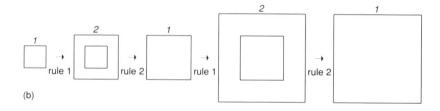

(b)

alternate between rules 1 and 2 to generate a series of single and double squares, doubling in size. No other designs are possible.

Figure 3.23 shows how state labels can be used to control the repetition of rule applications.

In figure 3.23a, a rule is labeled so that it can apply only once. Different states are associated with the left- and right-sides of the rule. Applying the rule thus changes the state of a design, preventing immediate reapplication. In figure 3.23b, the rule is labeled so that it can apply repeatedly any number of times. Here, the same state is associated with the left- and right-sides of the rule. Applying this rule thus leaves the state of a design unchanged, allowing unlimited reapplications of the rule in succession.

Only one state is associated with each side of a rule in the rules above. More than one state may be associated with either or both sides of a rule using *variable states*. A variable state stands for one or more states. When a variable state is associated with a rule, the range of values it can have must also be given. The range of values may be given explicitly or by specifying conditions that values must satisfy.

A rule with variable states is illustrated in figure 3.23c. Here, variables are associated with both sides of the rule. The range of values that may be assigned to these variables are also specified. To apply a rule with variable states, each variable in the rule must be assigned a value from the specified range. The rule may then be applied in the usual way. For example, in the rule of figure 3.23c,

3.23
Using state labels to
control the repetition of
rule applications.

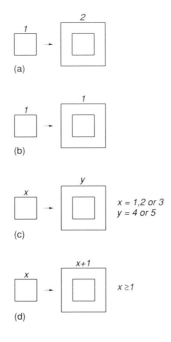

(a)

(b)

(c)

$x = 1,2 \text{ or } 3$
$y = 4 \text{ or } 5$

(d)

$x \geq 1$

the variable x may be given a value of *1*, *2*, or *3* and the variable y may be given a value of either *4* or *5*. Thus, the rule applies to a design in a state *1*, *2*, or *3*, to produce another design in a state *4* or *5*.

Variable states can be used to count and control the exact number of times a rule is applied. Figure 3.23d, for example, shows a rule with variable states again associated with both sides of the rule. Here, however, the variable state on the right-side of the rule is a function of the variable state on the left-side. The variable x that appears on both sides may be any integer greater than or equal to one. The rule thus applies to a design in a state *1* or greater. Applying the rule increases the state of a design by one. Like the rule of figure 3.23b, this rule can be applied an unlimited number of times in succession. Unlike the previous rule, the state of a design generated with this rule indicates exactly how many times the rule has been applied. The number of times the rule may be applied can be limited simply by restricting the values that may be assigned to x to some limited range. If the range of values is restricted to *1*, *2*, and *3*, for example, the rule may apply at most three times.

Rules need not have any state labels associated with their left- or right-sides. A rule with no state label on its left-side applies to a design in any state to generate another design in the state specified on its right-side. A rule with no state label on its right-side applies to a design in the state specified by its left-side to generate a design in any state. A rule with no state labels on either side

applies to a design in any state to generate another design in exactly the same state. In other words, the absence of a state label on either side of a rule is equivalent to the presence of a variable state with an unlimited range of possible values. When both sides of a rule have no state labels, then the variables on the two sides, and the values assigned to them, are assumed to be the same.

Shape rules defined in terms of spatial relations and labels describe how designs can be constructed. To begin the construction of a design, a starting or initial shape must be given.

An initial shape

An *initial shape* is a shape or combination of shapes from the vocabulary, with or without spatial or state labels. An initial shape has a definite location, orientation, and size in some two- or three-dimensional coordinate system. Again, the coordinate system is usually not shown, but is assumed. The location, orientation, and size of an initial shape determine the locations, orientations, and sizes of the designs generated from it. Fixing the initial shape in a definite place and with a definite size allows designs to be constructed in relation to some context such as a piece of paper, a canvas, a site plan, or other frame of reference with some explicit or assumed coordinate system.

Consider, for example, the Greek cross rule shown in figure 3.24a. The rule can be applied to generate designs starting with any of the initial shapes shown in figure 3.24b. Each initial shape is located, oriented, or sized differently with respect to an implicit frame of reference, here, the page on which it appears. Designs generated from each initial shape are illustrated immediately below. (It is assumed that each design is located in the same place on the page as the initial shape from which it is derived.) The first design is "orthogonal" with respect to the page. The second is "diagonal." The third design is relatively "small." The fourth is "larger." By fixing the initial shape within a context or coordinate system, designs produced from it may be described in terms of extrinsic, contextual properties such as those above.

An initial shape provides a starting condition for generating designs. Conditions for ending generations of designs are provided by a final state.

A final state

A *final state* is a state label or range of state labels. A final state specifies when a design is in a completion or final stage of a derivation.

For example, consider designs generated by applying the rules of figure 3.22a to an initial shape consisting of a single square in a state 1. If a final state of 1 is specified, then only designs made up

3.24

Applying a shape rule to
different initial shapes.

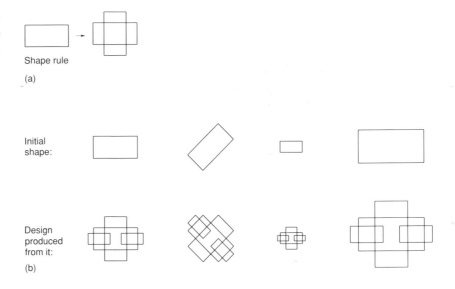

Shape rule

(a)

Initial
shape:

Design
produced
from it:

(b)

of single squares are in a completion stage. If, on the other hand, a
final state of 2 is specified, then only designs made up of double
squares are in a completion stage.

A final state may be not just one state, but a range of states.
Consider, for instance, designs generated by applying the rule of
figure 3.23d to the initial shape described above. If the final state
is any even integer, then only designs made up of an even number
of squares are in a completion stage. Similarly, if the final state is
any odd integer, then only designs made up of an odd number of
squares are in a completion stage. If the final state is restricted to a
limited range of states, say, any integer between *1* and *5*, then a
limited number of designs, for example, designs with between one
and five squares, are in a completion stage.

A final state may be blank (denoted by #) in which case a design
in any state is in a completion stage.

A shape grammar

A set of shape rules, an initial shape, and a final state constitute a
shape grammar. The shape rules of a grammar apply to the initial
shape, and to shapes produced from it, to create designs. Only
those designs in a final state and with all spatial labels erased are
in the *language* defined by the grammar. The requirement that all
spatial labels be erased from designs can be disregarded, if so
specified, for those labels considered to be necessary parts of final
designs. For example, letters or other labels identifying functional
areas in architectural plans need not be erased when so indicated.

3.25
Examples of shape
grammars.

I:

initial shape

1:

2:

shape rules

F: #
final state

shape grammar

designs in the language
(a)

I:
initial shape

1:

2:

shape rules

F: *1* or *2*
final state

shape grammar

designs in the language
(b)

Figure 3.25 gives four simple examples of shape grammars and designs in the languages they define.

The grammar of figure 3.25a is based on the rule of figure 3.17a. This grammar uses only spatial labels and no state labels. The grammar of figure 3.25b is based on the rules of figure 3.22a. This grammar uses only state labels and no spatial labels.

The grammar of figure 3.25c uses neither spatial nor state labels. It is based on unlabeled versions of the rules of the grammars above. Because no labels are used, the grammar generates a very diverse language of designs.

The grammar of figure 3.25d uses both spatial labels and state labels to generate a more restricted language of designs. The state labels *1* and *2* in the first two rules are used to alternate applications of rules 1 and 2. The spatial label ⋆ in these rules identifies squares that can be circumscribed by larger squares. The spatial label ● in rule 1 is the same as the spatial label in the rule of figure 3.19a and determines the same results. Rules 3 and 4 erase spatial labels. A derivation of a design is illustrated below the grammar. Other designs in the language defined by the grammar are also

I:
initial shape

1:

2:

3:
shape rules

F: #
final state

shape grammar

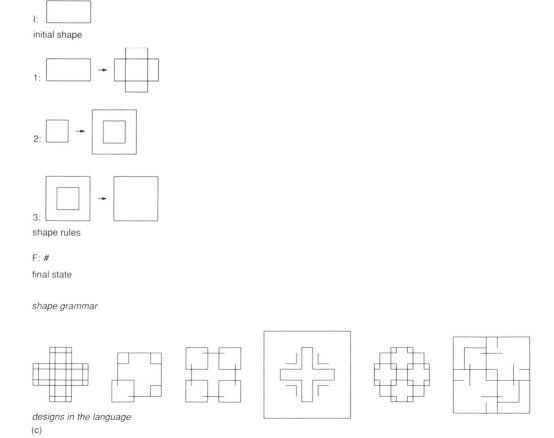

designs in the language
(c)

3.25 continued

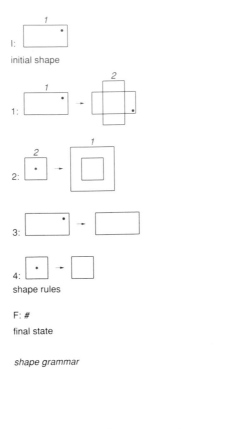

I:
initial shape

1:

2:

3:

4:
shape rules

F: #
final state

shape grammar

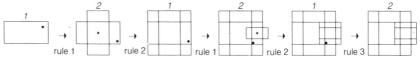

rule 1 rule 2 rule 1 rule 2 rule 3

derivation of a design

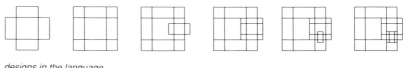

designs in the language
(d)

shown. Designs are made up of successively smaller Greek crosses, and successively smaller Greek crosses inscribed in squares, that spiral clockwise around the right sides of designs.

The stage-by-stage program for defining a shape grammar given above can be generalized to define a *parametric shape grammar*.

3.26

A shape schema that defines a family of rectangles.
a. A shape schema. Values assigned to the variables x_1, x_2, x_3, x_4, y_1, y_2, y_3, and $y4$ must satisfy the condition: The points (x_1, y_1), (x_2, y_2), (x_3, y_3), and (x_4, y_4) are the vertices of a rectangle.
b. Some shapes defined by assigning values to the variables in the schema.

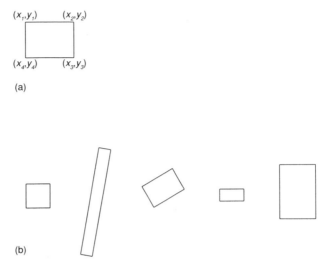

A parametric shape grammar is based on a vocabulary of *shape schemata*. Each shape schema stands for one or more different shapes. A shape schema is defined by allowing aspects of a shape, such as its dimensions, angles, position, and so on, to vary in specified ways. The aspects that vary are the variables of the shape schema. By assigning values to all the variables in a shape schema, an actual shape is defined. The ranges of values that may be assigned to variables must be given along with the schema. These may be specified explicitly or by giving conditions that values must satisfy. Figure 3.26a shows a shape schema that determines a family of rectangles. The variables in the schema are the coordinates of its vertices. Conditions that values assigned to variables must satisfy are given informally. Figure 3.26b shows some shapes defined by assigning different values to variables in the schema.

Shape schemata can be arranged in any way to form a *spatial relation schema*. By assigning values to all of the variables in the spatial relation schema, an actual spatial relation is defined. Figure 3.27a shows a spatial relation schema between two shape schemata. Conditions that values assigned to variables in the relation must satisfy are also given. The schema defines a family of spatial relations between two rectangles of equal size that are separated by a distance proportional to their sizes. Figure 3.27b shows some spatial relations defined by assigning different values to variables in the schema.

A spatial relation schema determines *shape rule schemata* in the same way that a spatial relation determines shape rules. Given any relation schema between two shape schemata, four rule schemata can be defined: two rule schemata for adding shapes

3.27

(a)

A spatial relation schema that defines a family of spatial relations.
a. A spatial relation schema. Values assigned to the variables x_1, x_2, x_3, x_4, x_5, x_6, x_7, x_8, y_1, y_2, y_3, y_4, y_5, y_6, y_7, and y_8 must satisfy the conditions:
1. The points (x_1, y_1), (x_2, y_2), (x_3, y_3), and (x_4, y_4) are the vertices of a rectangle.
2. The points (x_5, y_5), (x_6, y_6), (x_7, y_7), and (x_8, y_8) are the vertices of a rectangle.
3. The distance between the points (x_1, y_1) and (x_2, y_2) is equal to the distance between the points (x_5, y_5) and (x_6, y_6).
4. The points (x_1, y_1), (x_2, y_2), (x_5, y_5), and (x_6, y_6) are coincident with a straight line.
5. The distance between the points (x_2, y_2) and (x_5, y_5) is equal to one-quarter the distance between the points (x_1, y_1) and (x_2, y_2).
b. Some spatial relations defined by assigning values to the variables in the schema.

(b)

and two rule schemata for subtracting shapes. Figure 3.28, for example, shows an addition rule schema defined from the spatial relation schema of figure 3.27a. By assigning values to all of the variables in a rule schema, an actual shape rule is defined. The rule may then be applied in the usual way.

To restrict the application of a rule schema, labels can be associated with it. The spatial labels associated with a rule schema, or the state labels associated with a rule schema, may themselves be a schema. In a *state label schema*, the state on the right- or left-side of a rule may be a variable. Variable states were described earlier. In a *spatial label schema*, the spatial labels on the right- or left-side of a rule may be variables. Unlike a variable state which may vary in only one way, a variable spatial label may vary in two ways: the label itself can vary (as does a variable state label) or the position of the label may vary. To apply a rule with spatial or state label schemata, values must be assigned to each variable label. The range of values that may be assigned to variable labels must, as usual, be specified.

Label schemata may also be associated with regular shape rules. A shape rule with label schemata defines a rule schema since variables are included in the definition of the rule.

A parametric shape grammar is specified in terms of a set of rule schemata, an initial shape, and a final state. The rules of a parametric grammar apply to the initial shape, and to shapes produced from it, to define a language of designs in the usual way. Some of

3.28

A shape rule schema that defines a family of shape rules. Values assigned to variables must satisfy the conditions given in figure 3.27a.

the shape grammars presented in the following chapters are parametric. The schemata used to define rules in these grammars are all discussed informally. Any regular shape grammar, such as any of the grammars in figure 3.25, may be considered a special case of a parametric shape grammar – one in which all variables may be assigned only one value.

A shape grammar or parametric shape grammar defined in the standard format outlined here may not be the shortest or most concise grammar for characterizing a particular style or language. Rules must always be broken down into separate, elementary steps that add and subtract shapes. However, by demanding that shape rules take this simple form, the different spatial and non-spatial mechanisms behind the generation of designs are distinguished:

(1) spatial relations that specify how shapes are added and subtracted in relation to other shapes.
(2) spatial labels that identify the places in designs where shapes can be added and subtracted, and
(3) nonspatial, state labels that order the addition and subtraction of shapes.

Rules of this kind are easier to define, easier to understand, and easier to transform than more complex ones.

4 Recursive structures of shape grammars

The *recursive structure* of a shape grammar is a description of the relationships between the rules of the grammar as they apply to generate designs. Indirectly, it describes the structure of relationships between the different spatial relations which are encoded in the rules of a grammar and which are used to construct designs. Recursive structures provide another way to compare different grammars and the languages they define. If making up new grammars and languages from existing ones, they provide a guide to the construction of new rules which behave in the same way as old ones.

The recursive structure of a shape grammar is given by a relation on the set of rules and initial shape of the grammar. A pair of rules (*rule x, rule y*) is in the relation when application of *rule x* makes it possible to apply *rule y* subsequently in the derivation of a design in the language. *Rule x* may be the initial shape or an addition rule that adds shapes to a design; *rule y* may be an addition or a subtraction rule that is applied to a part of a design that includes the shape, or part of the shape, added by a previous application of *rule x*.

It may be impossible to have a complete knowledge of how the rules of a shape grammar apply to produce designs or, more specifically, to foresee all possible designs generated by the grammar, as well as their derivations. Thus, the recursive structure of a grammar must often be defined in terms of a limited understanding of the language it generates, that is, in terms of a limited subset of the language that the grammar is known to produce. Whenever different understandings of a grammar and its language are possible, different definitions of its recursive structure may also be possible. This appeal to a known part of a language as a way of fixing one's knowledge of it, is not unusual. A common way of showing the language defined by a grammar is to

give a partial but representative catalogue of designs in the language. The language of Palladian villa designs, for example, was described in this way.[1] The recursive structure of a grammar is similarly defined in terms of a selected catalogue of designs and their derivations. If a design can be generated by a grammar in different ways, then multiple derivations of that design may be included in the catalogue.

Given a shape grammar defined in the standard format described earlier, together with derivations of designs in the language it generates, the recursive structure of the grammar is defined as follows.

For each addition or subtraction rule that adds or subtracts a shape in some step of a derivation, a set R of rules used in previous steps of the derivation is defined. The initial shape is considered here to be the first addition rule used in a derivation since it adds the first shape to a design. The set R is a smallest or least set of addition rules used in previous steps of the derivation, such that the sum of the shapes added by these rules includes the part of the design to which the left-side of the addition or subtraction rule is matched, when it is applied. The recursive structure of the shape grammar consists of all and only those pairs of rules (*rule x, rule y*) where *rule y* is an addition or subtraction rule applied in some step of a derivation as described above, and *rule x* is in the set R defined for *rule y*. When *rule y* is the initial shape, then the set R is empty and *rule x* is designated by #.

In the simplest case, the set R defined for some *rule y* consists of a single addition rule that adds a shape to which (or part of which) the left-side of *rule y* is matched in a subsequent rule application. If the set R consists of more than one addition rule, then *rule y* is matched with an *emergent* shape – a shape that is made up of, or emerges from, shapes added by more than one rule.

For any *rule y*, it may sometimes be possible to define more than one least set R. The choice of a particular set R is then arbitrary and reflects a particular interpretation of the relationships between rules.

For some rules used in a derivation, no set R is defined. No set R is defined whenever a rule applied in a step of a derivation is a rule that neither adds nor subtracts a shape, but a rule that manipulates labels only – for example, a rule that erases labels (see figure 3.21). Such rules are not included in the definition of a recursive structure. The recursive structure of a grammar thus describes the interaction of just those rules that correspond to the two basic compositional actions of adding and subtracting shapes in accordance with spatial relations.

Figure 4.1 shows how the recursive structure of the shape grammar illustrated in figure 3.25c is defined. Derivations of two designs in the language defined by the grammar are shown in figure 4.1a. In each step of each derivation, either an addition rule

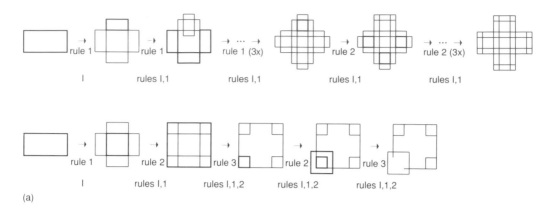

(a)

{(#, I),(I,1),(I,2),(I,3),(1,1),(1,2),(1,3),(2,2),(2,3)}

(b)

4.1
Defining the recursive
structure of the grammar
of figure 3.25c.
a. Derivations of two
designs.
b. The recursive
structure of the
grammar expressed as a
set and as a graph.

or a subtraction rule is applied. In each step, the part of the design to which the rule is matched is indicated with bold lines. Below each step, the rule applied, along with the set R of previously applied rules that make that rule application possible, are given. On the basis of these two derivations, the recursive structure of the grammar is defined as shown in figure 4.1b. Recursive structures can be expressed either symbolically as a set of ordered pairs or graphically as a directed graph. Both representations are shown in this figure. In this particular example, the recursive structure defined for the grammar does not change if any additional derivations are considered.

Figure 4.2 shows the definition of the recursive structure of the shape grammar illustrated in figure 3.25d. Derivations of three designs in the language are given in figure 4.2a. The rules applied, the shapes to which they are applied, and the sets R defined in different steps are indicated as in the example above. For those steps in which shapes are neither added nor subtracted, no set R is defined. Figure 4.2b shows the recursive structure of the grammar. Again, consideration of any other derivations would not change the definition of the recursive structure.

4.2

Defining the recursive structure of the grammar of figure 3.25d.
a. Derivations of three designs.
b. The recursive structure of the grammar expressed as a set and as a graph.

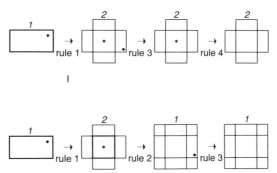

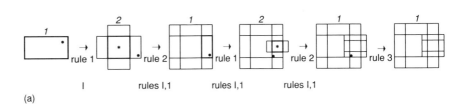

(a)

$\{(\#,I),(I,1),(I,2),(1,1),(1,2)\}$

(b)

Given the recursive structure of a shape grammar, the recursive structure of any part, or subset of the rules, of the grammar can be defined straightforwardly. The recursive structure of a part of a grammar is that subset of the recursive structure of the entire grammar that contains all and only those pairs of rules that are in the specified part of the grammar. Consider, for example, the recursive structure of the grammar in figure 3.25c defined in figure 4.1b. The recursive structure of the entire grammar includes all three rules of the grammar. The recursive structure of just rules 1 and 2 of the grammar, however, consists only of the pairs of rules (1, 1), (1, 2), and (2,2).

The recursive structures of different grammars, or parts of them, can be compared. The recursive structure of one grammar is the same as, or *isomorphic* to, the recursive structure of another grammar whenever there is a one-to-one function *F* from rules of one grammar to rules of the other grammar, such that the pair

(*rule x, rule y*) is in the recursive structure of one grammar if and only if the pair (*F*(*rule x*), *F*(*rule y*)) is in the recursive structure of the other grammar. In other words, the recursive structures of two grammars are isomorphic whenever rules in one grammar can be matched with rules in the other grammar and relationships between corresponding rules are the same. The structure-preserving function *F* that matches the rules of the two grammars is called an *isomorphism*.

Isomorphisms between parts of different grammars, or even parts of the same grammar, are also possible. Isomorphisms between parts of grammars are defined in the obvious way: a one-to-one function is specified that matches addition and subtraction rules of one part with addition and subtraction rules of the other part so that pairs in the recursive structures of the two parts are related as described above.

When different grammars, or parts of them, have isomorphic recursive structures, the spatial relations encoded in the rules of the grammars apply to construct designs in parallel ways. Though the designs generated by different grammars may be quite different visually, their underlying structures may be equivalent. Isomorphic recursive structures are discussed further in the next chapter.

5 Transformations of shape grammars

Transformations of shape grammars in standard format are comprised of three independent operations: *rule addition, rule deletion*, and *rule change*. Each operation is performed on a grammar to produce one or more new grammars.

Rule addition and rule deletion are straightforward, essentially self-explanatory operations. They involve either adding rules to a grammar or subtracting rules from a grammar to produce new grammars. Rule change is more complex and is developed here in more detail than rule addition and rule deletion. With rule change, the rules of a grammar are modified in various ways to produce new rules of new grammars. Of the three mechanisms for transforming grammars, rule change is probably the most illuminating. Rule change demonstrates relationships between different grammars by showing relationships between the individual rules of these grammars, that is, by deriving rules of one grammar from rules of another grammar. With rule addition and deletion, on the other hand, the rules added to or taken away from a grammar are not explicitly derived from or related to other rules. However, all three operations are equivalent in terms of the power they provide for defining new and interesting languages of designs.[1]

Rule addition, rule deletion, and rule change are discussed separately and, for the most part informally, in the sections that follow. Interested readers may refer to Knight for the formal details of these different transformation operations.[2]

Rule addition

Rule addition transforms a shape grammar into new shape grammars by adding shape rules to it. Adding either an initial shape or a final state to a grammar is not allowed since this would result in an incorrectly defined grammar. Only one initial shape and one

final state (possibly a variable representing a range of states) may be defined for a shape grammar.

An example of rule addition is given in figure 5.1. A simple shape grammar is shown in figure 5.1a. The one rule of the grammar is based on the Greek cross spatial relation. Some designs in the language defined by the grammar are also shown. The shape grammar in figure 5.1a can be transformed by adding a rule to it as shown in figure 5.1b. The added rule, rule 2, is based on the spatial relation between two squares illustrated in the previous chapter. The new grammar in figure 5.1b generates all of the designs generated by the original grammar in figure 5.1a as well as new designs. New designs are produced by applying the new rule, rule 2, either alone or in conjunction with rule 1. Adding rule 2 to the grammar in figure 5.1a thus extends the language the grammar generates. Some new designs in the extended language are illustrated.

The shape rule added to the grammar in figure 5.1a to produce the grammar in figure 5.1b is an addition rule. A rule added to a grammar may also be a subtraction rule. For example, the grammar in figure 5.1a can be transformed by adding a subtraction rule to it as shown in figure 5.1c. The added rule, rule 2, is based on the same Greek cross spatial relation that rule 1 is based on. Again, the new grammar generates all of the designs generated by the original grammar as well as new ones. Some new designs are illustrated. In general, adding rules to a grammar, without also deleting or changing other rules, will either extend the language the grammar generates, or not change the language at all.

When rules are added to a shape grammar and the language the grammar generates is extended, then the recursive structure of the new grammar will obviously not be isomorphic to the recursive structure of the original grammar. The rules of the new grammar will apply to construct designs in more and different ways than the rules of the original grammar. However, the recursive structure of a part of the new grammar – for example, that part that contains the original grammar – may be isomorphic to the recursive structure of the original grammar.

Rule deletion

Rule deletion is the inverse of rule addition. Rule deletion transforms a shape grammar into new shape grammars by subtracting, or deleting, shape rules in it. Deleting either an initial shape or a final state from a grammar is not allowed since this would result in an incompletely defined grammar.

Rule deletion is illustrated by figure 5.1. The shape grammar in figure 5.1c, for example, can be transformed into the shape grammar in figure 5.1a by subtracting rule 2 from it. Similarly, the shape grammar in figure 5.1b can be transformed into the shape

5.1
Rule addition and rule deletion. The grammar in a is transformed into the grammars in b and c by adding a rule; conversely, the grammars in b and c are transformed into the grammar in a by deleting a rule.

I:
initial shape

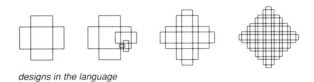

1:
shape rule

F: #
final state

shape grammar

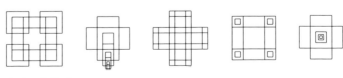

designs in the language

I;
initial shape

1:

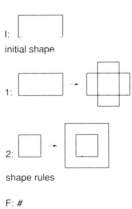

2:

shape rules

F: #
final state

shape grammar

designs in the language

(b)

5.1 continued

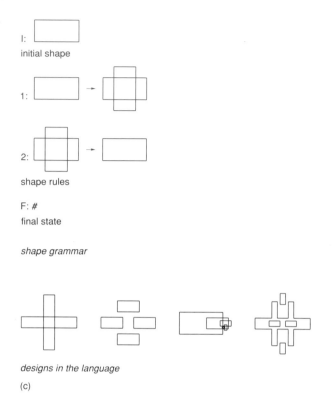

I:

initial shape

1:

2:

shape rules

F: #

final state

shape grammar

designs in the language

(c)

grammar in figure 5.1a by subtracting rule 2 from it. In each case, deleting a rule from a grammar – whether a subtraction rule or an addition rule – prevents certain designs from being generated. In general, deleting rules from a grammar, without also adding or changing other rules, will either reduce the language the grammar generates, or not change the language at all.

If the language generated by a shape grammar is reduced by rule deletion, then the recursive structure of the new grammar will not be isomorphic to the recursive structure of the original grammar. The rules of the new grammar will apply to construct designs in fewer and less varied ways than the rules of the original grammar. However, the recursive structure of the new grammar may be isomorphic to the recursive structure of that part of the original grammar that contains the new grammar.

Rule change

Rule change transforms a shape grammar into a new shape grammar by changing the shape rules, initial shape, or final state in it. Thus, unlike rule addition and rule deletion, rule change

applies not only to the shape rules of a grammar but also to its starting condition (the initial shape) and its ending condition (the final state). Rule change changes a rule, initial shape, or final state by changing any of its spatial or nonspatial components: spatial relations, spatial labels, or state labels. Changes to any one of these components can have subtle to marked effects on the language a grammar generates. Each of these different ways of changing the rules or other parts of a shape grammar is examined here in turn. Changes to state labels are discussed first, followed by changes to spatial labels, and last, changes to spatial relations.

Changing state labels

State labels control the order in which the rules of a grammar apply in derivations of designs. They specify the various stages or states that a design must go through to be in the language defined by a grammar. State labels can be associated with the rules, the initial shape, or the final state of a grammar. Changing the state labels associated with each of these parts of a grammar has varied effects on derivations of designs. Changing the state labels associated with rules, for example, can affect both the sequence and the number of times that rules apply in a derivation. Changing the state label associated with the initial shape can affect which rules apply first in a derivation. Changing the state label associated with the final state can affect which rules apply last in a derivation. Though each of these changes can affect derivations differently, different changes can have either different or identical outcomes in terms of the language a grammar generates.

Figures 5.2 through 5.4 give some examples of changing state labels in a grammar. In figure 5.2, a shape grammar is illustrated. The initial shape of the grammar is a square in a state *1*. Rule 1 is based on a spatial relation between a square and a cross; it applies to subdivide a square into four smaller squares. Rule 2 is based on a spatial relation between two squares; it applies to embed a square inside another square. The rules are ordered by state labels so that rule 1 applies first, followed by rule 2. Rule applications continue to alternate between the two rules. The final state of the grammar is 2. Thus, rule 1 always applies last in derivations of designs in the language. A design in the language is shown. Because of the way that state labels are assigned to the rules, initial shape, and final state of the grammar, every design in the language has exactly the same relationship between the number of subdivided squares in it and the number of embedded squares in it: the number of subdivided squares is always one more than the number of embedded squares.

Changing the state labels associated with any part of the

5.2

A shape grammar.

I:
initial shape

shape rules

F: *2*
final state

shape grammar

design in the language

grammar in figure 5.2 can transform the grammar into a variety of new grammars that differ in interesting ways. For example, the grammar can be transformed by changing the state labels associated with the rules. As they are defined now, each rule has a different state – either 1 or 2 – associated with each side, and the states on the two sides of one rule are reversed on the two sides of the other rule. If the same two states 1 and 2 are associated with the rules but in different ways, then new rules can be produced. If, for instance, all possible assignments of states 1 and 2 to both sides of the rules are considered, then sixteen different pairs of rules can be defined: each side of a rule can be assigned one of two states, each rule can have one of four different assignments of states, and the pair of rules together can have one of sixteen different assignments of states. Each of these different pairs of rules determines a different shape grammar. The sixteen different grammars are illustrated in figure 5.3. Designs in the languages defined by the grammars are also shown.

Nine of the grammars define languages with no designs in them. Some of the nine grammars do generate designs, but none

5.3
Rule change. The grammar of figure 5.2 is transformed into new grammars by changing the state labels associated with its rules.

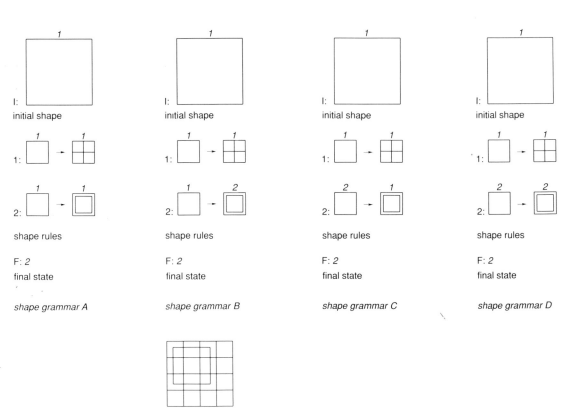

I: initial shape

1: 2: shape rules F: 2 final state *shape grammar A*

I: initial shape

1: 2: shape rules F: 2 final state *shape grammar B*

I: initial shape

1: 2: shape rules F: 2 final state *shape grammar C*

I: initial shape

1: 2: shape rules F: 2 final state *shape grammar D*

design in the language

that are in a final state of 2 (*Grammars A, C, D, I, M*). Others generate no designs at all because no rule applies to the initial shape in a state *1* (*Grammars K, L, O, P*). The remaining seven grammars, however, generate seven distinct languages of designs. In each of these grammars, rules 1 and 2 apply in a different sequence and/or a different number of times.

In *Grammar B*, either rule can apply first, but rule 2 must apply last. Rule 1 applies any number of times; rule 2 applies just once. The grammar thus generates designs with exactly one embedded square and any number of subdivided squares.

Grammar E is the opposite of *Grammar B*. Again, either rule can apply first, but rule 1 must apply last. Rule 1 applies just once; rule 2 applies any number of times. The grammar thus generates designs with exactly one subdivided square and any number of embedded squares.

In *Grammar F*, either rule applies first and applies only once. The grammar generates just the two designs shown.

Grammar G is the original grammar. The two rules apply alternately, starting with rule 1. Each rule can apply any number of times. The grammar generates designs in which the number of

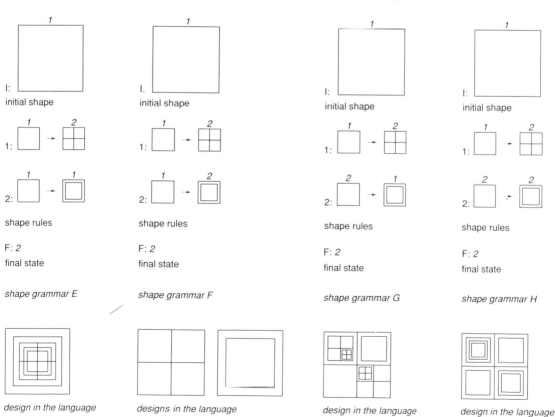

I:
initial shape

1:

2:

shape rules

F: *2*
final state

shape grammar E

design in the language

I.
initial shape

1:

2:

shape rules

F: *2*
final state

shape grammar F

designs in the language

I:
initial shape

1:

2:

shape rules

F: *2*
final state

shape grammar G

design in the language

I:
initial shape

1:

2:

shape rules

F: *2*
final state

shape grammar H

design in the language

subdivided squares is equal to the number of embedded squares plus one.

In *Grammar H*, rule 1 must apply first, but either rule can apply last. Rule 1 applies just once; rule 2 applies any number of times. The repetition of rules in this grammar is the same as in *Grammar E*. Thus, both grammars generate designs with exactly one subdivided square and any number of embedded squares. However, the sequencing of rules in the two grammars is different. *Grammar H* generates designs by first subdividing the initial square and then embedding squares repeatedly, while *Grammar E* generates designs by first embedding squares within the initial square repeatedly and then subdividing one square. Thus, each grammar generates many designs that cannot be generated by the other.

Grammar J is the opposite of *Grammar G*, the original grammar. The two rules apply alternately, starting with rule 2. Each rule can apply any number of times. The grammar generates designs in which the number of embedded squares is equal to the number of subdivided squares plus one.

Grammar N is the opposite of *Grammar H*. Rule 2 must apply

5.3 continued

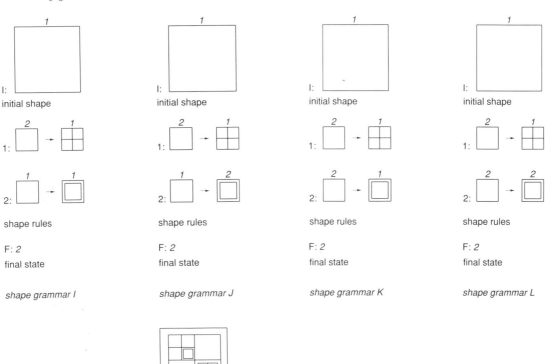

I: initial shape

1:

2:

shape rules

F: *2*
final state

shape grammar I

I: initial shape

1:

2:

shape rules

F: *2*
final state

shape grammar J

I: initial shape

1:

2:

shape rules

F: *2*
final state

shape grammar K

I: initial shape

1:

2:

shape rules

F: *2*
final state

shape grammar L

design in the language

first, but either rule can apply last. Rule 1 applies any number of times; rule 2 applies just once. The grammar thus generates designs with exactly one embedded square and any number of subdivided squares. The repetition of rules in this grammar is the same as in *Grammar B*. Both grammars generate designs with the same relationship between the number of embedded squares and the number of subdivided squares. However, the sequencing of rules in the two grammars is different. *Grammar N* generates designs by first embedding one square in the initial square and then subdividing squares repeatedly, while *Grammar B* generates designs by first subdividing squares repeatedly and then embedding one square. Each grammar generates many designs that cannot be generated by the other.

The shape grammar in figure 5.2 was transformed into all of the new grammars above by changing the state labels associated with its rules. The grammar can be transformed into still more new grammars by changing the state labels associated with its initial shape and final state. For example, if the states *1* and *2* are associated with the initial shape and final state in different ways, then new grammars can be defined. Figure 5.4 shows the four

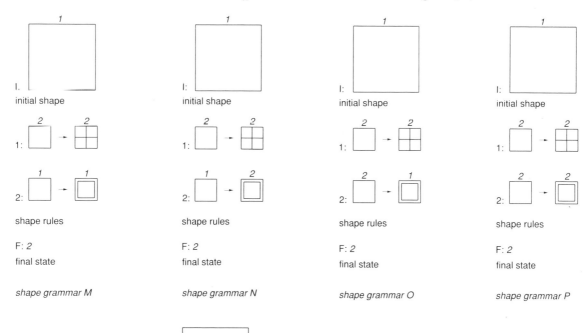

shape grammar M
 shape grammar N
 shape grammar O
 shape grammar P

design in the language

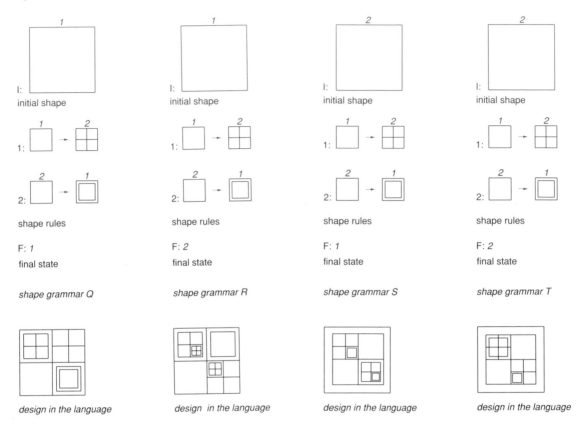

I:
initial shape

1:

2:

shape rules

F: *1*
final state

shape grammar Q

design in the language

I:
initial shape

1:

2:

shape rules

F: *2*
final state

shape grammar R

design in the language

I:
initial shape

1:

2:

shape rules

F: *1*
final state

shape grammar S

design in the language

I:
initial shape

1:

2:

shape rules

F: *2*
final state

shape grammar T

design in the language

5.4
Rule change. The grammar of figure 5.2 is transformed into new grammars by changing the state labels associated with its initial shape and final state.

different grammars produced by assigning states *1* and *2* to the initial shape and final state of the grammar in all possible ways.

In each grammar, the two rules apply alternately any number of times. However, because the states associated with the initial shape and final state are different in each grammar, the rule which applies first and the rule which applies last in a derivation of a design in the language, differ. Each grammar thus generates a different language. A design in the language defined by each grammar is shown.

Grammar Q generates designs with equal numbers of subdivided squares and embedded squares.

Grammar R is the original grammar. Again, it generates designs in which the number of subdivided squares is equal to the number of embedded squares plus one.

Grammar S is the opposite of *Grammar R*. *Grammar S* generates designs in which the number of embedded squares is equal to the number of subdivided squares plus one. The language defined by this grammar is identical to the language defined by *Grammar J* in figure 5.3. To produce *Grammar J*, states *1* and *2* are inter-

changed in the rules of the original grammar. To produce *Grammar S*, on the other hand, states *1* and *2* are interchanged in the initial shape and final state of the original grammar. Both of these state label changes have the same effect on the language defined by the original grammar.

Grammar T is similar to *Grammar Q*. It also generates designs with equal numbers of subdivided squares and embedded squares. However, in *Grammar T*, rule 2 applies first, while in *Grammar Q*, rule 1 applies first. *Grammar T* thus generates designs in which a square is always embedded in the initial square, while *Grammar Q* generates designs in which the initial square is always subdivided. Each grammar generates many designs that cannot be generated by the other.

When the state labels of a shape grammar are changed, the recursive structure of the new grammar may or may not be isomorphic to the recursive structure of the original grammar – in other words, relationships between the rules of the original grammar may or may not be preserved in a transformation of it. Figure 5.5a, for example, shows the recursive structure of the shape grammar of figure 5.2. Figure 5.5b shows the recursive structures of the twenty transformations of the grammar, *Grammars A* through *T*, discussed above. The recursive structure of the

5.5

The recursive structure of the grammar of figure 5.2 and the recursive structures of transformations of the grammar in figures 5.3 and 5.4.

shape grammar of figure 5.2

(a)

shape grammars A,C,D,I,K,L,N,O,P

shape grammar B

shape grammar E

shape grammar F

shape grammars G,J,Q,R,S,T

shape grammar H

shape grammar M

(b)

original grammar is isomorphic only to the recursive structures of *Grammars G, J, Q, R, S,* and *T. Grammars G* and *R* are identical to the original grammar; the others are new. The structure-preserving function between the original grammar and any of the six grammars above is obvious: it matches the initial shape, rule 1, and rule 2 of the original grammar with the initial shape, rule 1, and rule 2, respectively, of a transformation of it. Even though the languages generated by these grammars may be different, the relationships between the spatial relations used to construct designs in these different languages are the same.

Changing spatial labels

Spatial labels control the places where the rules of a grammar apply in derivations of designs. Unlike state labels, they can be associated only with the rules and initial shape of a grammar. Changing the spatial labels associated with either of these parts of a grammar can affect the language the grammar generates.

Several examples of changing the spatial labels associated with a rule of a grammar were given in the previous chapter. Figures 3.13 through 3.20 showed how changing the spatial labels associated with a rule based on the Greek cross changes the kinds of designs the rule generates. While all of the designs produced by the rule are constructed in terms of the same spatial relation, different labelings of the rule produce designs with very different characteristics.

Changing the spatial labels associated with the initial shape of a grammar can have equally diverse results. Consider the grammar shown in figure 5.6. The initial shape of the grammar is a rectangle with a spatial label – a dot – in the top right corner. Rule 1 of the grammar is a rule based on the Greek cross. The rule is labeled as shown previously in figure 3.19. Rule 2 erases the spatial label. Since no state labels are used in the rules or initial shape, the final state of the grammar is blank. The grammar generates designs like the one illustrated. Successively smaller Greek crosses spiral clockwise about the right arm of the largest cross in the design.

If the spatial label associated with the initial shape of the grammar is changed, then the designs generated by the grammar may also change. Figure 5.7 shows the initial shape of the grammar labeled in other ways. Instead of being placed in the top right corner of the rectangle as above, a spatial label is placed in the bottom right corner of the rectangle (figure 5.7a), in the bottom left corner (figure 5.7b), in the top left corner (figure 5.7c), and in both the top right and bottom left corners (figure 5.7d). A design generated by applying the rules of the grammar to each of these different initial shapes is also shown. In figure 5.7a, successively smaller Greek crosses spiral counterclockwise about the right arm

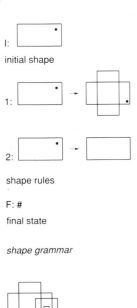

5.6

A shape grammar.

I:

initial shape

1:

2:

shape rules

F: #

final state

shape grammar

design in the language

5.7
Rule change. The grammar of figure 5.6 is transformed by changing the spatial label associated with its initial shape.

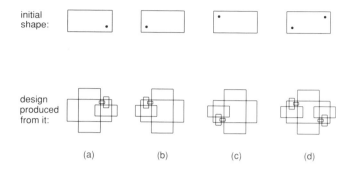

(a) (b) (c) (d)

of the largest cross in the design. In figure 5.7b, crosses spiral clockwise about the left arm of the largest cross in the design. In figure 5.7c, crosses spiral counterclockwise about the left arm of the largest cross in the design. And in figure 5.7d, crosses spiral clockwise about both the left arm and the right arm of the largest cross in the design. Changing the position of the spatial label associated with the initial shape thus changes the orientations of designs generated from it. Changing the number of spatial labels associated with the initial shape changes the complexity of designs produced from it.

A general approach for enumerating different spatial labelings of both the rules and the initial shape of a grammar has been described by Stiny.[3] Stiny's approach is based on the symmetry properties of the shapes used in a rule or initial shape. The symmetry of a shape is determined by the different euclidean transformations that transform the shape into exactly the same shape. The transformations that determine the symmetry of a shape on the left-side of a rule can be used to identify the different transformations under which the rule can be applied. The application of a rule can then be restricted to each one of these distinct transformations by adding spatial labels in different ways. These different labelings of a rule according to the symmetries of the shapes in it lead, in turn, to designs themselves with distinct symmetry properties. Different labelings of an initial shape according to its symmetry also leads to distinct designs. This approach is especially useful in distinguishing the various kinds of designs that can be generated with particular rules or from a particular initial shape.

When the spatial labels of a shape grammar are changed, the recursive structure of the new grammar may or may not be isomorphic to the recursive structure of the original grammar. In the examples given above (the grammar of figure 5.6 and the changes described in figure 5.7 and figures 3.13 through 3.20), the recursive structure of a grammar is preserved when spatial labels are changed in the very simple ways described. Other kinds of changes, however, may lead to grammars in which rules are not related to one another in the same ways.

Changing spatial relations

Spatial relations are the basis for the rules of a shape grammar. Encoded as rules, spatial relations specify how shapes in a vocabulary can be combined to construct designs. Spatial relations are thus the principle determinants of the composition of designs in a language.

The spatial relations used to define the rules of a grammar can be changed by replacing the shapes in them with other shapes. Since the initial shape of a grammar is, like a spatial relation, made up of a shape or shapes from a vocabulary, it can be changed in the same ways. However, the final state of a grammar, which has no spatial component, cannot be included in these kinds of changes.

The ways of changing spatial relations (or initial shapes) are limitless. However, changes to spatial relations can be thought of informally in two ways. Since a spatial relation is defined in terms of (1) some shapes and (2) an arrangement between these shapes, a spatial relation can be changed by (1) changing a shape in the relation or (2) changing the arrangement of shapes in the relation. These two kinds of changes can be realized formally by replacing shapes in a relation with other shapes in two different ways. The first type of change can be realized by replacing a shape in a relation with a geometrically nonsimilar shape – for example, replacing a rectangle with a triangle. In other words, a new spatial relation is produced by *introducing a new shape* into a relation. The second type of change can be realized by replacing a shape in a relation with a geometrically similar shape – for example, replacing a rectangle with a rotation of it. In this case, a new spatial relation is produced by *resizing* or *repositioning a shape* in a relation by translating, rotating, reflecting, or scaling it.[4] An interesting change that can correspond to either of these two kinds of changes is a *transposition* of shapes in a spatial relation. In a transposition, a shape in a spatial relation is replaced with another shape in the relation, and vice versa. The shapes that replace one another may be nonsimilar as in (1) or similar as in (2). However, the final result of a transposition is a spatial relation between the same shapes in a different arrangement as in (2).

Informally, these different ways of changing spatial relations have long been a common source of innovation in design. Figure 5.8, for example, illustrates how new and different designs are created using the first way of changing spatial relations – by introducing new shapes into spatial relations. In each case, the shapes in spatial relations are changed while the overall arrangements of shapes remain the same.

Figure 5.8a shows the plans of three houses by Frank Lloyd Wright. The plan of the "Life" house is composed of various spatial relations between rectangular areas serving different functions.

5.8
Changing spatial relations in designs by introducing new shapes.
a. Three house plans by Frank Lloyd Wright. (After L. March and P. Steadman, *The Geometry of Environment*, (Cambridge, MA, 1974, p. 27.)
b. Two church plans based on the Latin cross. The Renaissance church of San Salvatore, Venice by Giorgio Spavento (top). The Baroque church of Santa Maria della Divina Providenza, Lisbon by Guarino Guarini (bottom). From *Architettura Civile* by Guarino Guarini (Turin, 1737. Reprinted by The Gregg Press, 1964).
c. Three designs for garden pavilions by J. B. Fischer von Erlach. Top, bottom: Courtesy, Bild-Archiv der Österreichischen Nationalbibliothek, Vienna. Middle: Courtesy, Graphische Sammlung Albertina, Vienna.

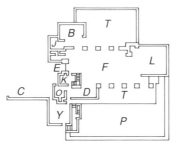

Life "House for a family of $5000 – $6000 income" (1938)

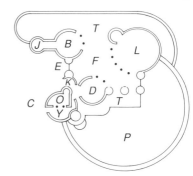

Jester house (1938)

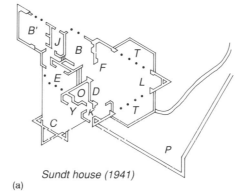

Sundt house (1941)

(a)

B	bedroom
B'	Sundt bedroom
C	car port
D	dining-room
E	entrance
F	family room
J	bathroom
K	kitchen
L	living-room
O	office
P	pool
T	terrace
Y	yard

(b)

5.8 continued

Des Erzbischoffen von Salzburg Comelis Matheum Lilip
gloembet für allenkamb für Spehend Klentoshen
1694

(c)

The Jester house is created by introducing a new shape, a circle, in place of each rectangle. Similarly, the Sundt house is created by replacing each rectangle with a new shape, a triangle. Although the three plans appear to be very different stylistically, the arrangements of shapes in the underlying spatial relations are approximately the same, only the shapes in the relations are changed.[5]

In figure 5.8b, two church designs are illustrated. On the top is the plan of the Renaissance church of San Salvatore attributed to Giorgio Spavento and designed in the early 1500s. Like many other church designs of this time and earlier, the design for San Salvatore is based on the Latin cross. On the bottom is the plan of the Baroque church of Santa Maria della Divina Providenza designed by Guarino Guarini in the late 1600s. It too is based on the Latin cross. The stylistic differences between this design and the earlier, Renaissance design (and between much of Baroque and Renaissance design, in general) derive in part from the introduction of new shapes into a schema of spatial relations that otherwise remain unchanged. Ovals replace rectangles, while the overall arrangement of shapes is kept the same.

The garden pavilions shown in figure 5.8c are related in the same way. These designs are three in a series of pavilion designs by the Baroque architect J. B. Fischer von Erlach. Each design is composed of different shapes in analogous arrangements. The pavilion shown at the top is composed of ovals and squares. In the pavilion below, squares are replaced with irregular hexagons. From this design, the pavilion at the bottom may be conceived by replacing ovals with regular hexagons, and irregular hexagons with ovals. Alternatively, this last design may be conceived, from the first one, by introducing hexagons in place of squares and, using the alternate type of spatial relation change, by repositioning ovals through rotations.

Fischer von Erlach's pavilion designs introduce the second way of changing spatial relations – by resizing or repositioning shapes in relations using any of the euclidean transformations. This kind of spatial relation change can be seen informally in as wide a variety of contexts as the first. Figure 5.9 gives a few elementary examples. In each case, new designs are produced by changing the arrangements of shapes in spatial relations while keeping the shapes the same.

Figure 5.9a shows two studies for the design of a city hall by the Neorationalist architect Aldo Rossi. Each design is composed of spatial relations between simple three-dimensional forms – a conical structure housing assembly and exhibition spaces, and wings that provide office space. Alternative designs are generated in a straightforward manner – by repositioning the office wings with respect to the conical structure through reflections and translations.

(a)

5.9
Changing spatial
relations in designs by
rearranging shapes.
a. Studies for the design
of a city hall, Muggiò,
Italy by Aldo Rossi.
Courtesy, Professor
Dott. Aldo Rossi.
b. Architectural
mouldings.
c. Alternative plans
for a church by Guarino
Guarini. From
Architettura Civile by
Guarino Guarini (Turin,
1737. Reprinted by The
Gregg Press, 1964).

(b)

ovolo

cyma recta

cavetto

cyma reversa

Two pairs of architectural mouldings are illustrated in figure
5.9b. The profiles of these and most other classical mouldings can
be defined in terms of spatial relations between straight and
curved elements. Some mouldings can be derived from others by
changing the arrangements of elements. For example, the profiles
of the ovolo and the cavetto mouldings shown at the left of the
figure are constructed in terms of spatial relations between
straight lines and quarter-circles. One moulding can be derived
from the other by reflecting the quarter-circle across a diagonal
axis. The cyma recta and the cyma reversa shown to the right are
related in exactly the same way. Both are constructed in terms
of spatial relations between straight lines and S-curves. One

(c)

moulding can be derived from the other by reflecting the S-curve across a diagonal axis.

In figure 5.9c, alternative designs for a church by Guarino Guarini are represented in one plan. The two sides of the plan show two possible treatments of the relationship between the central nave and a side aisle. Disregarding the transept, the shapes in both designs remain essentially the same, only the arrangement of shapes is changed. One design can be derived from the other by translating a bay of the aisle with respect to a bay of the nave.

Repeatedly changing a spatial relation, either by repositioning shapes or by introducing new shapes, can result in a transposition of shapes in the relation. Consider, for example, the three designs for dairies by the Neoclassical architect John Soane shown in figure 5.10. The plans in figure 5.10a and figure 5.10b were produced as alternative designs for one commission. The plan in figure 5.10c was designed two years later. The plan in figure 5.10a can be constructed roughly in terms of a spatial relation between a rectangle and a half-oval. If the rectangle in the relation is replaced with a different shape, a half-oval, then a spatial relation between two half-ovals is produced. This is the spatial relation that occurs in the plan in figure 5.10b. If the larger half-oval in this spatial relation is then replaced with a rectangle, then a spatial relation between a half-oval and a rectangle is produced. This new spatial relation is a transposition of the original relation. It is the spatial relation that occurs in the plan in figure 5.10c.

Interestingly, transpositions in design are similar to a phenomenon in natural language called *metathesis*. Metathesis is the

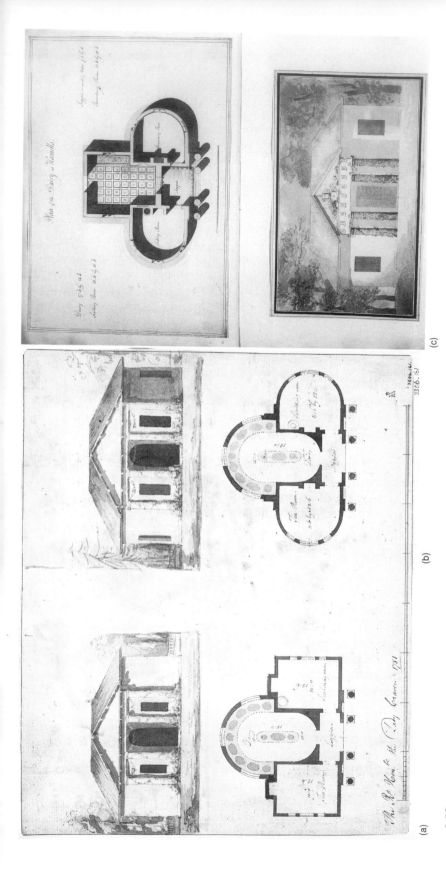

5.10

Changing spatial relations in designs by transposing shapes.

a, b. Two alternative plans and elevations for a dairy design by John Soane. Courtesy of the Board of Trustees of the Victoria and Albert Museum.

c. Plan and elevation for Hammels Park dairy by John Soane. By courtesy of the trustees of Sir John Soane's Museum.

5.11

Metathesis

OLD ENGLISH MODERN ENGLISH

brid \longrightarrow bird

transposition of letters, sounds, or syllables in a word, and accounts for many of the changes in spoken languages. One striking case of metathesis is diagrammed in figure 5.11. The modern English word "bird" is derived from the Old English word "brid" by transposing the letters "i" and "r". Metathesis often occurs spontaneously as, for example, when one accidentally says "evelate" instead of "elevate". If repeated often enough, some of these mistakes may be assimilated into the language. This unintentional aspect of metathesis, however, points to a crucial difference between metathesis and transpositions, and more generally, between transformations in natural languages and transformations in design languages. Transpositions in spatial relations, unlike metathesis in words, can be used consciously and deliberately to introduce change in design. Also unlike metathesis, the interchange of shapes in a transposition need not occur simultaneously but in successive steps as in the series of Soane designs illustrated above. The intermediate step in a transposition can be as productive as the final one.

Changing spatial relations, in any of the different, informal ways described above, is a basic and well used means for creating new designs. However, the potential of this kind of change can be exploited more fully by treating spatial relation changes in a less casual way. By expressing in a more precise manner both the description of a spatial relation change and the way the change is carried out, the possibilities inherent in this type of change can be explored in more depth and with more sophistication.

The operation of replacing a shape in a spatial relation to change it into a new spatial relation can be defined formally in terms of a *change rule*. A change rule is a rule of the form $X \rightarrow Y$ where X and Y are shapes and the arrow (\rightarrow) indicates in the usual way that the shape X is replaced with the shape Y. A change rule applies to a spatial relation underlying a rule of a shape grammar to change it into a new spatial relation. The new spatial relation can then be used to define a new rule. Change rules thus apply indirectly to the shape rules of a grammar to change them into new shape rules. By changing the rules of a grammar in this way, a new grammar is produced which in turn generates a new language of designs.

A change rule applies to a spatial relation to change it into another spatial relation in much the same way that a shape rule applies to a design to change it into another design. A change rule $X \rightarrow Y$ applies to a spatial relation whenever the shape X matches a shape, or part of a shape, in the relation. In other words, a change rule applies to a spatial relation whenever there is a shape A in the relation and a euclidean transformation t such that $t(X) \leq A$. If the shape X matches a shape, or part of a shape, A in the relation, then the matched version of the shape X is erased from the shape A and substituted with the shape Y, similarly transformed. More formally, if $t(X) \leq A$, then the shape A is replaced with the shape

$[A - t(X)] + t(Y)$. All other shapes in the spatial relation remain unchanged.

The power of a change rule in producing spatial relations is like that of a shape rule in producing designs. Like shape rules, change rules apply recursively. A change rule can be applied to a given spatial relation and then reapplied to any of the spatial relations produced from it, to generate not just one new spatial relation but a series of new spatial relations. Also like shape rules, change rules apply nondeterministically. In any step of the generation of new spatial relations, there may be a choice of shapes in a relation to which the change rule applies. Further, there may be a choice of euclidean transformations under which the rule applies to a particular shape. Applying the rule to different shapes in a relation or to the same shape under different transformations may lead to different results.

Any new spatial relation produced by a change rule can be used to specify a new shape rule in the obvious way. If a shape A' replaces a shape A in a spatial relation used to define some rule, then the shape A' replaces the shape A in the definition of the rule. For example, if an addition rule $A \rightarrow A + B$ is defined in terms of a spatial relation $A + B$ and the shape A in the relation is replaced with a shape A', then the new spatial relation $A' + B$ defines a new rule $A' \rightarrow A' + B$. If the shape B in the spatial relation is replaced with a shape B', then a new rule $A \rightarrow A + B'$ is defined. Subtraction rules are changed in exactly the same way.

Change rules can also apply to replace the shapes that make up the initial shape of a grammar. The replacement of a shape in an initial shape is defined in the same way as the replacement of a shape in a spatial relation.

Figures 5.12 through 5.14 give three simple examples of defining and applying change rules. Each example illustrates one of the different ways of changing spatial relations into new ones: by introducing new shapes, by repositioning shapes, and by transposing shapes.

Figure 5.12a shows a spatial relation between a rhombus and a square. A shape grammar based on this relation is illustrated in figure 5.12b. The two rules of the grammar are the two different addition rules that can be defined from the spatial relation. A design generated by the grammar is also shown.

A change rule is defined in figure 5.12c. The rule allows a new shape to be introduced into a spatial relation by replacing a rhombus with an equilateral triangle. The position of the triangle with respect to the rhombus it replaces is indicated with dashed lines. On each side of the change rule, these lines mark the same location in the coordinate system in which each shape is located. Applying the change rule in figure 5.12c to the spatial relation in figure 5.12a generates two new spatial relations. These are shown in figure 5.12d, together with the original spatial relation. The

5.12

Rule change. A grammar is transformed by introducing new shapes into the spatial relations underlying its rules.

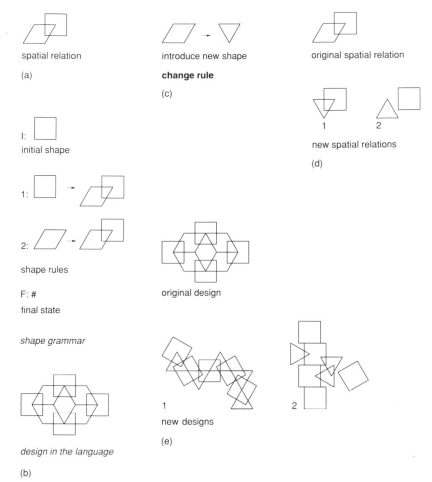

spatial relation

(a)

introduce new shape

change rule

(c)

original spatial relation

I: initial shape

1:

2:

shape rules

F: #

final state

shape grammar

design in the language

(b)

1 2

new spatial relations

(d)

original design

1 2

new designs

(e)

two new relations are produced by applying the change rule to the original relation under two different matching transformations. In this particular example, the number of new spatial relations that can be generated from the original one is limited: only two relations can be generated from the original relation and no more can be generated by reapplying the change rule to these.

Each of the two new spatial relations in figure 5.12d can be used to change each rule of the original grammar into a new rule. Thus, a total of four new grammars can be defined. New designs generated by two of the new grammars are illustrated in figure 5.12e, together with the original design. Design 1 is generated by a grammar in which both rules are based on spatial relation 1. Design 2 is generated by a grammar in which both rules are based on spatial relation 2. Grammars in which one rule is based on relation 1 and the other on relation 2 generate other new designs.

Figure 5.13a shows a spatial relation between a rectangle and an L-shape. A shape grammar based on this relation is illustrated in figure 5.13b. The two rules of the grammar are the two addition

rules that can be defined in terms of the spatial relation. Two designs generated by the grammar are also shown.

A change rule is defined in figure 5.13c. The rule allows a shape to be repositioned in a spatial relation by rotating a rectangle 90°. The position of the rectangle before rotating it, with respect to the rectangle after rotating it, is indicated with dashed lines. Applying the change rule in figure 5.13c to the spatial relation in figure 5.13a generates an unlimited number of new spatial relations. Some of these are shown in figure 5.13d, together with the original spatial relation. Spatial relations 1 through 4 are produced by applying the change rule to the original spatial relation under four different matching transformations. The change rule can then be

5.13

Rule change. A grammar is transformed by repositioning shapes in the spatial relations underlying its rules.

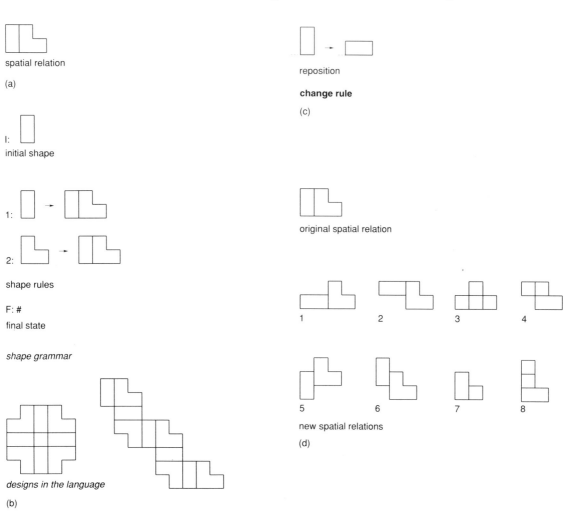

spatial relation

(a)

I:

initial shape

1:

2:

shape rules

F: #

final state

shape grammar

designs in the language

(b)

reposition

change rule

(c)

original spatial relation

1 2 3 4

5 6 7 8

new spatial relations

(d)

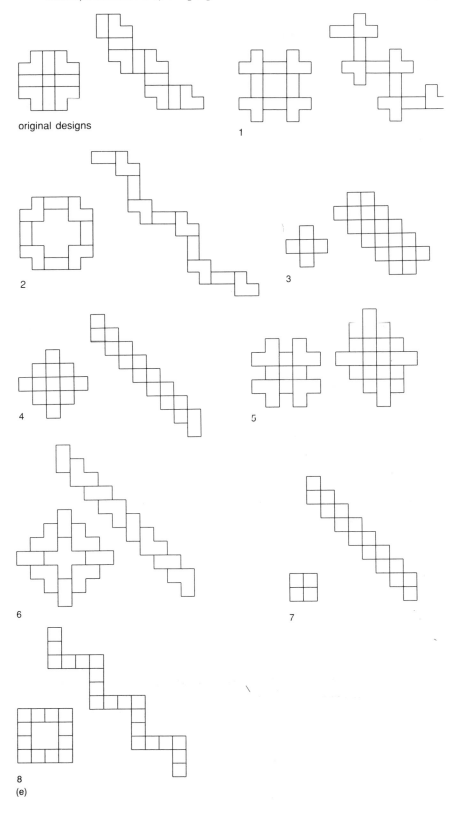

original designs

1

2

3

4

5

6

7

8
(e)

reapplied to any of these new relations to produce still more new relations. For example, spatial relation 5 is produced by applying the change rule to spatial relation 1, spatial relation 6 is produced by applying the change rule to spatial relation 2, spatial relations 7 and 8 are produced by applying the change rule to spatial relations 3 and 4, respectively. Many other relations can be generated by applying the change rule to spatial relations 1 through 4 under different transformations, and by continuing to reapply the rule recursively to any new spatial relation produced.

Each new spatial relation produced can be used to change each rule of the original grammar into a new rule. An unlimited number of new grammars can thus be defined. The two rules of each new grammar can be based on the same new spatial relation or on different new spatial relations. New designs generated by eight new grammars are illustrated in figure 5.13e, together with the original designs. Two designs are shown for each grammar. Each pair of designs is generated by a grammar in which both rules are based on one of the eight spatial relations in figure 5.13d. The number underneath each pair of designs corresponds to the number of the spatial relation in figure 5.13d on which the two rules of the grammar are based.

Figure 5.14a shows a spatial relation between two right triangles. A shape grammar based on this relation is illustrated in figure 5.14b. Again, the two rules of the grammar are the two addition rules that can be defined in terms of the spatial relation. A design generated by the grammar is also shown.

A pair of change rules is defined in figure 5.14c. Each rule is the inverse of the other. One rule replaces a right triangle with a smaller right triangle; the other replaces a right triangle with a larger right triangle. In the two rules, the positions of the larger and smaller triangles with respect to one another are the same. Together, the two rules allow shapes to be transposed in a spatial relation by replacing a larger triangle with a smaller triangle, and vice versa. Pairs of rules that transpose shapes in this way may be expressed more concisely with one change rule as shown in figure 5.14d.

Applying the change rule in figure 5.14d to the spatial relation in figure 5.14a produces an unlimited number of new spatial relations. Some of these are shown in figure 5.14e, together with the original spatial relation.

Spatial relations 1 through 4 are four possible intermediate steps in the transposition of the two triangles in the original spatial relation. Spatial relations 1 and 2 are generated by applying the change rule (in the direction →) to replace the larger triangle in the original relation with a smaller one. Spatial relations 3 and 4 are generated by applying the change rule (in the direction ←) to replace the smaller triangle in the original relation with a larger one.

5.14 (opposite)
Rule change. A grammar is transformed by transposing shapes in the spatial relations underlying its rules.

spatial relation

(a)

 I:

initial shape

 1:

 2:

shape rules

F: #
final state

shape grammar

design in the language

(b)

change rules

(c)

transposition

change rule

(d)

original spatial relation

1 2 3 4

5 6 7 8

9 10

new spatial relations

(e)

 original design 1

 2 3

 4

 5

6

 7

 8

 9

 10

(f)

Spatial relations 5 through 8 are four possible final steps in the transposition of the two triangles in the original relation. Spatial relations 5 and 6 are generated from spatial relation 1 by replacing the smaller triangle from the original relation with a larger one. Spatial relations 7 and 8 are generated from spatial relation 2 in the same way. (Alternatively, relations 5 and 7 can be generated from relation 3, and relations 6 and 8 can be generated from relation 4 by replacing the larger triangle from the original relation with a smaller one.)

The change rule can now be reapplied to any of spatial relations 5 through 8 to begin new transpositions. For example, spatial relation 9 and spatial relation 10 are each a possible intermediate step in the transposition of spatial relation 5 and spatial relation 6, respectively. Although not shown here, the change rule can also be applied in ways that do not lead to transpositions. For instance, the rule can be applied recursively in one direction only to replace a triangle in a spatial relation with successively smaller or successively larger triangles.

Any of the unlimited number of new spatial relations generated from the original relation can be used to change each rule of the original grammar into a new rule. An unlimited number of new grammars can again be defined. New designs generated by ten new grammars are illustrated in figure 5.14f, together with the original design. Each design is generated by a grammar in which both rules are based on one of the ten spatial relations in figure 5.14e. The number underneath each design corresponds to the number of the spatial relation in figure 5.14e on which the two rules of the grammar are based.

When the spatial relations underlying the rules of a grammar are changed, the recursive structure of the new grammar may or may not be isomorphic to the recursive structure of the original grammar. Figure 5.15, for example, shows a simple grammar. The spatial relations between L-shapes underlying the two rules of the grammar, a typical frieze-like design generated by the grammar, and the recursive structure of the grammar are also shown. Figure 5.16 shows two change rules that change an L-shape in two different ways: by repositioning it (figure 5.16a), and by replacing it with a new L-shape (figure 5.16b). One change rule applies to transform the grammar in figure 5.15 into a new grammar with the same recursive structure. The other change rule applies to transform the grammar into a new grammar with a different recursive structure.

Applying the first change rule to the spatial relations as well as the initial shape of the grammar in figure 5.15 transforms the grammar into the new grammar shown in figure 5.17. As with the original grammar, the new grammar generates frieze-like designs such as the one illustrated. The recursive structure of the new grammar is also shown. It is isomorphic to the recursive structure

5.15
A shape grammar.

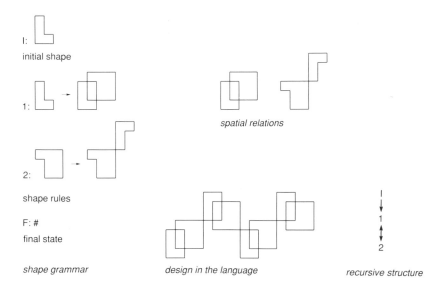

I:

initial shape

1:

2:

shape rules

F: #

final state

spatial relations

shape grammar *design in the language* *recursive structure*

5.16
Change rules.
a. Reposition.
b. Introduce new shape.

(a) (b)

5.16

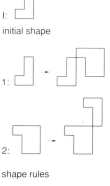

I:

initial shape

1:

2:

shape rules

F: #

final state

5.17
A transformation of the
grammar of figure 5.15
by applying the change
rule of figure 5.16a.

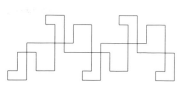

shape grammar *design in the language* *recursive structure*

5.18

A transformation of the grammar of figure 5.15 by applying the change rule of figure 5.16b.

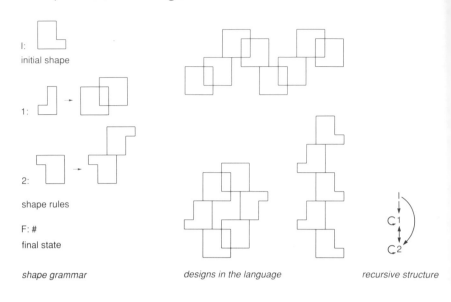

I: initial shape

1:

2:

shape rules

F: #
final state

shape grammar designs in the language recursive structure

of the original grammar. Designs are constructed in analogous ways by the two grammars.

Applying the second change rule to the spatial relations and initial shape of the grammar in figure 5.15 transforms the grammar into the new grammar shown in figure 5.18. This new grammar generates more varied kinds of designs than does either the original grammar or the new grammar of figure 5.17. Some designs generated by the grammar are illustrated. As might be expected, the recursive structure of the grammar is not isomorphic to the recursive structure of the original grammar. The rules of this grammar can apply to construct designs in ways unlike those of the original grammar.

Rule addition, rule deletion, and rule change

All of the different ways of transforming a shape grammar into new shape grammars which were discussed in this chapter are outlined in figure 5.19. To review, a shape grammar can be trans-

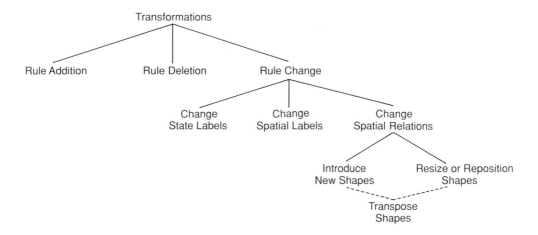

5.19

The different ways of
transforming a shape
grammar.

formed in three basic ways: by adding rules, by deleting rules, and
by changing rules. Further, rules can be changed by changing state
labels, by changing spatial labels, and by changing spatial rela-
tions. Last, spatial relations can be changed by introducing new
shapes, by resizing or repositioning shapes, and, as a special case
of the first two, by transposing shapes.

Each of the three basic transformation operations – rule addi-
tion, rule deletion, and rule change – can be applied alone to a
grammar to produce new grammars. Each can also be applied in
combination with another. When more than one operation is
used to transform a grammar, the order in which operations
are performed is inconsequential since each operation applies
independently of any other. The historical examples of stylistic
transformations presented in the following three chapters
each illustrate how different grammatical transformations are
used conjointly to characterize the change of one style into
another.

To demonstrate relationships between grammars for different
languages or styles, different transformation operations may be
defined that not only transform one grammar into another, but
preserve the recursive structure of the original grammar as well.
When comparing past or contemporary styles of designs, finding
the closest formal relationship between two styles might thus
entail finding an isomorphism between the recursive structures of
the grammars that generate these styles. Creating a completely
new style on the basis of a known one, on the other hand, might
entail making up an isomorphism from the recursive structure of
the grammar for the known style to a recursive structure of a
grammar for a new style. Because the recursive structure of the
original grammar, or perhaps a part of it, is preserved, knowledge

of how its rules work is transferred to the new grammar. The structure of the new grammar and of the designs it generates are immediately understandable even though the new designs may show no immediate similarities to the original designs. If, on the other hand, the recursive structure of a grammar is not preserved, the results of successive changes may be increasingly difficult to understand as the structures of new grammars begin to differ significantly from the structure of the original grammar.

Standard format grammars and transformations

In a standard format grammar, addition and subtraction rules make explicit the spatial relations used to construct designs. It is straightforward to transform rules of this kind and easy to see the consequences of transformations. In developing a grammar for a complex language, however, the grammar may become lengthy and unwieldy if all of the rules are expressed in this way. In presenting a grammar, it may sometimes be expedient to combine an addition rule and a subtraction rule into a single rule that simultaneously adds and subtracts shapes.

For example, figure 5.20a shows an addition rule and a subtraction rule each based on the same spatial relation between two squares. Used together, the rules allow a square to be rotated 45° as shown in figure 5.20b. If the sole purpose of these rules is to rotate a square, then the two rules can be combined into the single rule shown in figure 5.20c. This rule simultaneously subtracts a square from a design and adds a new, rotated square to it. The spatial relation underlying the rule, though, is no longer shown

(a)

5.20

Combining an addition rule and a subtraction rule into a single rule.
a. An addition rule and a subtraction rule.
b. Applying the rules to rotate a square.
c. A combined addition and subtraction rule that rotates a square.

(b)

(c)

explicitly in the rule. When developing grammars for comparative purposes, it may be convenient to combine rules in this way, especially when transformation operations (in particular, rule change) do not apply to these rules, or when the separate addition and subtraction rules that make up a combined rule are easily inferred. If transformation operations do apply to a combined addition/subtraction rule, then they are assumed to apply to the separate addition and subtraction rules that define it. Combined addition/subtraction rules are used in the grammars presented in Part III.

Part III Examples

In the following three chapters, the formal model defined in Part II is applied to describe three historical examples of stylistic change: one in the decorative arts, one in the fine arts, and one in architecture. In chapter 6, the transformation of an important decorative motif on ancient Greek pottery is described. In chapter 7, transformations of the *De Stijl* style of painting in the works of two artists are presented. In chapter 8, the transformation of Frank Lloyd Wright's well-known Prairie-style architecture into his later Usonian-style architecture is explored. Each of these case studies provides new understandings of the styles considered, including many basic insights not accessible using traditional methods of analysis. They are of interest not only from an historical point of view, but also from the point of view of design today. They suggest a variety of ways by which artists and designers can, and probably do, create new designs on the basis of known ones. They also suggest that the ways of creating new designs and new styles are diverse, open-ended, and constrained by little more than experience and imagination.

To simplify the presentation of the three examples, the formal details of shape grammars and transformations are not fully elaborated. For example, the spatial relations used to define the rules of grammars are generally not illustrated but are easily inferred. Additionally, some rules of grammars are combined addition/subtraction rules. Transformation operations that apply to grammars are usually described verbally and informally; explicit drawings of change rules, for instance, are given only where verbal descriptions may be ambiguous. Other, technical liberties have been taken in defining unessential details of grammars and transformations. These are explained, for the most part, in the notes.

6 Transformations of the meander motif on Greek Geometric pottery

Introduction

One of the peaks in the history of ancient Greek art is the *Geometric* style. The Geometric style spanned a period of some two hundred years, from about 900 BC to about 700 BC. It is distinguished by the very formal and abstract rectilinear designs painted on pottery, the primary art form of the time. To a lesser extent, Geometric designs can be found on metalwork and other small-scale art forms.

The Geometric style is bounded chronologically by very distinct earlier and later styles of painted pottery. The earlier, *Mycenaean* style is characterized by flowing, curvilinear plant and animal motifs. Following the breakup of the Mycenaean civilization and the succeeding Dark Ages, a new style, called the *Protogeometric*, emerged. The Protogeometric dates from about 1050 BC to about 900 BC and is generally viewed as a transitional stage between the Mycenaean and Geometric styles. In Protogeometric design, Mycenaean motifs are given geometric translations. The Mycenaean spiral motif, for example, was replaced with compass-drawn concentric circles and half-circles. Although the Protogeometric introduced the idea of abstract, geometric design, none of the motifs that were to become the hallmarks of the Geometric style are evident at this stage.

The end of the Geometric style is marked by a return to more naturalistic design and the beginning of the *Orientalizing* or *Archaic* style. Increased contact with the Orient at the turn of the eighth century BC had a pronounced influence on vase painting. Oriental-inspired animal and plant motifs were adopted and older Geometric motifs were either dropped or modified to suit the new style.

The Orientalizing style was succeeded by three other major styles of vase painting: the *Black-Figure* style, the *Red-Figure* style, and the *Hellenistic* style. Increasingly illusionistic representations of the human figure became the main decoration on Black-Figure and Red-Figure pottery. Geometric ornament was subordinated to borders framing larger figure scenes. By the late fourth century BC, painted pottery as an art form began to disappear. Hellenistic vase painting, which lasted until the first century BC, was the final stage in the history of this art.

Geographically, the Geometric style originated and was centered around Athens in the region called Attica. From Attica, the style spread to other regions where local variations, or schools, developed. After Attica, the second most important school, and the only other well-documented one, developed in the Argolid region, at one time the center of Mycenaean culture. Other schools developed at Corinth, Laconia, Thessaly, Boeotia, the Cyclades, Euroba, Crete, and various western and eastern Greek cities. Despite the geographic dispersion of the style, however, Attic Geometric remained the most powerful and prolific school throughout most of the Geometric period.

Chronologically, the Geometric is typically divided into three stages: *Early, Middle,* and *Late.* This subdivision was invented to characterize the development of Attic Geometric but can be applied to most other schools as well because of strong Attic influence in those regions. The approximate time span of each stage, though, varies from region to region. In Attica, Early Geometric lasted from 900 BC to 850 BC, Middle Geometric from 850 BC to 760 BC, and Late Geometric from 760 BC to 700 BC. In other regions, each stage begins after it starts in Attica, as would be expected. Late Geometric ends at different times in different regions depending on the degree of Attic or other influence.

Stylistic distinctions within the Geometric, both geographic and chronological, have been made on the basis of three criteria: the shape of pots, geometric decoration, and figure (animal and human) decoration. Differences in the shapes of pots have been used most successfully for chronological distinctions. Differences in decoration, however, have provided the richest and most reliable source for both chronological and regional distinctions. Geometric decoration, the basis of the style, is generally relied upon more heavily than figure decoration, which is not common until the Late Geometric.

Contemporary descriptions of geometric decoration, however, have been clumsy and informal in comparison with the precision and formal elegance of the designs themselves. The absence of sophisticated descriptions is particularly troublesome in recent research where the subtlest of stylistic distinctions within the Geometric have been attempted – the identification of individual painters and workshops within Attic and other regional schools.

Such research has depended upon more detailed, but no more sophisticated, descriptions of both abstract and figure decoration. It has been hampered by a prejudice that geometric decoration does not offer enough variation, is not rich enough, to distinguish between individuals or workshops. In the words of Jean M. Davison, a well known researcher in the field, "Linear design is not conducive to the expression of individuality."[1] As a result of such views, geometric decoration is sometimes undervalued as evidence for assigning a particular piece of pottery not only to a workshop but to a more general time period or place as well. A more rigorous approach to the analysis of these designs may be helpful in dispeling such myths by revealing just those subtleties of geometric expression thought to be lacking.

In the following study, the geometric motif called the *meander* will be examined. The meander is the most characteristic design of the Geometric style, and it undergoes a variety of transformations in the different stages, schools, and workshops of the Geometric. Very general changes of the meander have been noted in previous studies and used to characterize the different stylistic categories of the Geometric, but they have not been explored in any depth. Using the formal model for describing stylistic change presented in Part II, a more complete analysis of the meander is undertaken here. Formal descriptions of most known forms of the meander are given in terms of shape grammars. These descriptions explicate the underlying design of the meander from its earliest known form to the diversity of more complex forms that evolved from it. They provide new information for classifying Geometric pottery that, in most cases, corroborates other existing evidence. Relationships between different meanders are described in terms of grammatical transformations. These reveal surprisingly systematic correspondences between chronologically and geographically distinct designs. Perhaps most interestingly, they describe new, theoretical, and possibly undiscovered forms of the meander.

The formal analysis of the meander is preceded by an informal review of its development on Geometric pottery. The results of earlier studies are summarized and new observations are discussed. These form the basis for the more detailed analysis that follows.

The development of the meander motif on Geometric pottery

Early and Middle Geometric

During the Early Geometric period, the predominantly circular ornament of the Protogeometric was replaced by a repertory of new, rectilinear ornament. Of all the new designs, the meander was the most popular. How and why the meander came into use at

this particular time is something of a mystery. The meander occurs in the art of much earlier civilizations in the Aegean area, but not in Mycenaean or Protogeometric art. Suggestions have been made that it was borrowed from other contemporary cultures or, more simply, that it was invented independently by the Greeks.

Two variants of the meander appear on both Early and Middle Geometric pottery: the *battlement meander* and the *running meander*. Like other geometric and later, figure motifs, both types of meander are arranged in continuous bands around a vase or in short strips or panels. The battlement meander, the simpler of the two variants, is drawn with multiple, parallel lines, or is outlined and filled in with dots or hatching. The running meander is outlined and hatched. The upper flange of the running meander usually points or *runs* toward the left. During the Early Geometric, the battlement meander is more common than the running meander; during the Middle Geometric, the running meander is more common. An Early Geometric vase with a battlement meander and a running meander is shown in figure 6.1a. A Middle Geometric vase with running meanders is shown in figure 6.1b.

6.1
Greek Geometric pottery. The stage, school or region, workshop or painter, and museum invoice number for each piece of pottery are given where known.
a. Early Geometric.
Courtesy, Kerameikos Museum, Athens, Inv. No. 254.

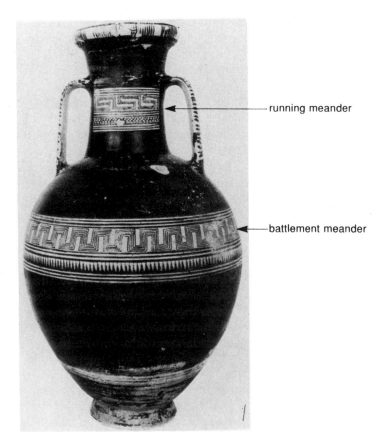

running meander

battlement meander

b. Middle Geometric. Courtesy, National Archaeological Museum, Athens, Inv. No. 218.

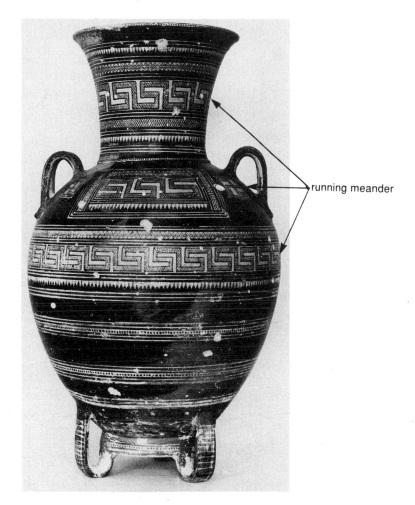

running meander

Through the Early and Middle Geometric periods, the development of the meander and other motifs was largely the work of the Attic school. Regions that had contact with Attica imitated Attic examples. Other regional schools continued in the Protogeometric styles. In the transition to Late Geometric, though, stylistic developments in different areas began to diverge. New ornamental motifs were adopted in different places, and older ornamental motifs were changed in different ways. Figure decoration, which was rare and experimental in the Early and Middle Geometric, became more common. In general, the vocabulary of ornament became richer, and ornamental fields expanded to cover the entire pot. In Attica, the simple battlement and running meanders continued to be used, but more complicated forms were introduced and soon became the dominant form of geometric decoration. In other regions, the meander underwent similar transformations.

The development of the meander in Attica and related developments in some other regions are considered separately below.

Late Geometric

Attica

The elaboration of ornament in the Late Geometric period makes it possible to recognize the work of individual painters and workshops in Attica and other regions.[2] In Attica, the earliest identifiable painter, and certainly the most influential one, was the Dipylon Master. The Dipylon Master and his workshop established standards of form, composition, and technique unrivaled by any subsequent work in the Geometric style. In the areas of decoration, the Dipylon Master is credited with the establishment of a variety of new meander forms typically called *complicated* or *complex* meanders. Complex meanders are elaborations of the simpler, running meander. They are formed by doubling, tripling, or quadrupling the height of the running meander. *Double, triple,* and *quadruple* meanders are illustrated on the two very large and well-preserved funerary vases shown in figures 6.1c and 6.1d. Both vases are representative of geometric decoration at its finest.

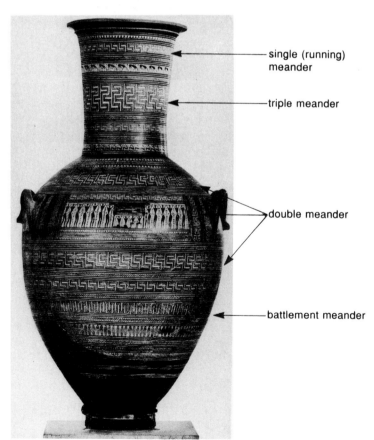

single (running) meander

triple meander

double meander

battlement meander

6.1 continued
c. Late Geometric, Attic, Dipylon Master. Courtesy, National Archaeological Museum, Athens, Inv. No. 804.

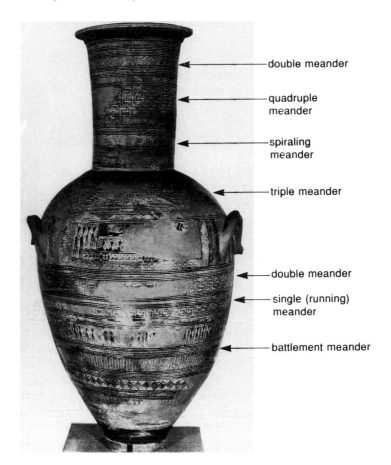

double meander

quadruple meander

spiraling meander

triple meander

double meander

single (running) meander

battlement meander

The double meanders on the two vases, and on all other Dipylon vases, are exactly the same. The triple meander on the vase in figure 6.1c, however, is different from the triple meander on the vase in figure 6.1d. The triple meander on the vase in figure 6.1d is common on Dipylon pottery as well as pottery produced by other Attic workshops. The other kind of triple meander is unusual. There seems to be only one instance of it on a Dipylon vase – the one shown here. The quadruple meander on the vase in figure 6.1d is also rare. Again, the only Dipylon vase it appears on is the one shown here.

The complex meanders described above are all produced by increasing the height of the running meander. An alternative, but much rarer, form of complex meander is produced by increasing the depth of the running meander. In other words, it is formed by adding extra hooks or turns within the turns of the running meander. This type of meander, here called a *spiraling meander*, appears on the vase in figure 6.1d and on one other Dipylon vase. Although uncommon on Geometric pottery, this kind of elaboration of the meander becomes commonplace on Post-Geometric pottery.

The simpler battlement and running meanders are still usual on Dipylon and other Attic vases but appear subordinate to the more complex meanders. Running, or *single*, meanders on Dipylon vases always run toward the left like most Early and Middle Geometric running meanders. All types of meanders are usually outlined and hatched.

Dipylon single, double, triple, and quadruple meanders were the prototypes for later Attic painters and workshops. Some workshops used exactly the same meanders. Others, however, used simple variations of Dipylon meanders. These were produced by changing the orientation of a Dipylon meander in different ways: by reversing its direction, by flipping it upside-down, or by both reversing its direction and flipping it upside-down. Formally, these changes correspond to reflecting a meander across a vertical axis, reflecting it across a horizontal axis, or reflecting it across both a horizontal and vertical axis. Depending on the symmetry of a meander design, however, some of these changes may be the same, thus limiting the possibilities for variation.

Two general principles appear to have governed the use of meander variations in most Attic workshops. First, whenever a variation of either a single, double, triple, or quadruple meander was used by a workshop, it was used consistently, that is, to the exclusion of any other variation of that meander. Second, whenever a variation of one (single, double, triple, or quadruple) Dipylon meander was used, then any other meander used was also a variation. That is, a workshop either adhered completely to Dipylon meanders or not at all. Meander variations are thus a stylistic trademark of a workshop and can be used with at least as much certainty as many other stylistic features in attributing pottery to a particular painter or workshop.

The Hirschfeld Painter, whose workshop was established soon after that of the Dipylon Master, used this method of stylistic variation as a way of distinguishing his work from the work of his more eminent contemporary. Surviving pottery from the Hirschfeld Workshop shows only the single meander and the double meander. These are always drawn in the reverse direction as those of the Dipylon Master. A Hirschfeld vase with single and double meanders is shown in figure 6.1e.

The work of the later Birdseed Workshop, so-called because of its frequent use of a bird and birdseed motif, also used variations of Dipylon single and double meanders. The Birdseed single meander, like the Hirschfeld single meander, is always a reversal of the Dipylon single meander. The Birdseed double meander is always an upside-down version of the Dipylon double meander. Both of these meanders appear on the Birdseed vase shown in figure 6.1f.

Interestingly, this vase was originally attributed to the Sub-Dipylon Workshop in an early study of Attic Geometric

6.1 continued
e. Late Geometric,
Attic, Hirschfeld
Painter. Courtesy,
National Archaeological
Museum, Athens,
Inv. No. 990.

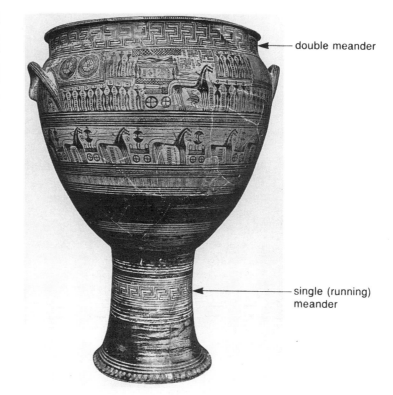

double meander

single (running)
meander

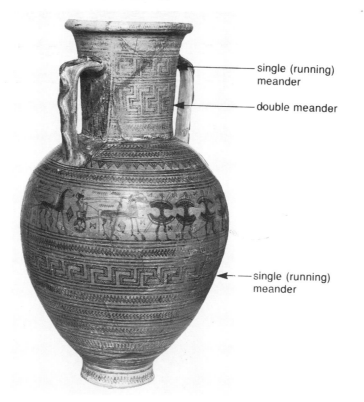

single (running)
meander

double meander

single (running)
meander

f. Late Geometric,
Attic, Birdseed
Workshop. Courtesy,
British Museum,
London,
Inv. No. 1914.4–13.1.

workshops.³ The Sub-Dipylon workshop basically followed the stylistic traditions set by the earlier Dipylon Workshop. In particular, Sub-Dipylon meanders were exactly like Dipylon meanders. The attribution of the vase in figure 6.1f to the Sub-Dipylon group was made on the basis of the shape of the vase and a variety of figure and geometric motifs. However, no mention was made of the inconsistency between the meanders on this vase and the meanders on other Sub-Dipylon pottery. Either the difference between these meanders was not recognized or, if it was, it was not considered to be stylistically significant. (The author of this attribution is also the author of the statement on linear design quoted in the Introduction.) The vase was subsequently attributed to the Birdseed Workshop on other stylistic grounds, but again no reference was made to the meanders.⁴

Variations of Dipylon meanders were also used by the Rattle Workshop and the Anavysos Painter. The Rattle Workshop used the upside-down version of the Dipylon double meander (figure 6.1g). The Anavysos Painter used a reversed single meander and a reversed quadruple meander (figure 6.1h).

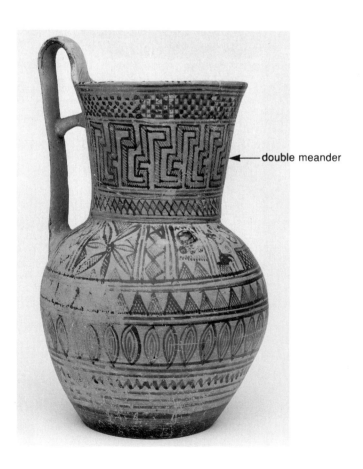

double meander

6.1 continued
g. Late Geometric,
Attic, Rattle Workshop.
Courtesy, British
Museum, London,
Inv. No. 1916.1–8.2.

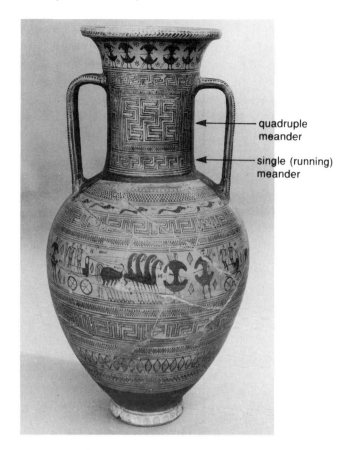

quadruple
meander

single (running)
meander

Pottery attributed to the Painter and Workshop of Athens 897 provides an exception to the two principles regulating the use of meander variations. The Athens 897 Workshop generally used Dipylon meanders. Pottery ascribed to the Painter, in particular, shows the Dipylon single meander, the Dipylon double meander, and both Dipylon triple meanders. However, two pots attributed to the Workshop, and possibly to the Painter, show two different variants of the double meander. A reversed double meander appears on one pot (figure 6.1i), a reversed and flipped double meander on the other (figure 6.1j).

Given the evidence of other painters and workshops, the use of different meanders by the same workshop, let alone the same painter, is curious. This may be an indication that the Athens 897 attributions should be reconsidered. If, however, the attributions are correct, then the inconsistent use of meanders may be indicative of a more general and widespread trend. The Athens 897 Workshop was active at the very end of the Late Geometric period, a time of decline in the quality and execution of geometric decoration in Attica and elsewhere. Few new motifs were introduced, and old ones were sloppily drawn. The eclectic use of

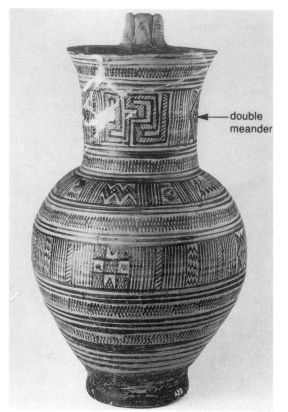

double
meander

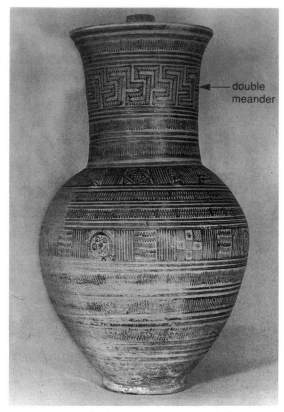

double
meander

6.1 continued
i. Late Geometric,
Attic, Athens 897
Workshop. Courtesy,
Württembergisches
Landesmuseum
Stuttgart,
Antikensammlung,
Inv. No. 4.29.
j. Late Geometric,
Attic, Athens 897
Workshop. Courtesy,
Staatliche
Antikensammlungen
und Glyptothek,
Munich, Inv. No. 8447a.

meanders in Athens 897 may simply be symptomatic of the more general breakdown of the system of geometric ornament.

Figure 6.1k shows a vase that has not yet been attributed to a specific painter or workshop but that shows variants of Dipylon meanders. Like Athens 897 pottery, it was produced at the end of the Late Geometric. The double meander on this vase is like the Birdseed and Rattle variant of the double meander. The triple meander is an upside-down version of a Dipylon triple meander. The single meander, though, is the same as the Dipylon single meander – a violation of the second of the two meander principles. As with Athens 897 pottery, this may be a sign of the very late date of the vase.

Dipylon complex meanders and workshop variations represent the main development in Attica of the older battlement and running meanders. Other meander forms were introduced during the Late Geometric but were used infrequently. Some of these are unrelated to Dipylon complex meanders or are simple embellishments of them. A few others, though, may be classed with the complex meanders developed by the Dipylon Master.

The meander pattern on the pot (unattributed) shown in figure 6.1l, for example, is a type of double meander. It is formed by two separated rows of battlement meanders. Each battlement meander is not outlined and hatched as it is when it occurs in a

6.1 continued
k. Late Geometric,
Attic. Courtesy, Allard
Pierson Museum,
Amsterdam,
Inv. No. 3491.

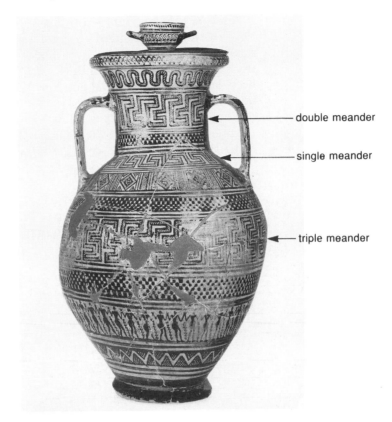

double meander

single meander

triple meander

l. Late Geometric,
Attic. Courtesy,
Staatliche
Antikensammlungen
und Glyptothek,
Munich, Inv. No. 6089.

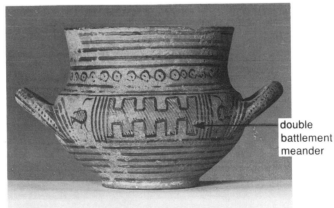

double
battlement
meander

separate band (see figures 6.1c and 6.1d). Instead, each is drawn with a single line, and the space between the two battlements is hatched.

Figure 6.1m shows a gold band with a complex, triple meander formed by three separated rows of running meanders. A double meander formed the same way, that is, by two separated rows of running meanders, appears on a pot made in neighboring Boeotia. This double meander seems to be the only known instance of this type of meander on pottery produced in an area around Attica.

Another type of double meander appears on the vase shown in figure 6.1n. This meander is more like Dipylon meanders than the meanders just described. It is formed with a continuous line instead of separated rows of lines. The vase on which it occurs has been attributed to the Athens 894 Workshop. Athens 894 produced at the very end of the Late Geometric and again, if attributions are correct, shows a lack of homogeneity in the use of meanders. In addition to the double meander on the vase in figure 6.1n, the more usual Dipylon double meander was used. The Dipylon single meander as well as the reversed single meander were also used.

The double meander on the vase in figure 6.1n can also be found, in reversed form, on three of the five pots shown in figure 6.1o. These pots and the chest on which they sit have been dated

6.1 continued
m. Late Geometric, Attic. Courtesy, Musée du Louvre, Paris, Inv. No. BJ93. Photograph, Musées Nationaux, Paris.

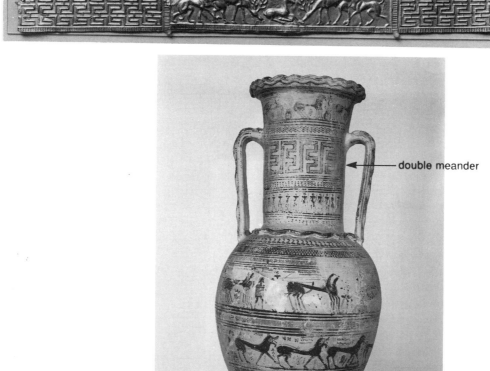

n. Late Geometric, Attic, Athens 894 Workshop. Courtesy, Musée du Louvre, Paris, Inv. No. CA3468. Photograph, Musées Nationaux, Paris.

6.1 continued
o. Middle Geometric,
Attic. Courtesy,
Ancient Agora
Museum, Athens.

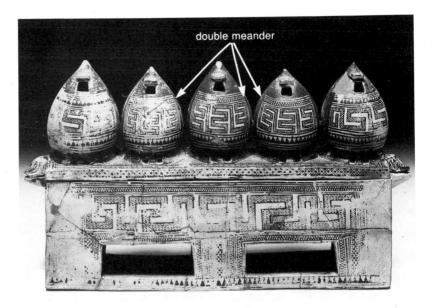

at the beginning of the Middle Geometric period, mostly on the basis of material found in the same area.[5] If the dating is accurate, this piece is a remarkable anomaly in the history of geometric decoration. Not only is the double meander unusual before the Late Geometric, but the overall complexity of the geometric decoration on this piece seems exceptional for its time. Nonetheless, geometric decoration was apparently outweighed by other evidence in giving this work an early date.

The Argolid

In the Argolid region, the major development of the meander was the *step meander*.[6] The step meander, like the Attic complex meander, is an elaboration in height of the running meander and is the most characteristic geometric decoration of the region. It ranges in height from two steps, the equivalent of the Attic double meander, to five or more steps. A three-step meander is illustrated on the vase in figure 6.1p.

Argive pottery is not as abundant as Attic pottery, so it is not easy to make generalizations about the use of the step meander. However, it does appear that Argive painters and workshops usually drew all of their step meanders, including the running or one-step meander, in the same direction. Variations in the direction of the step meander, like variations of the Attic complex meander, may thus have been a stylistic device used by painters to distinguish their work. On the vase (unattributed) shown in figure 6.1q, for example, both the one-step (running) meander and the two-step meander run or ascend toward the right. On the two vases shown in figures 6.1r and 6.1s, both attributed to the Argos

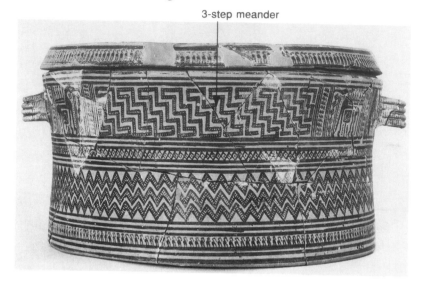

3-step meander

6.1 continued
p. Late Geometric,
Argive, Fence
Workshop. Collection,
Museum at Nauplia,
Inv. No. 4232.
Photograph, courtesy of
the Swedish Institute at
Athens.

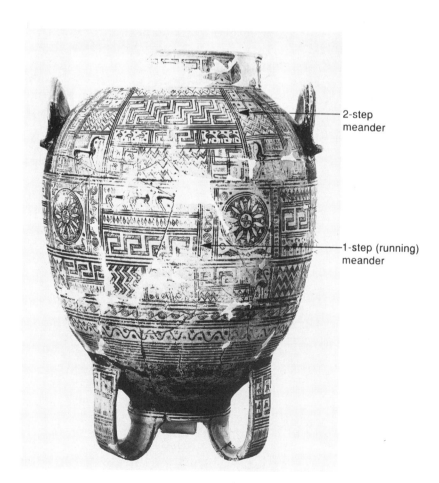

2-step
meander

1-step (running)
meander

q. Late Geometric,
Argive. Collection,
Museum at Argos,
Inv. No. C209.
Photograph, courtesy of
the Ecole Française
d'Archéologie, Athens.

6.1 continued
r. Late Geometric,
Argive, Argos C201
Workshop. Collection,
Museum at Argos,
Inv. No. C210.
Photograph, courtesy of
the Ecole Française
d'Archéologie, Athens.

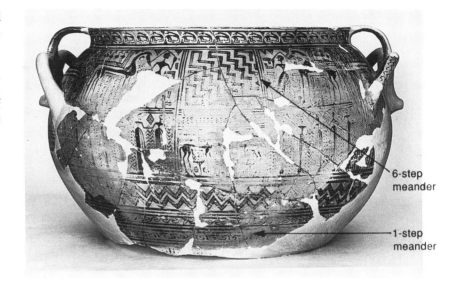

6-step
meander

1-step
meander

s. Late Geometric,
Argive, Argos C201
Workshop. Collection,
Museum at Argos,
Inv. No. C201.
Photograph, courtesy of
the Ecole Française
d'Archéologie, Athens.

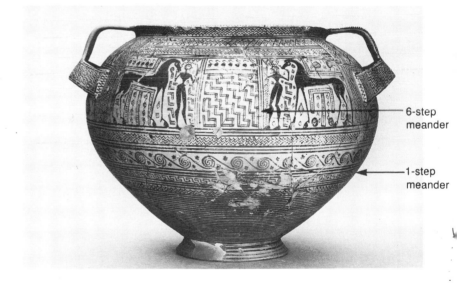

6-step
meander

1-step
meander

C201 Workshop, the direction of the meanders is reversed. Here, the step meanders run toward the left.

Like Attic meanders, Argive meanders were usually outlined and hatched. Meanders drawn with single lines, however, start to appear toward the end of the Late Geometric. The vases in figures 6.1r and 6.1s, for example, show single line running meanders. The vase in figure 6.1s also has single line multi-step meanders on its handles.

The Cyclades

In the Cyclades, meander designs generally followed Attic proto-
types. One vase, though, shows an unusual complex meander
(figure 6.1t). The meander is taller than most Attic or Argive
complex meanders and is very carelessly and inconsistently
drawn. The general pattern, however, is similar to the complex
meander on the Attic vases in figures 6.1n and 6.1o.

East Greece

Eastern Greek cities borrowed Attic decorations but also evolved
their own unique stock of designs. Several very original but idio-
syncratic variations of the meander were introduced. Most of
these are unrelated to meander developments in Attica and else-
where and will not be considered here. Two types of meander,
though, show interesting affinities with Attic and other complex
meanders.

 One of these is the *meander tree*[7] used in the east Greek island
of Rhodes. The meander tree is formed by two separated rows of
running meanders like the Boeotian meander described pre-
viously (p. 123). On painted pottery (figures 6.1u and 6.1v), the
two running meanders are drawn with single lines, and the space
between them is hatched. On unpainted, metal pots (figure 6.1w),
the two running meanders are raised lines, and the space between
them is blank.

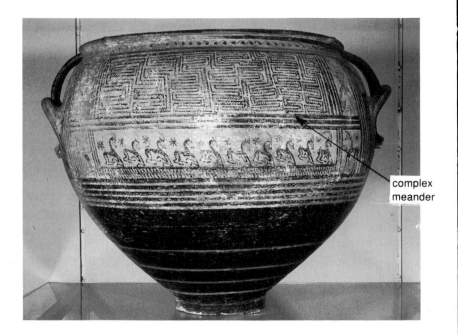

6.1 continued
t. Late Geometric,
Cycladic, Rottiers
Painter. Courtesy,
Musée du Louvre,
Paris, Inv. No. CA2946.
Photograph, Musées
Nationaux, Paris.

complex
meander

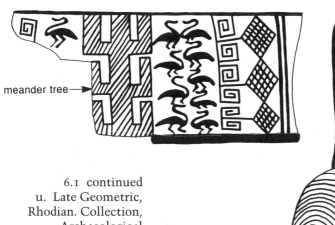

meander tree→

meander tree—

meander tree

6.1 continued
u. Late Geometric,
Rhodian. Collection,
Archaeological
Museum, Istanbul.
v. Late Geometric,
Rhodian. Courtesy,
Department of Near
Eastern and Classical
Antiquities, National
Museum, Denmark,
Inv. No. 12438.

w. Late Geometric,
Rhodian. Courtesy,
Museo dello Spedale dei
Cavalieri, Rhodes,
Inv. No. 13447.

The Rhodian meander tree is closely connected in design not only to the Boeotian meander but also to the Attic double and triple meanders illustrated in figures 6.1l and 6.1m. The Attic double meander is drawn and hatched exactly the same way as the painted Rhodian meander tree, but is formed with battlement meanders instead of running meanders. The Attic triple meander is like the Rhodian meander tree in metalwork but is composed of three, rather than two, rows of running meanders. Together, the three rows form two interlocking rows of meander trees. There is no known example of a painted triple meander formed in this way. It would be interesting to see how the addition of a third row would affect the way the design was painted.

Both the Attic triple meander and the Boeotian double meander are believed to have been copied from meander tree ornamentation imported from Rhodes.[8] No connection between the Attic double battlement meander and the Rhodian meander tree has yet been established, possibly because the relationship in design between the two has not been recognized. The double battlement meander may have been borrowed directly from Rhodes or it may have been an independent Attic invention based on the meander tree.

On the east Greek island of Samos, a meander similar to the meander tree was used. This meander pattern (figure 6.1x) is also formed by two separated rows of running meanders. The directions in which the two rows of meanders run, though, are different from the directions in which the two rows of the meander tree run, and each running meander is separately outlined and hatched.

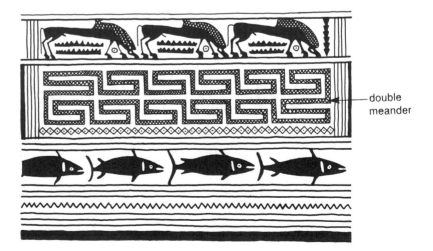

double meander

6.1 continued
x. Late Geometric, Samian. Courtesy, Deutsches Archaeologisches Institut, Athens.

Post-Geometric

With the rise of figure decoration toward the end of the eighth century BC, most meander and other geometric decorations fell out of use. The only meander that survived to become even more popular than before was the internally elaborated, spiraling meander. The spiraling meander continued to be used until the end of the Hellenistic period. It was elaborated further with additional internal hooks or turns, but was used only as a subsidiary border decoration (figures 6.1y and 6.1z). Of all the Late Geometric meanders, it was probably the most suitable for this purpose. Other complex meanders would certainly have been too bold. Instead of being outlined and hatched, the spiraling meander was drawn with a much simpler, single line. The older battlement and running meanders were also used occasionally as decorative borders and were also drawn with single lines.

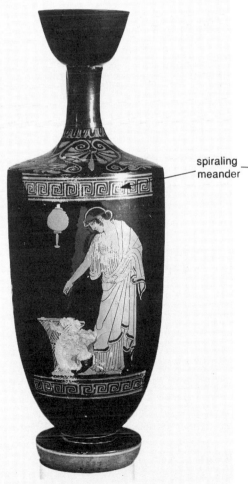
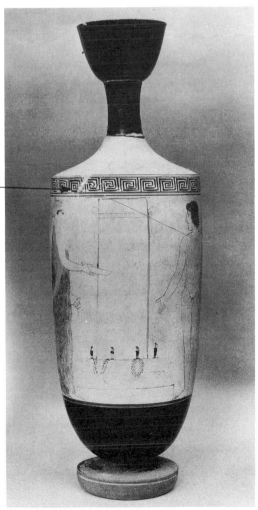

spiraling
meander

Analysis of the meander motif on Geometric pottery

Figures 6.2 through 6.4 illustrate the different meander forms described above. Since the survey of meanders undertaken for this study was not exhaustive, some meander forms related to those shown here may have been missed. However, those meanders that are shown are representative of the overall development of the meander.

To illustrate more clearly the relationships between different meander forms, meanders are represented with single lines regardless of how they were actually drawn on pottery (for example, outlined and dotted, outlined and hatched, or drawn with single lines). Changes in ways of drawing the meander will thus not be considered here. Similarities and differences in drawing methods do, however, provide supporting material for establishing relationships among meanders (for example, the relationship between the Attic double battlement meander and the Rhodian meander tree) and would be interesting to incorporate into the analysis.

The endings of meanders, when meanders are not continuous around a vase, are also not considered here. Endings appear to be irregular and are, in any case, not critical to this study.

Meanders used in the different stages of the Geometric and by the different regional schools are illustrated in figure 6.2. The right-hand side of the figure indicates which meanders were used in each stage of the Geometric and which meanders were most characteristic of each stage. The left-hand side specifies the type (single, double, triple, and so on) of each meander. To keep terminology uniform, Argive step meanders, usually called one-step, two-step, three-step, and so on, are here called single, double, triple, and so on. Only one orientation of each complex meander is shown; reflected variations in workshops are shown in the following figures.

Workshop variations of Late Geometric meanders in Attica are shown in figure 6.3. The complex meanders (except the spiraling meander) used by the Dipylon Workshop and variations of these meanders used by other painters and workshops are illustrated. In principle, each Dipylon meander can be varied in three ways: by a vertical reflection, by a horizontal reflection, or by a vertical and horizontal reflection. However, in the case of the single meander and the more common of the two triple meanders, a vertical reflection is the same as a horizontal reflection. A combined vertical and horizontal reflection is also the same as no reflection at all. These two meanders can thus be varied in only one way. All possibilities for varying the single and double meander were used by Attic potters. Not all possibilities for varying triple and quadruple meanders appear to have been used. However, triple and quadruple meanders are rare in comparison with single and

double meanders. It is possible that other variations of these meanders were used but no evidence of their use exists.

Workshop variations of Late Geometric meanders in the Argolid are shown in figure 6.4. Specific workshops are not named. Instead, workshops are separated into those that used right-running meanders and those that used left-running meanders. Blank spaces for meanders in this figure, as in the previous figure, do not imply that these meanders were never used, only that no evidence of them has been located.

Early and Middle Geometric meanders

Figure 6.5 shows a shape grammar that defines a language of Early and Middle Geometric meanders. In order to simplify the presentation of this shape grammar and the grammars that follow, shape grammars are defined here as *parallel* shape grammars. In a parallel shape grammar, rules apply simultaneously, or in parallel, in derivations of designs. That is, whenever a rule is applied to one part of a design, it must be applied simultaneously to all other parts of the design to which it is applicable.

The initial shape of the grammar in figure 6.5 is a labeled line segment in a state 0. The spatial labels in the initial shape and in the following rules control how rules are applied. Rule 1 allows a labeled line segment to be extended indefinitely while remaining in a state 0. Rule 2 replaces a labeled line segment with an S-shape. The pair of spatial labels associated with the line segment on the left-side of the rule fixes the placement and orientation of the S-shape that replaces the line segment. The S-shape also contains a labeled line segment, allowing the rule to be applied recursively to embed smaller S-shapes in S-shapes previously generated, in other words, to form the hooks or turns of a meander.[9] The state label p in this rule is a variable label. Each time the rule is applied to a design in some state, the state of the design is increased by one. Thus, the number of times rule 2 is applied in a derivation of a design is encoded in the state of the design. Rule 3 erases labels. The final state q of the grammar is also a variable. It may be any state between 0 and 2.

Figure 6.6 shows how the rules of the grammar apply to generate meanders. Straight lines, battlement meanders, and running meanders of any length are all in the language defined by the grammar. All meanders end so that the two ends, if joined together, would form a continuous band.

Straight lines, although not usually classed with meanders, may be considered a form of meander, at its simplest extreme, and are also a common geometric motif. They are generated from the initial shape of the grammar by applying rule 1. Battlement meanders are generated from straight lines by applying rule 2 to replace all line segments with S-shapes. Running meanders are generated

6.2 (over)

Meanders used in the different stages of the Geometric and by the different regional schools. The vertical lines at the right-hand side of the figure indicate which meanders were used during each stage (Early, Middle, Late) of the Geometric as well as during the Post-Geometric. The bold sections of these lines indicate which meanders were most characteristic of each stage. (The Cycladic meander is a neater, more uniform redrawing of the Cycladic meander on the pot in figure 6.1t.)

single

Attic

Argive

Dipylon Athens 894 Rhodian – related

double

triple

triple

quadruple

quintuple
or more

spiraling

and more complex

Post

Middle
Early

Cycladic *East Greek*

Rhodian Samian

Late

Post

Attic Workshops

6.3 Workshop variations of Late Geometric meanders in Attica.

Anavysos Athens 897 unattributed

6.4

Workshop variations of
Late Geometric
meanders in the
Argolid. Workshops
used either
right-running or
left-running meanders.

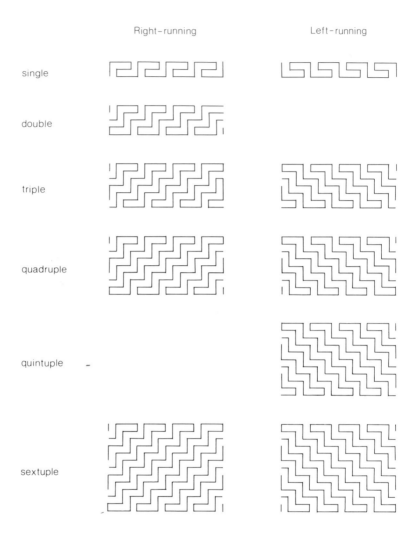

Argive Workshops

Right-running Left-running

single

double

triple

quadruple

quintuple

sextuple

from battlement meanders by applying rule 2 again to replace the
middle line segments of S-shapes previously generated with
smaller S-shapes. Further applications of rule 2 to running mean-
ders produce more complex, spiraling meanders. However, the
states of these designs – 3 or greater – are not final states. Spiraling
meanders are therefore excluded from the language. Straight lines,
not usually considered to be a form of meander, can be similarly
excluded from the language by allowing the final state q to be
equal to 1 or 2 but not 0. Straight lines are included here to show
their relationship to other meanders.

The states of designs not only distinguish designs in the
language from those that are not in the language. They also

6.5

A shape grammar that defines a language of Early and Middle Geometric meanders.

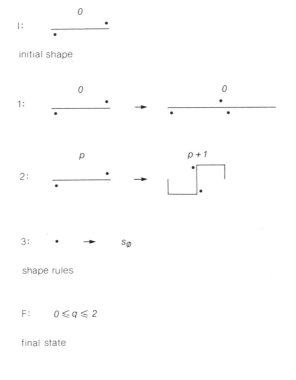

Early and Middle Geometric grammar

distinguish designs characteristic of one stage of the Geometric from designs characteristic of another stage. Designs in a state *1* – battlement meanders – are most characteristic of Early Geometric. Designs in a state *2* – running meanders – are most characteristic of Middle Geometric. Designs in a state *3* or more – spiraling meanders – are most characteristic of Post-Geometric. Designs in a state *0* – straight lines – are characteristic of all stages of the Geometric.

Late Geometric meanders

An analysis of Late Geometric complex meanders reveals that all of these meanders, except the spiraling meander, are constructed in an elegantly simple way – by stacking rows of battlement or running meanders one on top of another. Figure 6.7 outlines the construction of these meanders.

Double meanders are constructed from two rows of running meanders or, in the case of the Attic double battlement, from two rows of battlement meanders. Triple meanders are constructed from three rows of running meanders, quadruple meanders from four rows of running meanders, and so on. Rows of meanders are

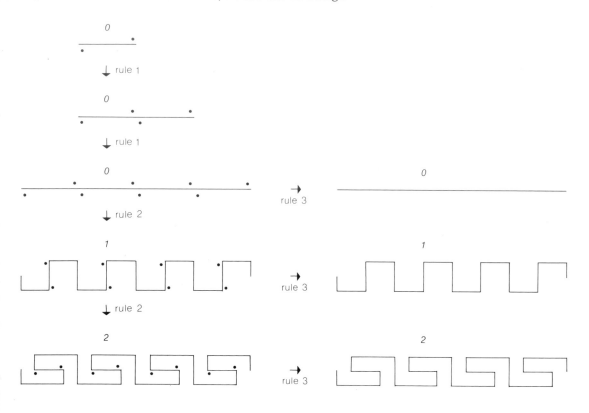

Derivations of straight line, battlement, and running meanders

6.6
Derivations of designs
by the Early and Middle
Geometric grammar.

6.7 (opposite)
The underlying
construction of Late
Geometric complex
meanders. Rows of
battlement or running
meanders are stacked
one on top of another
and shifted by 0 units,
1/4 unit, or 1/2 unit.
Rows are either joined
or separated. When rows
are joined, lines at the
bottom of a row that do
not overlap lines at the
top of the adjoining row
are erased.

either separated or joined. Separated rows are used to form the East Greek complex meanders and the related Attic double battlement and triple meanders. Joined rows are used to form all other complex meanders. When rows are joined, parts of the bottom and top lines of adjoining rows overlap. To produce a continuous line complex meander from joined rows, lines at the bottom of a row that do not overlap lines at the top of the adjoining row are erased.

The differences between complex meanders used by the different regional schools are the result of different schools using different relationships between adjacent rows of meanders. These relationships can vary in three ways.

First, if the basic S-shaped unit of a running meander is considered to be 1 unit, then adjacent rows of meanders can be shifted so that both rows line up (0 shift), one row is shifted by 1/4 unit (1/4 shift), or one row is shifted by 1/2 unit (1/2 shift). Attic meanders are produced either by rows shifted 1/4 unit (the Dipylon meanders as well as workshop variations) or by rows shifted 0 units (the Athens 894 meander and the Rhodian-related meanders). Argive meanders are produced by rows shifted 1/2 unit, the Cycladic meander by rows shifted 0 units and 1/4 unit,

Attic

Dipylon: 1/4 shift

Athens 894: 0 shift

Rhodian-related: 0 shift

Argive: 1/2 shift

Cycladic: 0 shift & 1/4 shift

East Greek

Rhodian: 0 shift

Samian: 1/4 shift

1 unit

the Rhodian meander by rows shifted 0 units, and the Samian meander by rows shifted 1/4 unit.

Second, adjacent rows of meanders may run in the same direction or in opposite directions.

Third, adjacent rows may be shifted so that one row begins before (to the left of) or after (to the right of) the other row.

In principle then, four relationships can be defined for each of the three types of row shifts described above. However, for rows shifted by 0 units or by 1/2 unit, relationships between adjacent rows are the same (except for endings) regardless of which row starts first. Thus, only two different relationships can be defined for rows shifted by 0 or 1/2 units. For rows shifted 1/4 unit, relationships between adjacent rows differ according to which row starts first only when meanders run in the same direction. Thus, only three different relationships can be defined for rows shifted 1/4 unit. In total then, seven different relationships between adjacent rows of running meanders, either joined or separated, can be defined.

In figure 6.8, these different relationships are illustrated. The left-hand side of the figure shows the seven relationships represented as seven spatial relations between two joined rows of running meanders 1 unit each. To the right of each of the seven spatial relations, the double meander that can be produced from that relation is shown. Each is produced by extending the 1-unit running meanders in the relation and by erasing nonoverlapping lines as described above. Two of the seven spatial relations – 1 and 7 – do not define continuous line double meanders. However, if the running meanders in these relations are separated by 1/4 unit, then the two East Greek double meanders are produced. Spatial relation 1 produces the Samian complex meander; spatial relation 7 produces the Rhodian complex meander. Of the remaining five meanders, three were used by Late Geometric potters. Spatial relations 3 and 6 produce Attic complex meanders, spatial relation 4 produces the Argive step meander. No evidence of spatial relations 2 and 5 being used has yet been found.

The transformation of Early and Middle Geometric meanders into Late Geometric meanders

6.8 (opposite)
All possible relationships between adjacent rows of running meanders joined and shifted by 1/4 unit, 1/2 unit, and 0 units, and the double meanders constructed from them.

The five spatial relations between joined meanders and the two spatial relations between separated meanders in figure 6.8 are the basis for all of the different Late Geometric complex meanders (except the spiraling meander) used by regional schools and by workshops within regional schools. They are also the basis for completely new complex meanders. The stylistic transformation of Early and Middle Geometric meanders into these later meanders can be represented formally by transforming the shape

1/4 shift

double meanders produced by
extending spatial relations
between separated meanders

spatial relations
formed by
separating 1 unit
running meanders

1/2 shift

0 shift

double meanders produced by
extending spatial relations
between joined meanders

spatial relations
between joined
1 unit running
meanders

1

2

3

4

5

6

7

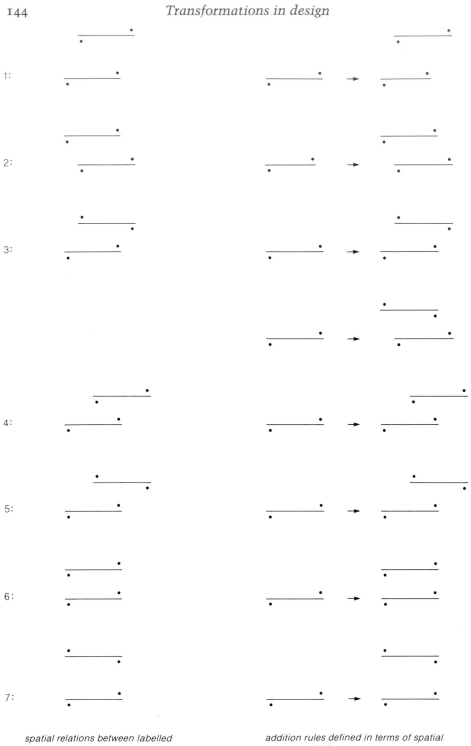

1:

2:

3:

4:

5:

6:

7:

spatial relations between labelled
line segments

addition rules defined in terms of spatial
relations at left

6.9 Defining shape rules for Late Geometric complex meanders.

4:

5:

6:

7:

8:

9:

10:

11:

12:

13:

rules defined by adding labels to rules at left *erasing rules*

grammar for Early and Middle Geometric meanders into shape grammars for the different Late Geometric regional meanders. This transformation is based on the incorporation of the spatial relations described above into the Early and Middle Geometric grammar. Rule addition, rule deletion, and rule change define the transformation. Rule addition plays the major role.

Rule addition: The spatial relations in figure 6.8 are translated into the more elementary spatial relations between line segments shown in figure 6.9. (To illustrate spatial relations between line segments more clearly, they are drawn at twice the scale of spatial relations between running meanders in figure 6.8.) Each line segment stands for one S-shaped unit of a running meander. A pair of spatial labels is associated with each line segment to fix the orientation of the S-shape it represents (as in the initial shape and rules 1 and 2 of the Early and Middle Geometric grammar). These spatial relations are used to define the addition rules shown to the right. In theory, two addition rules can be defined from each relation. However, the two addition rules defined from each of spatial relations 1, 2, 4, 6, and 7 are exactly the same. The two addition rules defined from spatial relation 5 are different but produce the same results when the lines are extended to create meanders. The two addition rules defined from spatial relation 3, however, are different and produce different results. Thus, a total of eight different addition rules can be defined from the seven spatial relations.

In order to coordinate these rules with the rules of the Early and Middle Geometric grammar, other labels are added to them as shown to the right and are explained later. Rules are also renumbered so that their indices (4 through 11) are different from the indices (1 through 3) of the rules of the Early and Middle Geometric grammar. Each of the eight rules so defined specifies a different way of stacking rows of meanders. Each rule may be added to the Early and Middle Geometric grammar by itself or with any number or combination of other stacking rules. Here, only the addition of rules one at a time or two at a time will be considered. Only one or two different ways of stacking rows were actually used to create any one complex meander.

In conjunction with the eight stacking rules, two erasing rules are defined. Rule 12, which erases overlapping lines, is added whenever any of rules 5 through 10 is added. Rule 13 is added whenever either rule 4 or 11 is added.

Combining stacking rules 4 through 11 one at a time and two at a time, together with erasing rules 12 and 13, defines thirty-six sets of rules that can be added to the Early and Middle Geometric grammar.

Rule deletion: No rules are deleted.

Rule change: Minor changes are made to the labels in the initial shape and rules of the Early and Middle Geometric grammar. These are made to accommodate the addition of new stacking rules. The spatial labels associated with line segments in the initial shape and rule 1 are doubled as shown in figure 6.10. The upper bound on the final state of the grammar is increased from 2 to 3.

6.10
The spatial labels associated with line segments in the initial shape and rule 1 of the Early and Middle Geometric grammar are changed as shown.

 Rule addition, deletion, and change are applied to the grammar for Early and Middle Geometric meanders to produce a collection or family of thirty-six grammars for Late Geometric meanders. Each late Geometric grammar contains all of the rules (slightly modified) of the Early and Middle Geometric grammar plus one or two stacking rules and one or two erasing rules.[10] Each grammar generates the same straight line, battlement, and running meanders, but different double, triple, quadruple, and other complex meanders. Some grammars define languages of meanders used by the different Late Geometric regional schools. Other grammars define completely new languages of Late Geometric meanders.

 Because rules have been added to the Early and Middle Geometric grammar to produce Late Geometric grammars with languages more diverse than the Early and Middle Geometric language, the recursive structure of any Late Geometric grammar is not isomorphic to the recursive structure of the Early and Middle Geometric grammar. However, the recursive structure of the Early and Middle Geometric grammar is preserved in that part of any Late Geometric grammar that contains the modified initial shape and rules of the Early and Middle Geometric grammar. In other words, part of each late Geometric grammar applies to construct designs in exactly the same way as the Early and Middle Geometric grammar.

 In figures 6.11a through 6.14a, some grammars in the family of Late Geometric grammars are illustrated. The grammars in figures 6.11a, 6.12a, and 6.13a define languages of Attic, Argive, and Rhodian meanders, respectively. The grammar in figure 6.14a defines a new language of complex meanders. The four grammars differ only with respect to the stacking and erasing rules they contain. The Attic grammar contains stacking rules 6 and 7 and erasing rule 12. The Argive grammar contains stacking rule 8 and erasing rule 12. The Rhodian grammar contains stacking rule 11 and erasing rule 13. The new grammar contains stacking rule 9 and erasing rule 12.

 Stacking rules in all grammars apply recursively to add lines parallel to lines previously generated. The inside dots on line

I:

initial shape

1:

2: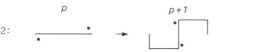

3: • ⟶ s_\emptyset

6:

7:

12:

shape rules

F: $0 \leqslant q \leqslant 3$

final state

Attic grammar

(a)

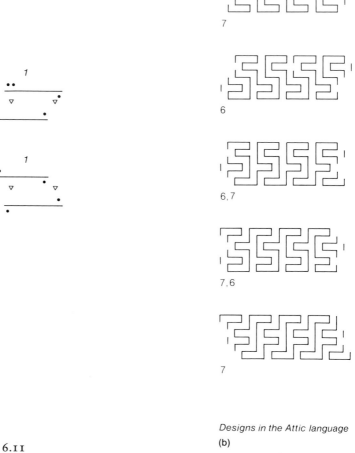

Designs in the Attic language

(b)

6.11

A shape grammar that defines a language of Late Geometric Attic meanders and some designs generated by the grammar. The numbers underneath each meander indicate which stacking rule or rules are used to generate that meander. (For presentational purposes, meander designs in this and following figures are drawn one-half their actual size as generated by the rules shown; that is, they are drawn the same size as meander designs in figures 6.2 through 6.4, 6.7, and 6.8.) A derivation of a design is also shown.

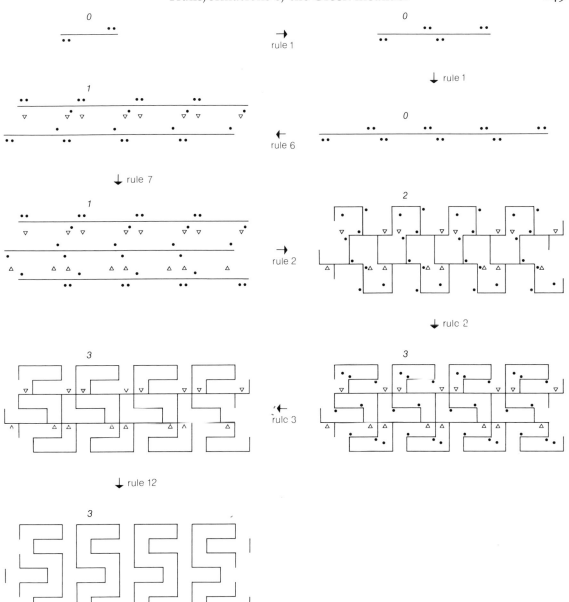

Derivation of an Attic triple meander

(c)

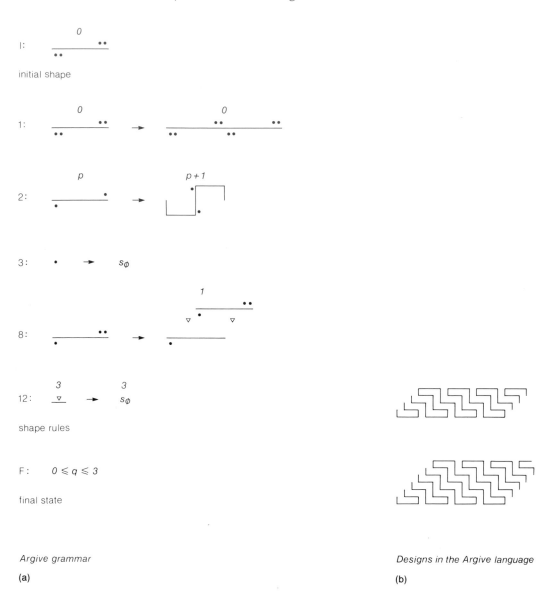

Argive grammar

(a)

Designs in the Argive language

(b)

6.12

A shape grammar that defines a language of Late Geometric Argive meanders and some designs generated by the grammar.

segments in these rules, as well as in the initial shape and rule 1, control the placement of parallel lines. (Outside dots control the placement and orientation of S-shapes. See p. 133). A line may first be added either above or below a line generated by rule 1. Lines may continue to be added above the top line and/or below the bottom line in a stack of parallel lines. Whenever a stacking rule is applied, the state of the design is increased by one or, if the design is already in a state *1*, it remains in a state *1*.

The label ∇ in a stacking or erasing rule marks a nonoverlapping line that must be erased. This label and the line it marks can only be erased in a state 3 – after rule 2 has been applied exactly twice. The label \square in a stacking or erasing rule can only be erased in a state 2 – after rule 2 has been applied exactly once. Both labels thus control the number of times rule 2 must be applied in a derivation of a design in a language.

Each of the grammars in figures 6.11a through 6.14a, and every other grammar in the family of Late Geometric grammars, generates straight line, battlement, and running meanders by applying only rules 1, 2, and 3 (the rules of the Early and Middle Geometric grammar). Each grammar also generates double, triple, quadruple, and more complicated meanders by recursively applying a stacking rule or rules. The different double and triple meanders, of a fixed length, generated by the grammars in figures 6.11a through 6.14a are shown in figures 6.11b through 6.14b. All of the double meanders shown in these figures are generated by applying a stacking rule to add a line above a line generated by rule 1. All of the triple meanders are generated by applying a stacking rule or rules to add a line both above and below a line generated by rule 1. Reflected variations of the meanders shown here can also be generated by the grammars in figures 6.11a, 6.13a, and 6.14a by changing the directions in which parallel lines are added.

The meanders generated by the grammar in figure 6.11a are, with one exception, typical Dipylon meanders or reflected variations of Dipylon meanders. The numbers of the stacking rules used to generate each meander are given below each meander. The double meander generated by rule 6 is the Dipylon double meander; the double meander generated by rule 7 is a horizontal reflection of this meander. The triple meander generated by rule 6 is a Dipylon triple meander. The two triple meanders generated by rules 6 and 7 are reflected variations of the other, less common Dipylon triple meander. The triple meander generated by rule 7 alone is a new meander. Assuming that complex meanders were actually designed in a way similar to the one described here, it may be that this meander was considered by Attic potters but rejected for aesthetic or other reasons. In figure 6.11c, a derivation of a triple meander is shown.

Each of the meanders, or reflected variations of the meanders, generated by the grammar in figure 6.11a can also be generated by a grammar containing only stacking rule 6 or by a grammar containing only stacking rule 7. Some of the complex meanders generated by these grammars are exactly the same. The way they are derived, though, is different. To generate the same complex meander in different grammars, parallel lines must be added in different directions.

The meanders generated by the grammar in figure 6.12a are typical Argive step meanders.

I:
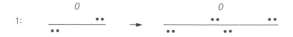

initial shape

1:
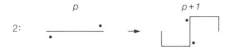

2:

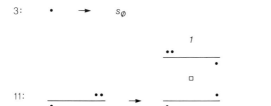

3: • → s_\emptyset

11:

13: \square → s_\emptyset

shape rules

F: $0 \leqslant q \leqslant 3$

final state

Rhodian grammar

(a)

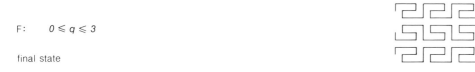

Designs in the Rhodian language

(b)

6.13

A shape grammar that defines a language of Late Geometric Rhodian meanders and some designs generated by the grammar.

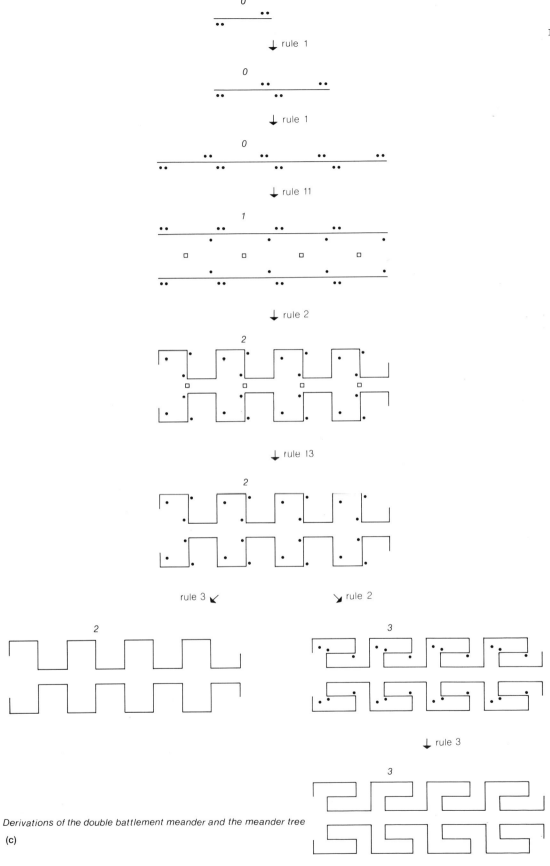

Derivations of the double battlement meander and the meander tree

(c)

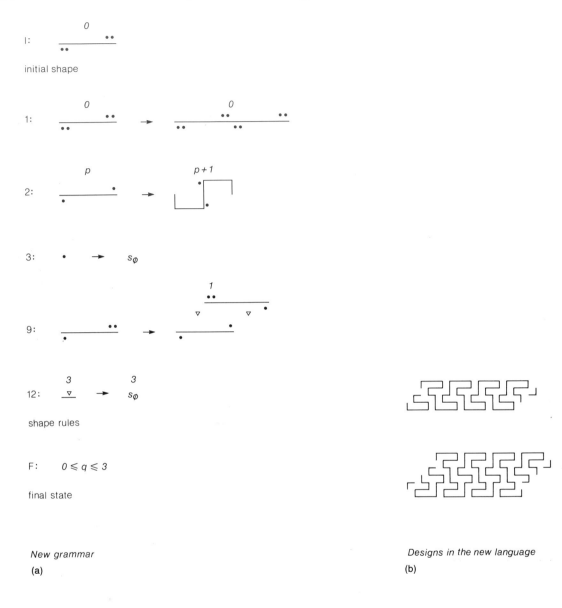

I: initial shape

1:

2:

3:

9:

12:

shape rules

F: $0 \leqslant q \leqslant 3$

final state

New grammar

(a)

Designs in the new language

(b)

6.14

A shape grammar that defines a language of new Late Geometric complex meanders and some designs generated by the grammar.

The meanders generated by the grammar in figure 6.13a are Rhodian meanders or Rhodian-inspired meanders. All of the meanders are separated and are composed of either battlement or running meanders. The double battlement meander and the triple running meander occur outside of Rhodes but may be Rhodian imports (see p. 130). The double running meander is the Rhodian meander tree. The triple battlement meander is new. Derivations of the double battlement meander and the meander tree are illustrated in figure 6.13c.

The meanders generated by the grammar in figure 6.14a are all new. Again, if the method for constructing complex meanders

described here reflects the ancient Greek method for constructing complex meanders, these meanders and other new meanders may have been tried by Late Geometric potters.

Other grammars in the family of Late Geometric grammars generate other regional or new languages. The grammar containing stacking rule 4, for example, generates Samian complex meanders and the grammar containing stacking rules 6 and 10 generates Cycladic complex meanders. Detailed descriptions of every grammar and the language it defines would be too lengthy to give here. Instead, a few additional illustrations that begin to show the variety of complex meanders that can be produced with these grammars are given.

Figure 6.15 shows all of the possible triple meanders composed of running meanders (excluding reflected variations) that can be generated by grammars in the family. (All possible double meanders are shown in figure 6.8.) Each meander is generated by applying the stacking rule, or pair of stacking rules, contained in some grammar. Each is generated in the same way that the triple meanders in figures 6.11b through 6.14b are generated (see above). Meanders that were used during the Late Geometric, or that are shorter or taller versions of such meanders, are marked with asterisks. The triple meander produced by the grammar containing rule 10, for example, does not appear to have been used on Late Geometric pottery; the double meander produced by rule 10, however, was used.

Figure 6.16 shows some quadruple and quintuple meanders. All are produced by the Attic grammar shown in figure 6.11a. All four possible quadruple meanders (excluding reflected variations) generated by this grammar are shown; only one of several possible quintuple meanders is shown. An asterisk marks the one quadruple meander that was used by Attic potters.

In addition to the double, triple, quadruple, and other multi-story meanders, all of the Late Geometric grammars generate the spiraling meander – the alternative but rare form of complex meander used by the Dipylon Master and by some other regional schools. A derivation of a spiraling meander is given in figure 6.17. Because the upper bound on final states has been increased to 3 in Late Geometric grammars, the spiraling meander, as well as the multistory meanders, are included in the languages defined by these grammars. Increasing the upper bound on final states thus allows the complexity of Early and Middle Geometric meanders to be increased in alternative ways: by increasing the height of a meander with a stacking rule or by increasing the depth of a meander with the S-shape embedding rule (rule 2). In a few isolated instances, Late Geometric potters used both methods of complexification together to create meanders. The complex meanders on the two Attic vases shown in figure 6.18, for instance, are formed by embedding S-shapes within double meanders.

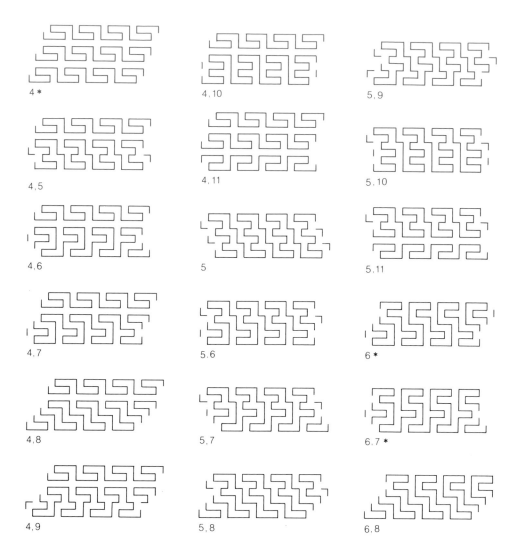

6.15
All possible triple meanders composed of running meanders (excluding reflected variations) that can be generated by Late Geometric grammars. The numbers underneath each meander indicate which stacking rule or rules are used to generate that meander. Meanders that were used during the Geometric or that are shorter or taller versions of such meanders are marked with asterisks.

Both can be generated by changing the conditions (labels, final states, etc.) under which the S-shape embedding rule in the Attic grammar can apply. Since neither meander is typical of the Late Geometric, however, the grammars that produce them are not included in the family of Late Geometric grammars defined here.

The transformation of Late Geometric meanders within regional schools

The stylistic change of Early and Middle Geometric meanders into Late Geometric regional meanders was represented formally by transforming the Early and Middle Geometric grammar into

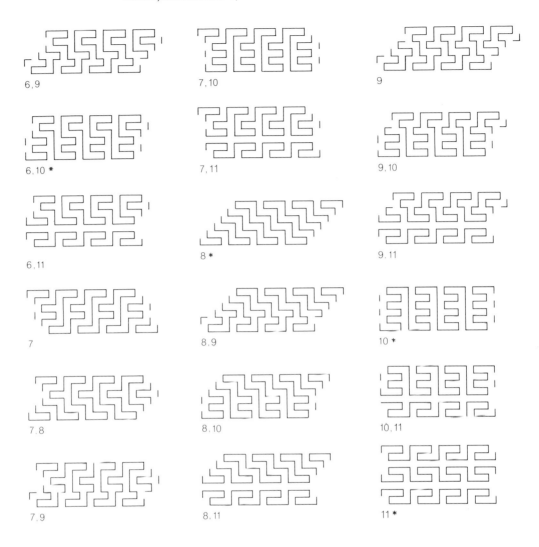

6,9 7,10 9

6,10 * 7,11 9,10

6,11 8 * 9,11

7 8,9 10 *

7,8 8,10 10,11

7,9 8,11 11 *

different Late Geometric regional grammars. The transformation was defined essentially by rule addition.

Stylistic differences between the different Late Geometric regional schools were represented indirectly by differences in the stacking rules added in the transformation. Differences between regional schools can be expressed in another way using rule change. By changing the spatial relations underlying a stacking rule or rules in one regional grammar, other regional grammars can be defined. Spatial relations are varied or changed in the specific ways discussed previously (see pp. 140–142). These changes correspond more generally to one of the different ways of changing spatial relations discussed in chapter 5 – by repositioning shapes in spatial relations.

6.16
Quadruple and quintuple meanders generated by the Late Geometric Attic grammar shown in figure 6.11a. An asterisk marks the one meander used by Attic potters.

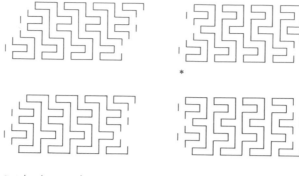

quadruple meanders

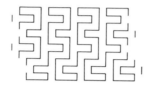

quintuple meander

More subtle stylistic differences between the different workshops within Late Geometric regional schools – in particular, the Attic and Argive schools – can be represented in a similar way. Grammars for Attic and Argive meanders can be transformed into other grammars for workshop variations of these meanders using rule change. The details of the transformation are as follows.

Rule addition and rule deletion: No rules are added or deleted.

Rule change: Attic and Argive workshops both used different orientations of complex meanders to distinguish their pottery from the pottery of other workshops. These variations can be represented formally by changing the spatial labels in the rules and initial shape of an Attic or Argive grammar in the two ways illustrated in figure 6.19. First, the spatial labels associated with an initial shape can be reflected as shown in figure 6.19a. This reverses the direction in which a meander runs. Second, an inside dot can be removed from either the top or bottom of a line segment in an initial shape or rule 1 as shown in figure 6.19b. This changes the orientation of a meander by restricting the direction – up or down – in which parallel rows of meanders are added with stacking rules.

6.17

A derivation of a
spiraling meander by a
Late Geometric
grammar.

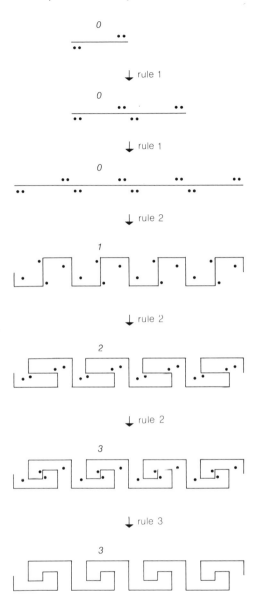

Rule addition, deletion, and change are applied to an Attic or
Argive grammar to produce families of Attic and Argive gram-
mars. Included in each family are grammars that define languages
used by the different Attic or Argive workshops. Other grammars
define new languages.

Figures 6.20a and 6.21a show two workshop grammars in the
family of Attic grammars. Both are transformations of the Attic
grammar containing stacking rule 6 (see p. 151). In both of the
grammars, the spatial labels in the initial shape have been

6.18
Two Late Geometric Attic vases with complex meanders formed by increasing both the height (number of rows) and the depth (number of internal turns) of the running meander. A simplified drawing of each complex meander is shown next to the vase on which it appears.
a. Courtesy, Johannes Gutenberg–Universität Mainz, Inv. No. 47.
b. Courtesy. Musée d'art et d'histoire, Geneva, Inv. No. 19301.

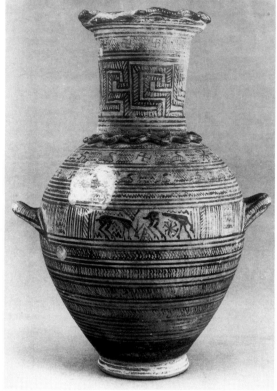

(a)

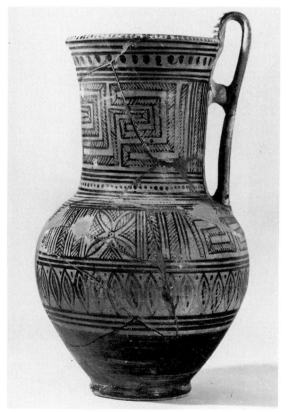

(b)

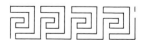

6.19
The spatial labels associated with line segments in the initial shape and rule 1 of an Attic or Argive grammar are changed in the two ways shown.

reflected. In the grammar in figure 6.20a, the lower inside dot in the initial shape and in rule 1 has been removed; in the grammar in figure 6.21a, the upper inside dot in the initial shape and in rule 1 has been removed. Thus, in the grammar in figure 6.20a, parallel lines can only be placed above lines generated by rule 1; in the grammar in figure 6.21a, parallel lines can only be placed below lines generated by rule 1.

The grammar in figure 6.20a defines a language of Hirschfeld meanders. The grammar in figure 6.21a defines a language of Birdseed meanders. The single, double, and triple meanders generated by each grammar are shown in figures 6.20b and 6.21b. Neither workshop actually used any kind of triple meander. If they had, the grammars given here predict what they might have been. The triple meander generated by the Hirschfeld grammar is a vertical reflection of a Dipylon triple meander, just as the double meander is a vertical reflection of a Dipylon double meander. The triple meander generated by the Birdseed grammar is a horizontal reflection of a Dipylon triple meander, just as the double meander is a horizontal reflection of a Dipylon double meander.

Workshop grammars in the family of Argive grammars generate either left-running step meanders or right-running step meanders. Left-running meanders are generated by grammars like the one shown previously in figure 6.12a. Right-running meanders are generated by grammars in which the spatial labels in the initial shape have been reflected. Removing a dot from the initial shape or rule 1 does not affect the orientation of Argive meanders. Figure 6.22a shows a right-running Argive grammar. Meanders generated by the grammar are shown in figure 6.22b.

The recursive structures of grammars in a family of Attic or Argive grammars are all isomorphic to one another.

Post-Geometric meanders

The stylistic change from Late Geometric meanders into Post-Geometric meanders can be represented by transforming any one of the grammars for Late Geometric meanders into a grammar for Post-Geometric meanders. Rule deletion plays the central role in the transformation.

Rule addition: No rules are added.

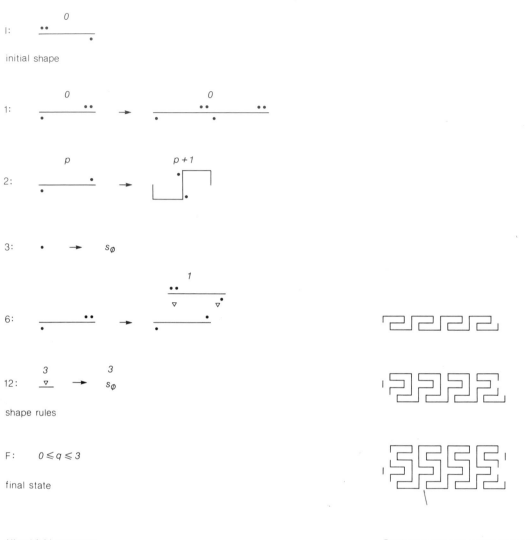

I: initial shape

1, 2, 3, 6, 12: shape rules

F: $0 \leqslant q \leqslant 3$

final state

Hirschfeld grammar

(a)

Designs in the Hirschfeld language

(b)

6.20

A shape grammar that defines a language of Hirschfeld meanders and some designs generated by the grammar.

Rule deletion: Any one of the thirty-six sets of stacking and erasing rules that was added to the Early and Middle Geometric grammar to produce a Late Geometric grammar is deleted from the Late Geometric grammar containing those rules.

Rule change: One change to state labels is made. The upper bound on final states is increased to *13*.

Rule addition, deletion, and change are applied to any Late Geometric grammar to produce the grammar for Post-Geometric meanders illustrated in figure 6.23. The grammar generates straight line meanders, battlement meanders, running meanders,

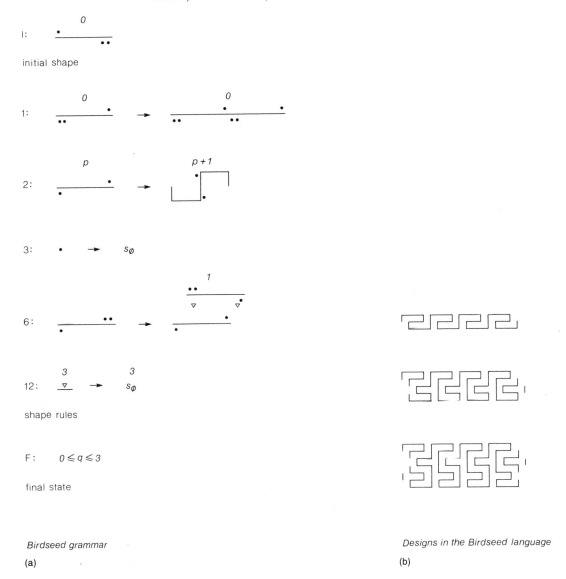

Birdseed grammar

(a)

Designs in the Birdseed language

(b)

6.21

A shape grammar that defines a language of Birdseed meanders and some designs generated by the grammar.

and spiraling meanders. Because the upper bound on final states has been increased to thirteen, spiraling meanders with up to ten internal turns (added to the running meander) are included in the language. This limit on the complexity of spiraling meanders is provisional; more elaborate spiraling meanders may have been used.

The recursive structure of the Post-Geometric grammar is obviously not isomorphic to the recursive structure of any Late Geometric grammar. It is isomorphic, though, to the recursive structure of the Early and Middle Geometric grammar. The two grammars that characterize the very earliest and the very latest forms of the meander are almost identical.

I:

initial shape

1:

2:

3: • → s_\emptyset

8:

12:

shape rules

F: $0 \leqslant q \leqslant 3$

final state

Right·running Argive grammar

(a)

Designs in the right·running Argive language

(b)

Discussion

6.22

A shape grammar that
defines a language of
right-running Argive
meanders and some
designs generated by the
grammar.

The battlement and running meanders that mark the beginning of
the Geometric style are extremely simple designs. Yet from them,
Greek potters were able to develop a rich variety of new, more
elaborate designs. The methods used to create most all of these
designs appear to have been very systematic, yet they led to
designs just as personalized and expressive as many of the less
formal, figure designs. Different regional schools used the same
general method to form complex meanders – stacking rows of
meanders – but different spatial relations between stacked rows
to create unique designs. Within regional schools, different

6.23

A shape grammar that
defines a language of
Post-Geometric
meanders.

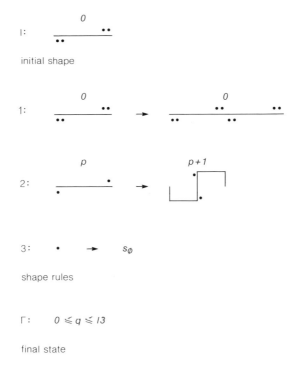

workshops used the same spatial relations but used different orientations of these relations. Different orientations often produced very different looking designs.

The invention and use of meander designs did not end with the ancient Greeks. The battlement and running meanders continue to be a very popular form of ornament in many cultures and are the basis for many other more complicated designs. The maze-like quality of these designs has had a broad range of appeal extending from the traditional artist/craftsman to the more scholarly humanist. The poet Goethe, for example, explored a number of new possibilities for meander designs in his well-known sketchbooks. A few of his designs are shown in figure 6.24.

The architect Le Corbusier used still another variation of the meander, called a *redent*, as the basis for architectural plans in his theoretical "Radiant City." The *redent*, shown in A of figure 6.25a, is the basic pattern for apartment buildings in the Radiant City. More complex patterns or plans are produced from the *redent* in the same way that Late Geometric potters produced complex meanders from the simpler battlement and running meanders: rows of *redents* are stacked one on top of another and

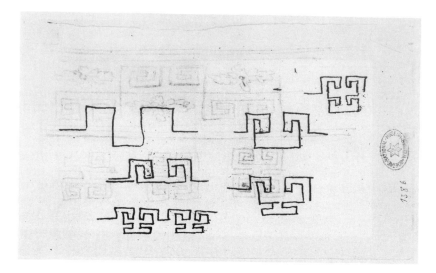

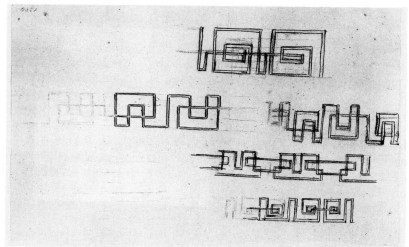

then shifted by different amounts to create different designs. Some of the possible designs that can be constructed in this way are shown in B–G of figure 6.25a; figure 6.25b shows how these designs are used in the overall plan of the Radiant City. Exactly the same compositional principles are at work some 2000 years after the ancient Greeks, but in a completely different context and scale.

Part of the continuing fascination with meander designs may lie in the apparent inscrutability of their construction. A fuller appreciation, however, comes from knowing just how they are made.

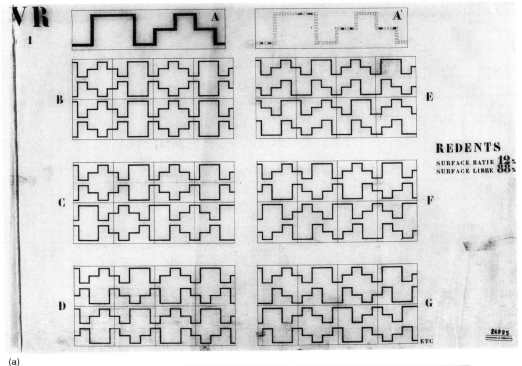

(a)

6.25

a. Le Corbusier's variation of the meander, called a *redent* (A), and a variety of plans for apartment buildings (B-G) constructed by stacking rows of *redents*.
b. *Redent* designs for apartment complexes in Le Corbusier's "Radiant City." Copyright, 1992 ARS, New York/ SPADEM, Paris.

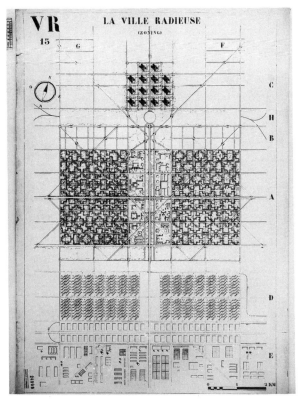

(b)

7

Transformations of *De Stijl* art: the paintings of Georges Vantongerloo and Fritz Glarner

Introduction

The art movement known as *De Stijl* was founded in Amsterdam in 1917 by a small group of Dutch artists. The movement soon spread to become a major international influence on art lasting long after the group was officially dissolved. In the early aesthetic program of *De Stijl*, painting, as opposed to sculpture and architecture, was the central concern. One of the principal objectives of painting was the representation of abstract and universal relationships between the two elements of painting – form (or line) and color. Probably the most well-known and influential realization of this objective in painting was the system of horizontal and vertical lines and colored rectangular areas employed by Piet Mondrian and Theo Van Doesburg. Early *De Stijl* paintings by these two artists are shown in figure 7.1. Mondrian's and Van Doesburg's rectangular compositions were adopted and interpreted in different ways by other *De Stijl* artists and their successors, including sculptors and architects who extended the two-dimensional relationships between lines and colors into relationships between colored planes and volumes in three dimensions.

In this study, the paintings of two artists, Georges Vantongerloo and Fritz Glarner, will be examined. Both artists began their work using elements of the *De Stijl* horizontal–vertical paradigm; both gradually transformed this paradigm to produce their own very unique styles of painting. Vantongerloo, a member of the original *De Stijl* group, was directly influenced in his early career by *De Stijl* aesthetics. Glarner, thirteen years younger than Vantongerloo, was only peripherally involved with artists, including Vantongerloo, who had been a part of the *De Stijl* circle. His early career, however, included a period of close contact with Mondrian during Mondrian's late career.

7.1

Early *De Stijl* paintings.
a. Piet Mondrian,
*Composition: color
planes with grey
outlines*, 1918.
Collection, Max Bill.
b. Theo Van Doesburg,
*Composition in
Discords*, 1918, Oil on
canvas, 63.5 × 58.5 cm.
Courtesy, Öffentliche
Kunstsammlung Basel,
Kunstmuseum.

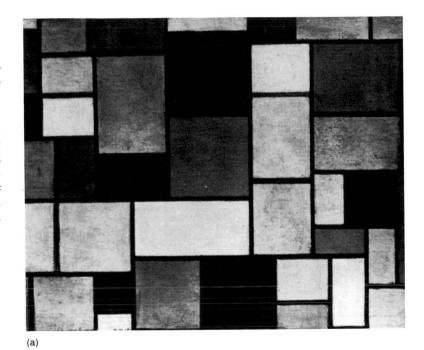

(a)

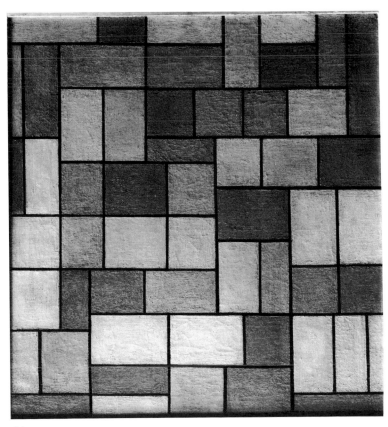

(b)

The paintings of Vantongerloo and Glarner studied here were produced over a period of twenty years and twenty-four years, respectively: Vantongerloo's paintings from 1919 to 1939 and Glarner's paintings from 1945 to 1969. Before the beginning of each period, each artist experimented briefly with a representational style of painting. In the years 1919 and 1945, respectively, each established the more abstract model or style from which most subsequent work evolved. The closing year of each period marks the end of a series of transformations away from the original model.

Within the time periods examined, each artist's work is divided chronologically into several stages where each stage represents a significant development or transformation in the artist's style of painting. The distinguishing features of paintings produced in each stage are characterized in terms of simple shape grammars. Relationships between successive stages are characterized in terms of grammatical transformations that describe how a grammar for one stage is changed into a grammar for a succeeding stage. Because rules are often added or subtracted in transformations of grammars, the recursive structures of grammars for different stages are generally not isomorphic. Recursive structures are usually preserved, however, in those parts of grammars transformed by rule change alone.

The grammars for different stylistic stages are general and minimally detailed in order to focus on, and clearly illustrate, the main object of this study – the transformations from one stylistic stage, or grammar, to the next. All of the grammars are parametric shape grammars – shapes and labels in some of the rules of the grammars are allowed to vary in different ways. However, the schemata used to define rules (that is, the variables and the conditions that values assigned to variables must satisfy) are not given explicitly but are described informally instead.

The rules of each grammar are divided into rules that define relationships between forms or lines, and rules that define relationships between colors. Form rules and color rules are further subdivided into categories of form and color rules that have specific compositional functions. These categories allow rules that have the same or similar functions in different stylistic stages to be correlated and compared.

The paintings that were used to define the grammars and transformations for Vantongerloo and Glarner do not include all of the paintings produced by each artist during the time periods examined. Both artists produced paintings that depart in varying degrees from the grammars given here. The grammars describe very general trends in the painting styles of the two artists – exceptions to these trends are to be expected.

The paintings of Georges Vantongerloo

Georges Vantongerloo was born in Belgium in 1886. He studied sculpture and architecture at the Beaux-Arts Academies in Brussels and Antwerp. At the outbreak of World War I, he moved to the Netherlands where he became friends with Theo Van Doesburg. He joined the *De Stijl* group in 1917 shortly after it was founded. In 1919, he returned to Brussels briefly, then moved to Menton in the south of France in 1920, and then to Paris in 1928 where *De Stijl* and other abstract artists had settled. Vantongerloo quit the *De Stijl* group in 1921 but became involved in the early 1930s in two offshoot organizations in Paris, *Circle et Carré* and *Abstraction–Création*, along with Mondrian and other *De Stijl*-influenced artists. Vantongerloo remained active as both a painter and a sculptor until shortly before his death in Paris in 1965.

The development of Vantongerloo's paintings between 1919 and 1939 can be divided into seven stages represented by the grammars shown in figure 7.2. The initial shape, shape rules, and final state of each grammar are depicted in vertical columns. Rules in different grammars that are identical or have corresponding compositional functions are shown in the same horizontal row. When a rule in a grammar corresponds to more than one rule in another grammar, they are connected by lines as shown. Compositional categories are indicated on the left-hand side of the figure.

Stage I: Beginnings

The paintings produced by Vantongerloo during stage I, between 1919 and 1920, are the point of departure for future work. They follow closely the *De Stijl* horizontal–vertical style of composition and resemble some of the works of Mondrian and Van Doesburg produced about the same time (see figure 7.1). Three paintings from this period are shown in figure 7.3. In each painting, horizontal and vertical black lines divide the canvas into differently proportioned rectangles that are painted in various colors. Colors are not restricted to primaries, black, white, and greys – colors that become typical of *De Stijl* paintings, especially Mondrian's paintings, after 1920.

The grammar for Vantongerloo's stage I paintings generates a very general language of *De Stijl*-style rectangular compositions. More specifically, it generates all possible divisions of a rectangle (a canvas) into smaller, colored rectangles.

The initial shape of the grammar is a labeled rectangle with variable dimensions. The spatial label \times in the initial shape and in the following rules identifies rectangles that do not contain smaller rectangles. The spatial label | identifies the four lines that form the boundaries of a composition.[1]

Transformations in design

7.2 Shape grammars representing the seven stages in the development of Vantongerloo's paintings.

STAGE III 1929-37	STAGE IV 1936-37	STAGE V 1937-38

7.2 continued

7.3
Stage I Vantongerloo
paintings.
a. Georges
Vantongerloo, *Study*,
1919, Casein, 28 × 20
cm. Collection,
Max Bill.
b. Georges
Vantongerloo, *Study*,
1919, Casein, 30 × 22.5
cm., 28 × 20 cm.
Collection, Max Bill.
c. Georges
Vantongerloo,
Study no. III, 1920,
Casein, 22.5 × 30 cm.
Collection, Max Bill.

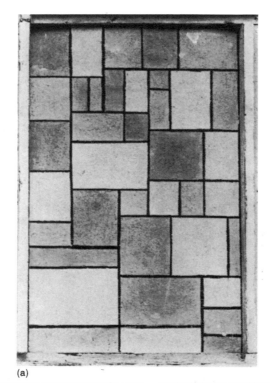

(a)

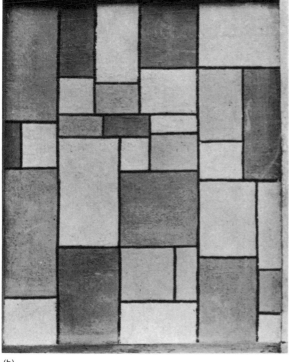

(b)

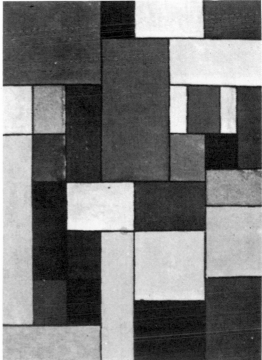

(c)

The form rules of the grammar consist of two rules, rules 6 and 7, that apply to produce *rectangular divisions*. Rule 6 divides a rectangle into two smaller rectangles; rule 7 combines two rectangles to form a larger rectangle.

The color rules of the grammar consist of four rules. Rule 8 initiates the application of color rules by changing states. Rules 9 and 11 color rectangular areas. Either one of these rules must be applied to each rectangular area created by rules 6 and 7 to erase the label × that identifies each rectangle. Rule 9 colors a rectangle with a color denoted by a variable label c_i. The color c_i is chosen from a palette of colors that does not appear to be restricted to any particular range of colors. Rule 11 allows a rectangular area to remain a neutral or background color. Rule 12 removes the outside frame or boundary lines of a composition when coloring is completed. The final state of the grammar is *1*.

The dimensions of rectangles in the rules of the grammar are allowed to vary so that rules may apply to, and produce, rectangles of any proportions.

A derivation of a design using the stage I grammar is shown in figure 7.4. A black and white illustration of the design generated here, along with black and white illustrations of designs generated by grammars for following stages, is given in figure 7.19.

Stage II: Transition

The second stage of Vantongerloo's work marks an important transition from the use of a very general system of rectangular divisions to the use of a more specific and personal one. This new rectangular system typifies Vantongerloo's paintings for the next twenty years. Stage II is represented by a single painting, produced in 1919–20, in which both the general and specific systems are combined (figure 7.5).[2]

In this painting, four bold black lines forming a pinwheel divide the canvas, also framed with bold black lines, into rectangular areas. Some of these rectangular areas are further subdivided by bold lines drawn perpendicular to bold lines previously drawn. Each of the boldly outlined rectangles formed by these divisions is then further subdivided by thin black lines and colored as in stage I paintings. A specific system of rectangular divisions is thus distinguished from the more general one from which it emerges, by the use of differently weighted dividing lines.

The grammar for stage I paintings is transformed into a grammar for stage II paintings using the operations described below. The key part of the transformation is the incorporation of new form rules for *pinwheel divisions* into the stage I grammar.

7.4 (opposite)

A derivation of a stage I design. In this figure and following ones, erased boundary lines in a final design are represented with fine lines to distinguish the design from the figure background.

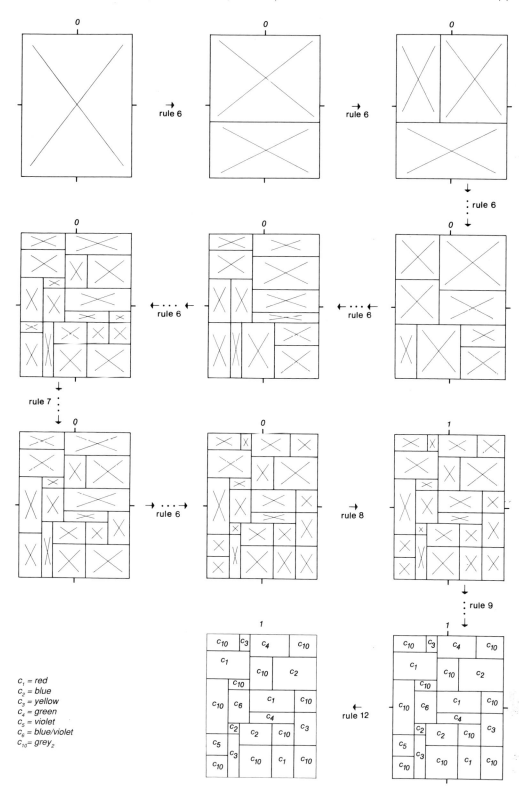

c_1 = red
c_2 = blue
c_3 = yellow
c_4 = green
c_5 = violet
c_6 = blue/violet
c_{10}= grey$_2$

7.5
A stage II Vantongerloo
painting. *Study,*
1919–20, Oil, 52 × 61.5
cm. Private collection,
Germany.

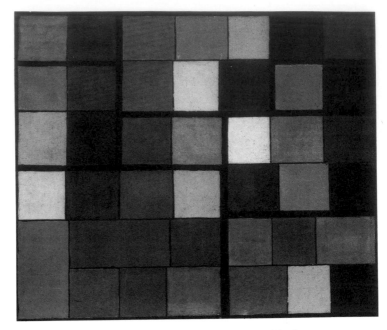

Rule addition: Rules 1, 2, 4, and 5 are added.

Rules 1, 2, and 4 are pinwheel division rules. Rule 1 divides a rectangle into five smaller rectangles by adding four bold lines that form a pinwheel.[3] Each line of the pinwheel is marked with the spatial label ●. In the generation of a design, application of rule 1 is obligatory and is allowed only once. Rule 2 is optional and can be applied any number of times. This rule divides a rectangle into two smaller rectangles by adding a bold line with the label ● perpendicular to a previously added bold line with the label ●. Because the label ● marks only one side of the bold line, only one of the two rectangles produced by rule 2 can be subdivided again by this rule. In both rules 1 and 2, the dimensions of rectangles can vary. Rule 4 erases the label ●.

Rule 5 is added to existing rectangular division rules. It terminates the application of pinwheel division rules and initiates the application of rectangular division rules by changing states.

Rule deletion: Rule 12 for removing the boundary lines of a composition is deleted.

Rule change: The introduction of new rules necessitates small changes in existing rules. The lines defining the initial shape are made bold and each spatial label | associated with it is removed. The state labels in the rectangular division rules, color rules, and the final state are changed as shown.

7.6 (opposite)
A derivation of a stage II
design.

A derivation of a design using the stage II grammar is illustrated in figure 7.6. Pinwheel division rules apply first, followed by

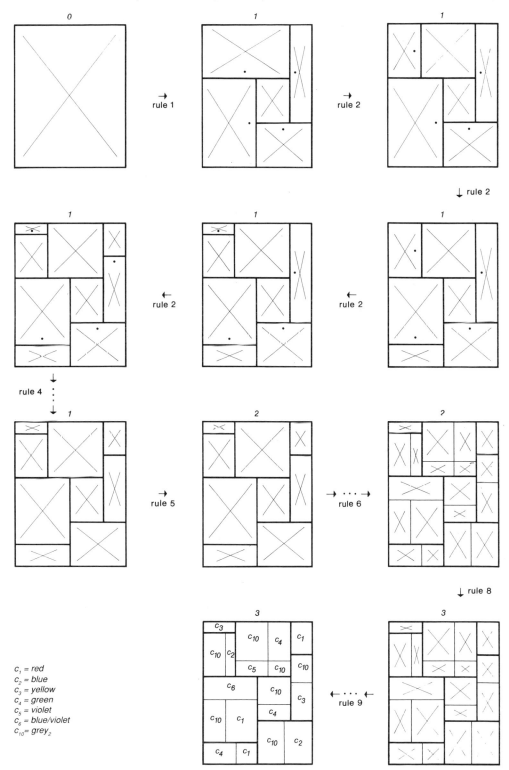

c_1 = red
c_2 = blue
c_3 = yellow
c_4 = green
c_5 = violet
c_6 = blue/violet
c_{10}= grey$_2$

Transformations in design

rectangular division rules, and last, by color rules. (See figure 7.19 for a black and white illustration of the final design.)

Stage III: A theme

7.7

Stage III Vantongerloo paintings.
a. Georges Vantongerloo, *Composition in the cone with orange color*, 1929, Oil on canvas, 60 × 60 cm. Courtesy, Beyeler Gallery, Basel.
b. Georges Vantongerloo, *Composition in an inscribed and circumscribed circle with violet, green, and red*, 1930, Oil on canvas, 85 × 72 cm. (whereabouts of owner unknown.)
c. Georges Vantongerloo, *Group*
$y = ax^2 + bx + c$
$y' = -2ax + b$
$y = -ax^2 + bx + c/-ax + b$
red, yellow, green, 1931, Oil, 129 × 114 cm. Collection, Max Bill.

Stage III is the longest stage in the period of Vantongerloo's paintings studied here. It extends from 1929 to 1937 and follows an interval of nine years in which Vantongerloo's work focused primarily on three-dimensional relationships in sculpture. When Vantongerloo resumed painting in 1929, the general system of rectangular divisions with which he began was abandoned in favor of the more unique and dynamic-looking pinwheel system. At the same time, the pinwheel system is generalized to allow for parallel, as well as perpendicular, divisions of rectangles produced by the pinwheel. The visual effect of parallel divisions leads to stylistic innovations in subsequent stages.

Figure 7.7 shows seven paintings produced during stage III. In each painting, a pinwheel forms the primary division of the canvas. The pinwheel is sometimes obvious (figure 7.7d), sometimes accentuated (figures 7.7f and 7.7g), and sometimes obscured (figure 7.7e). Secondary divisions are made by lines drawn either perpendicular or parallel to lines previously drawn. The rectangles formed by these divisions are colored or left a background color as in stage I and stage II paintings. Larger areas are usually given pale, neutral, or background colors; smaller or narrower areas are usually given darker or more prominent colors. The black border that is used in the stage II painting is not used in any of the stage III paintings. Toward the end of stage III, rectangles in paintings become longer and narrower and begin to take on the appearance of colored lines rather than of colored areas. See, for example, the rectangles in the paintings in figures 7.7e, 7.7f, and 7.7g. This effect is exploited by repeated parallel divisions that define multiple bands of colors as in the painting in figure 7.7e.

(a)

(b)

(c)

d. Georges Vantongerloo, *Composition y = x²/2 in red*, 1931, Oil on canvas, 34.2 × 25.5 cm. (whereabouts of owner unknown.)
e. Georges Vantongerloo, *2478/135 red/green*, 1936, Oil on plywood, 72.1 × 57.5 cm. Courtesy, Tate Gallery, London/Art Resource, New York.
f. Georges Vantongerloo, *Composition green–blue–violet–black*, 1937, Oil (triplex) on plywood, 64.2 × 101 cm. Courtesy, Solomon R. Guggenheim Museum, New York, 51.1301. Photograph: Robert E. Mates. Photograph © The Solomon R. Guggenheim Foundation.
g. Georges Vantongerloo, *Function of verticals, green–red*, 1937, Oil on plywood, 80 × 30 cm. Collection, Max Bill.

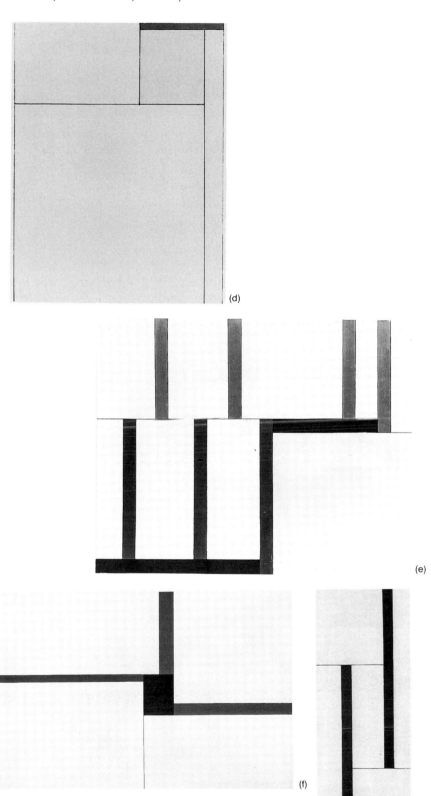

(d)

(e)

(f)

(g)

The grammar for stage II paintings is transformed into a grammar for stage III paintings essentially by removing rectangular division rules and by introducing a new pinwheel division rule for secondary, parallel divisions.

Rule addition: Rule 12 for erasing boundary lines is added back.

Rule deletion: Rules 5, 6, and 7 for rectangular divisions are deleted.

Rule change: The deletion of rectangular division rules requires some small changes in other rules. The lines defining the initial shape and pinwheel division rules 1 and 2 are changed from bold lines back to lines of the usual thickness. The state labels in the color rules and the final state are changed as shown.

The perpendicular division rule, rule 2, in the stage II grammar is carried over into stage III. At the same time, it is changed into a new rule for parallel divisions, rule 3, in the stage III grammar. Rule 3 is derived from rule 2 by repositioning shapes in the spatial relation underlying rule 2; in particular, by rotating the line dividing the rectangle in the rule by 90°. Although the new parallel division rule 3 and the old perpendicular division rule 2 could be collapsed into a single, more general rule, the two rules are distinguished here in order to distinguish between the different stylistic results of applying these rules (see figure 7.8).

7.8
The different results of making (a) perpendicular divisions and (b) parallel divisions to the areas formed by a pinwheel. Compare these compositions with the paintings in figures 7.7f and 7.7g.

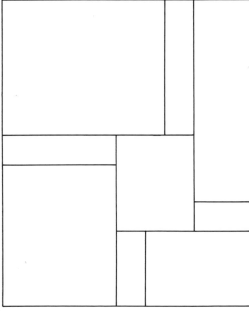

(a)

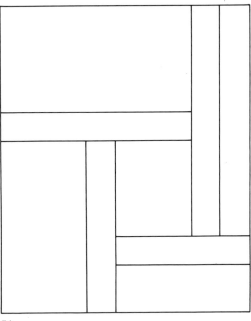

(b)

Finally, color rule 9 is changed by placing restrictions on the variable c_i. These restrictions make the color c_i of a rectangle a function of its area as described above.

A derivation of a design using the stage III grammar is shown in figure 7.9. (See figure 7.19 for a black and white illustration.)

Designs in the stage III language that are characteristic of the later part of stage III can be distinguished from designs characteristic of the earlier part of stage III by differences in their derivations. More specifically, they can be distinguished by differences in the assignment of values to variables in rules 2 and 3 that determine the proportions of rectangles, and by the number and sequence of applications of rule 3. The formal mechanisms developed by Stiny for describing designs according to their derivations would be most appropriate here for making stylistic distinctions between earlier and later stage III paintings.[4]

Stage IV: Experimentation

Stage IV, lasting from 1936 to 1937, is a short period of experimentation in which Vantongerloo appears to be testing the limits and possibilities of the compositional devices he has created so far. Five paintings from stage IV are shown in figure 7.10. In these paintings, the pinwheel is no longer the single focal point of compositions. Instead, compositions are eclectic and structured around multiple pinwheels, repeated parallel divisions, and more general, rectangular divisions. These are combined in different ways in different paintings so that no single, consistent compositional system emerges from the group as a whole. A grammar for this stage is left undefined.

Stage V: A theme renewed

The eclecticism of stage IV is followed by a return to a purer and simpler compositional format in stage V. The single pinwheel division is resumed while a new coloring system is introduced. The new coloring system marks Vantongerloo's first break with the strict horizontal–vertical format of *De Stijl*.

Figure 7.11 shows four stage V paintings done between 1937 and 1938. A pinwheel and optional perpendicular and parallel divisions partition each painting into rectangular areas exactly as in stage III paintings. Instead of being filled in with solid colors, however, the rectangles are filled in with colored straight line segments and colored curves. Still in the *De Stijl* mode, the colored straight lines are always drawn horizontally or vertically and form groups of parallel lines. The illusion of colored lines created by narrow and repeated parallel divisions in late stage III and stage IV paintings has, in this stage, become actual. The

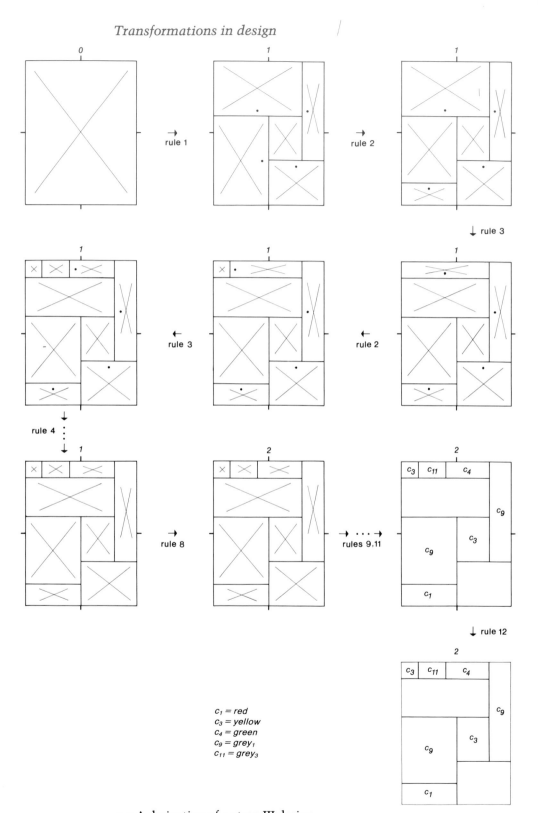

$c_1 = red$
$c_3 = yellow$
$c_4 = green$
$c_9 = grey_1$
$c_{11} = grey_3$

7.9 A derivation of a stage III design.

7.10
Stage IV Vantongerloo
paintings.
a. Georges
Vantongerloo, *Function
of red and green lines*,
1936, Oil on plywood,
102 × 68 cm.
(whereabouts of owner
unknown.)
b. Georges
Vantongerloo, *Interval
and function of black
lines*, 1937, Oil on
plywood, 80 × 35 cm.
(whereabouts of owner
unknown.)
c. Georges
Vantongerloo,
*Composition green–red,
blue, violet, red, yellow,
black*, 1937, Oil on
plywood, 66 × 47.6 cm.
Courtesy, Stedelijk
Museum, Amsterdam.

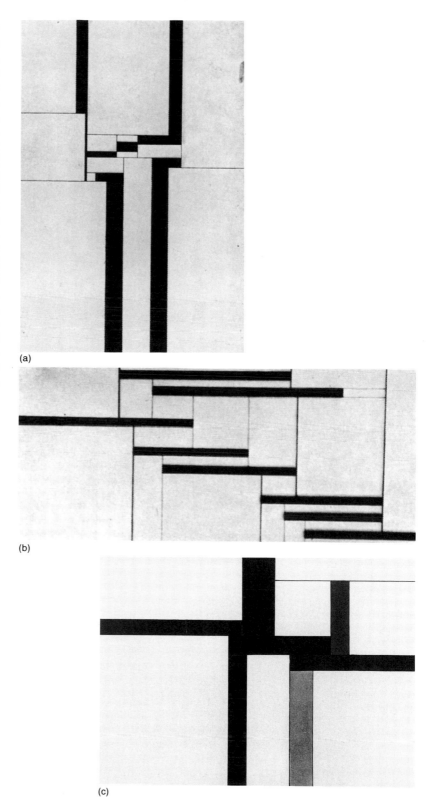

(a)

(b)

(c)

7.10 continued

d. Georges Vantongerloo, *Function of lines*, 1937, Oil on plywood, 101 × 83.2 cm. (whereabouts of owner unknown.)
e. Georges Vantongerloo, *13478/15 brown, beige, greenish, red green*, 1937, Oil (triplex) on plywood mounted on plywood subsupport, 60.5 × 101 cm. Courtesy, Solomon R. Guggenheim Museum, New York, 51.1302. Photograph: Robert E. Mates. Photograph © The Solomon R. Guggenheim Foundation.

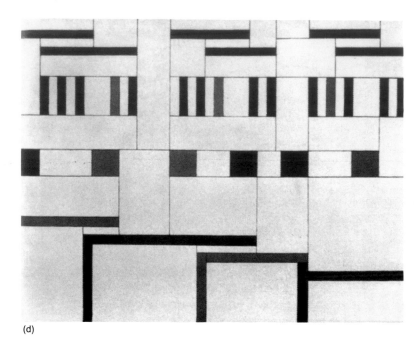

(d)

(e)

colored curves are completely new and are the first deviation from *De Stijl* rectilinear principles. Because they are very precisely drawn, however, the geometric look of *De Stijl* is preserved. (On the introduction of the curved line by Vantongerloo and other former *De Stijl* artists, Mondrian is reported to have remarked "I might have known.")[5]

Because the composition of stage V paintings is evolved more directly from stage III paintings than from stage IV paintings, a grammar for stage V paintings is derived directly from the grammar for stage III paintings. The stage V grammar is derived by transforming color rules only.

7.11
Stage V Vantongerloo
paintings.
a. Georges
Vantongerloo, *Function,
curves, straight lines*,
1937, Oil on plywood,
48.7 × 32.3 cm.
Collection, Max Bill.
b. Georges
Vantongerloo, *Curves*,
1937, Oil, 101.8 × 70.5
cm. Collection, Max
Bill.
c. Georges
Vantongerloo, *Function
of lines, curves, and
straight lines*, 1937, Oil
on plywood, 95 × 61 cm.
Collection, Max Bill.
d. Georges
Vantongerloo, *Function
parabola*, 1938, Oil on
plywood, 69.5 × 48.8
cm. Courtesy, Gallerie
Tarica, Paris.

(a)

(b)

(c)

(d)

Rule addition: No rules are added.

Rule deletion: No rules are deleted.

Rule change: Color rule 9 in the stage III grammar is changed into two new color rules, rules 9 and 10, in the stage V grammar. The new rule 9 applies recursively to place colored curves within a rectangle. The new rule 10 applies recursively to place colored straight line segments horizontally or vertically within a rectangle. The variable label c_i in each of these rules denotes the color of the straight or curved line. In both rules, the dimensions, curvature, and placement of a line can vary.

7.12

A derivation of a stage V design.

Figure 7.12 shows a derivation of a design using the stage V grammar. (See figure 7.19 for a black and white illustration.)

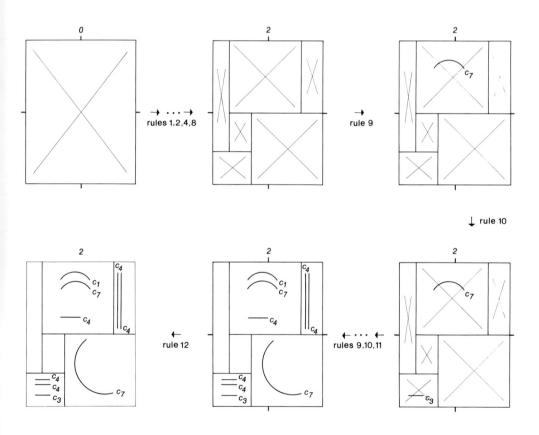

$c_1 = red$
$c_3 = yellow$
$c_4 = green$
$c_7 = magenta$

Stage VI: Transition

Stage VI, like stage II, is represented by a single, transitional painting (figure 7.13). Produced in 1938, this painting marks the passage from a tightly structured pinwheel format to its complete abandonment. The painting is comprised of a single pinwheel formed by four green, curved lines. The curved lines introduced in the previous stage as part of a new coloring system have here become integrated with a considerably loosened pinwheel division system.

The stage V grammar is transformed into a stage VI grammar by changing the pinwheel rule and deleting all other rules.

Rule addition: No rules are added.

Rule deletion: All of the secondary pinwheel division rules (rules 2, 3, and 4) are deleted. All of the color rules, except the rule for erasing boundary lines, (rules 8, 9, 10, and 11) are deleted.

Rule change: Pinwheel division rule 1 from stage V is changed into a new rule by introducing new shapes into the spatial relation underlying the rule. In particular, each of the four straight lines comprising the pinwheel in the rule is replaced with a colored, curved line. Each curved line is the same color denoted by the variable label c_i. In principle, four different curved pinwheel configurations can be produced by replacing the straight lines of the pinwheel with curved lines. These are illustrated in figure 7.14.

The final state is also changed as shown.

7.13
A stage VI Vantongerloo painting. *Extension, green curves,* 1938, Oil on masonite, 80 × 64.5 cm. Collection, Max Bill.

7.14
The four different pinwheel configurations comprised of curved lines that are produced from a pinwheel comprised of straight lines, by replacing each of the straight lines in the pinwheel with a curved line.

Rule deletion, addition, and change apply to the stage V grammar to produce four new grammars. Each grammar contains one rule for placing one of the colored, curved pinwheels shown in figure 7.14 within a rectangle. The grammar that uses the second pinwheel in figure 7.14 is the grammar for Vantongerloo's stage VI paintings. Line and color are defined simultaneously by the single form rule in this grammar.

Figure 7.15 shows a derivation of a design in the language defined by the stage VI grammar. (See figure 7.19 for a black and white illustration.) The counterclockwise rotation of the pinwheel in the final design of the derivation is different from the clockwise rotation of the pinwheel in the stage VI painting that Vantongerloo actually produced. Since Vantongerloo used both clockwise and counterclockwise rotations of pinwheels in his earlier paintings, it is reasonable to assume that he might have done the same had he produced other stage VI paintings.

Stage VII: A theme undone

Stage VII, lasting from 1938 to 1939, is the final stage of paintings linked to the *De Stijl* style. It is also the most productive stage. Six paintings from stage VII are shown in figure 7.16.

In stage VII paintings, the pinwheel has disappeared completely, releasing the colored lines and curves introduced in stage V from their rectangular confines. The curves in some paintings are more elaborate and expressive than the curves in previous paintings. In general, though, they still have a very crisp, geometric quality. The only vestiges of early, classic *De Stijl* are the straight line segments almost invariably placed horizontally or vertically within the rectangular frame of the canvas.

The grammar for stage VI paintings is transformed into a grammar for stage VII paintings by removing the one remaining form rule for pinwheel divisions and by adding back color rules from stage V.

Rule addition: Color rules 9, 10, and 11 from stage V (with changed state labels) are added.

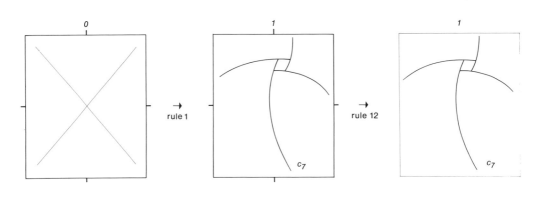

c_7 = *magenta*

<table>
<tr><td>7.15</td><td></td></tr>
</table>

7.15

A derivation of a stage VI design.

Rule deletion: Pinwheel division rule 1 is deleted.

Rule change: The final state is changed as shown.

A derivation of a design using the stage VII grammar is given in figure 7.17. (See figure 7.19 for a black and white illustration.) In contrast to the previous stage, designs in this stage are generated solely by color rules that simultaneously define relationships between colors and relationships between lines.

Paintings produced after stage VII are related to earlier paintings but no longer show any formal trace of *De Stijl*. Six paintings produced after 1939 are shown in figure 7.18. In these paintings, the colored lines and curves of stage VII paintings have become even more evocative and complex. Straight lines are no longer used. Compositions suggest movement and energy – qualities hinted at very early in Vantongerloo's work by the pinwheel and its implied radial motion. The pinwheel reappears in a new, more expressive guise, in fact, in one of these later paintings (see figure 7.18c).

The paintings of Fritz Glarner

Fritz Glarner was born in Zurich in 1899. He grew up primarily in Italy and France and attended art schools in Naples and Paris. In 1923, Glarner settled in Paris where he became acquainted with *De Stijl* and other abstract artists, among them Mondrian, Van Doesburg, and Vantongerloo. Despite his association with these artists, however, he never became a member of any of their organizations. Glarner's paintings at the time were comparatively traditional and undeveloped in relation to those of the Paris avantgarde, many of whom were much older than Glarner. In 1935, Glarner returned to Zurich for a year and then emigrated to the United States. He settled in New York City where he became reacquainted with Mondrian after Mondrian's arrival there in

7.16
Stage VII Vantongerloo
paintings.
a. Georges
Vantongerloo, *Curves –
straight lines – intervals
red – green – brown –
greenish*, 1938, Oil on
masonite, 80 × 37 cm.
Collection, Max Bill.
b. Georges
Vantongerloo,
*Variations of lines,
red–brown–greenish*,
1938, Oil on masonite,
80 × 49.5 cm.
Kawamura Collection.
c. Georges
Vantongerloo, *Function
of curves*, 1939, Oil on
masonite, 60 × 31.5 cm.
(whereabouts of owner
unknown.)
d. Georges
Vantongerloo, *Relation
of lines and colors*,
1939, Oil on
composition board,
72 × 52.5 cm.
Collection, The
Museum of Modern Art,
New York. The Riklis
Collection of McCrory
Corporation (fractional
gift).
e. Georges
Vantongerloo, *Function
of variants*, 1939, Oil on
American masonite,
101 × 69.5 cm.
(whereabouts of owner
unknown.)
f. Georges
Vantongerloo, *Curves*,
1939, Oil on masonite,
42 × 60 cm. Collection,
Max Bill.

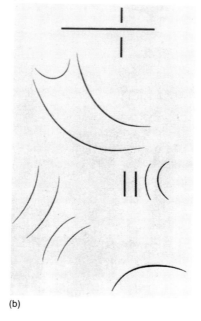

(a)

(b)

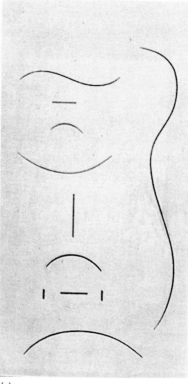

(c)

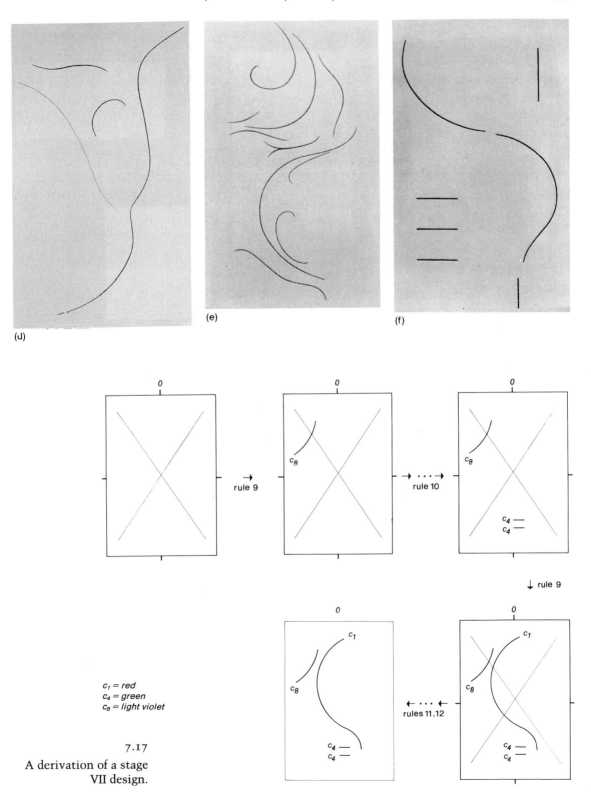

(d)

(e)

(f)

rule 9

rule 10

c_8

c_8

c_4 ⎯
c_4 ⎯

↓ rule 9

c_1 = red
c_4 = green
c_8 = light violet

7.17
A derivation of a stage
VII design.

c_1

c_8

c_4 ⎯
c_4 ⎯

← · · · ←
rules 11,12

c_1

c_8

c_4 ⎯
c_4 ⎯

(a)

(b)

(c)

(e)

(d)

(f)

7.18 (opposite)
Paintings by
Vantongerloo produced
after stage VII.
a. Georges
Vantongerloo, *Irrational
forms and colors:
connection form with
four equal sides and
unequal angles closed
line inequidistant from a
point called improperly
center: line with thick-
ness caused by a moving
point and changeable
dimension (changeable
color)*, 1942, Oil,
71 × 50 cm. (whereabouts
of owner unknown.)
b. Georges
Vantongerloo, *Element*,
1947, Oil, 50 × 61 cm.
Collection, Max Bill.
c. Georges
Vantongerloo,
Circonvolution, 1948,
Oil, 60 × 36 cm.
Collection, Max Bill.
d. Georges
Vantongerloo, *Nuclear
fission*, 1948, Oil,
23 × 28 cm. Collection,
Max Bill.
e. Georges
Vantongerloo, *Two
space zones, action and
reaction*, 1949, Oil,
98 × 40 cm. Collection,
Max Bill.
f. Georges
Vantongerloo,
Phenomenon, 1954, Oil,
64 × 43.5 cm.
Collection, Max Bill.

7.19
Stage, I, II, III, V, VI, and
VII designs. The deriva-
tions of these designs are
shown in figures 7.4, 7.6,
7.9. 7.12, 7.15, and 7.17,
respectively.

Stage I

Stage II

Stage III

Stage V

Stage VI

Stage VII

7.20

Shape grammars representing the five stages in the development of Glarner's paintings.

STAGE III
1956-57

STAGE IV
1958-62

STAGE V
1961-69

7.20 continued 1940. The two remained close friends until Mondrian's death in 1944. Around the time of their friendship, Glarner's paintings changed from figurative, representational themes to more abstract ones. His work then coalesced rapidly into a unique style of form and color composition that he called *Relational Painting*. For the next thirty years, he developed this style, producing the two parallel series of Relational Paintings for which he is now known. One series of Relational Paintings was done in a rectangular format; the other in a circular format. Glarner returned to Europe in 1971 where he died the following year.

This study focuses on Glarner's rectangular Relational Paintings produced between 1945 and 1969. Although Glarner began his Relational Paintings in 1941, it was not until 1945 that a consistent compositional system was established. (Much later, Glarner acknowledged a rectangular Relational Painting of 1945 as the true beginning of Relational Painting.) Glarner produced his last sketch for a Relational Painting in 1969.

The compositional system Glarner used for his circular Relational Paintings is similar to the one he used for his rectangular Relational Paintings, and its development parallels the development of the system for rectangular paintings. The development of

the circular paintings, however, does not appear to be as coherent nor as interesting as that of the rectangular paintings.

The development of Glarner's rectangular Relational Paintings can be divided into five stages represented by the five grammars shown in figure 7.20. The presentation of grammars in this figure follows the same format used in the presentation of grammars for Vantongerloo's paintings (see p. 171).

Before stage I, Glarner experimented with two different kinds of *De Stijl*-based compositions. In one kind of composition, rectangles and wedge-shapes painted in primary colors and grey are set against a white background and are connected by horizontal and vertical black lines (figure 7.21a). Only some of the paintings done using this compositional system were called Relational Paintings. In the other kind of composition, horizontal and vertical lines painted in primaries and greys divide the canvas into white or grey rectangular areas (figure 7.21b). These paintings resemble some of Mondrian's late paintings produced around the same time (for example, *New York City* (1941/42)). They differ from Mondrian's earlier paintings in that color is given to dividing lines instead of to the rectangular areas the dividing lines create. With modifications for color, these paintings can be generated,

approximately, using rectangular division rules similar to those used to generate Vantongerloo's stage I paintings (see figure 7.2). None of the paintings done using this second compositional system were called Relational Paintings.

The wedge-shapes Glarner used in the first compositional system, the rectangular divisions he used in the second system, and the typical *De Stijl* colors he used in both systems are integrated in Stage I of his Relational Paintings.

Stage I: A theme

Stage I lasts for five years, from 1945 to 1950. In this beginning stage, Glarner introduces a subtle dynamic into an otherwise conventional rectangular division format with the use of oblique divisions. Glarner's introduction of the oblique to simultaneously vitalize and particularize the rectangular format of *De Stijl* is analogous to Vantongerloo's introduction of the pinwheel in stage II of his paintings.

Three of Glarner's stage I paintings are shown in figure 7.22. In each of these paintings, the canvas is divided horizontally and vertically into rectangular areas. Each rectangle is then subdivided into two wedge-shapes by an oblique division. The placement of the oblique varies from rectangle to rectangle; usually, it divides the rectangle into wedge-shapes of unequal areas. The

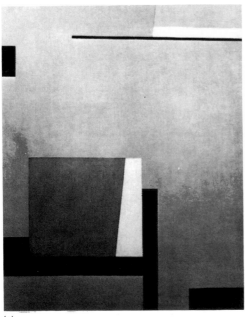

(a)

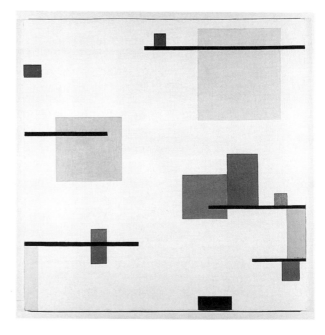

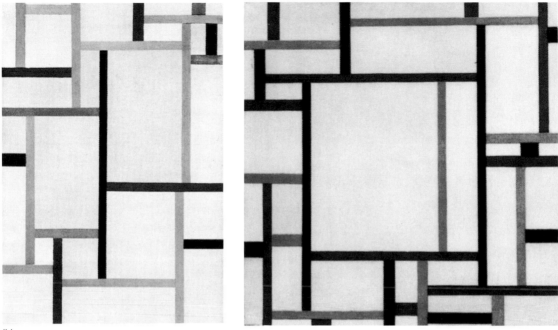

(b)

7.21

Paintings by Glarner
produced before stage I.
a. (opposite) Left: Fritz
Glarner, *Composition*,
1942, Oil on canvas,
106.5 × 86.5 cm.
(whereabouts of owner
unknown.)
Right: Fritz Glarner,
Relational Painting,
1943, Oil on canvas,
128.5 × 123 cm.
Courtesy, Yale
University Art Gallery.
Gift of Katherine
S. Dreier for the Collec-
tion Société Anonyme
b. (above) Left: Fritz
Glarner, *Painting, grey*,
1942, Oil on canvas,
97 × 96.5 cm. Courtesy,
Kunsthaus Zürich.
Right: Fritz Glarner.
Painting, white, 1945,
Oil on canvas,
82.5 × 79.5 cm.
Courtesy, Kunsthaus
Zürich.

angle of the oblique division deviates only slightly from 90° and,
in some instances, just barely suggests a wedge-shape rather than
a rectangle. Divisions, either rectangular or oblique, are not
delineated with black lines as in Vantongerloo's and other *De Stijl*
paintings.

Whenever two adjacent rectangles in a painting combine to
form a single, larger rectangle, the orientation and relationship
between the oblique divisions in them are restricted.[6] In prin-
ciple, there are six possible relationships between two obliquely
divided rectangles that form a larger rectangle. Figure 7.23 shows
these relationships. Only three of the six relations are used in
stage I paintings: relations 1, 2, and 3. Relation 1 is used most
frequently in paintings done during stage I and all subsequent
stages. In this relation, the narrow end of a wedge in one rectangle
meets at a right angle with the wide end of a wedge in the adjacent
rectangle. Relation 2 is close in appearance to relation 1 but is
used only occasionally. In this relation, the wide ends (or, alter-
natively, the narrow ends) of wedges in adjacent rectangles meet
at a right angle. Relation 3 is used very rarely.

The wedge-shaped areas formed by oblique divisions are
painted in primary colors, black, white, and various shades of
grey. With the exception of white and grey, no area is painted the
same color as a contiguous area. In most paintings, the relation-
ship between the colors of the two wedge-shapes formed by an
oblique division of a rectangle is further restricted. Usually, one
wedge is grey or white; the other is grey, white, black, or a primary
color.[7]

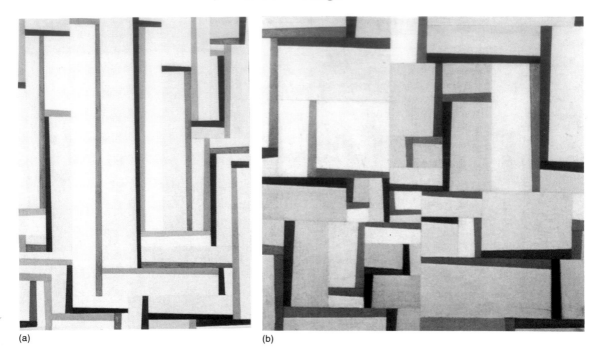

(a) (b)

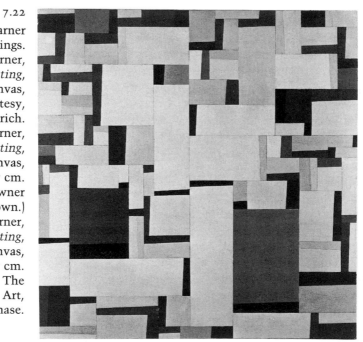

7.22
Stage I Glarner
paintings.
a. Fritz Glarner,
Relational Painting,
1945–8, Oil on canvas,
208 × 147 cm. Courtesy,
Kunsthaus Zürich.
b. Fritz Glarner,
Relational Painting,
1946, Oil on canvas,
109 × 107 cm.
(whereabouts of owner
unknown.)
c. Fritz Glarner,
Relational Painting,
1947–48, Oil on canvas,
109.5 × 107 cm.
Collection, The
Museum of Modern Art,
New York. Purchase.

(c)

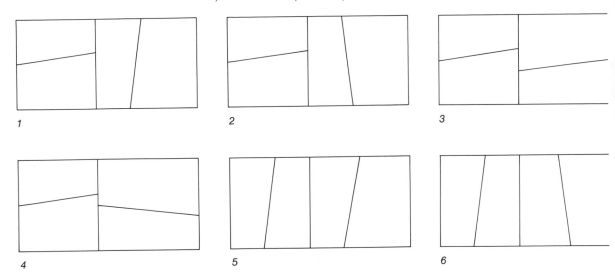

7.23

The six possible
relationships between
two obliquely divided
rectangles that form a
larger rectangle.

As with all of the Vantongerloo grammars, the grammars for
Glarner's paintings are separated into form rules that specify how
a canvas is divided and color rules that specify how the divided
areas are colored.

In the grammar for Glarner's stage I paintings, the initial shape
is a labeled rectangle with variable dimensions. The spatial label
× in the initial shape and rules of this grammar has the same
purpose that it has in the initial shape and rules of the Vantonger-
loo grammars: it either identifies a rectangle that does not contain
smaller rectangles or it identifies a wedge-shape that does not
contain smaller wedge-shapes.

Rules 1 through 5 and rules 13 through 15 of the grammar are
form rules.

Rules 1 and 2 apply to generate rectangular divisions. Rules 3
and 4 apply to find every pair of rectangles, generated by rules 1
and 2, that comprise a larger rectangle. Rule 3 places a circle with
the spatial label ● at the midpoint of each side of a rectangle. The
size of the circle is proportional to the length of the side it labels.
Whenever two rectangles share a complete side and thus form a
larger rectangle, the two circles at the midpoint of the shared side
coincide; the two labels on these circles remain separate. Rule 4
erases labeled circles. Whenever a side is shared by two rectangles,
a label ● remains to identify that side.

Rule 5 is an oblique division rule. The spatial label | marks the
midpoint of the oblique and identifies the two adjacent wedge-
shapes formed by applying this rule. Excluding labels, this rule is a
simple transformation of the rectangular division rule that Glarner
used in the second of the two kinds of paintings produced before
stage I (see pp.199–200) and that he carried over, as rule 1, into
stage I paintings. The oblique division rule can be derived from

the rectangular division rule simply by rotating the dividing line in the rule a few degrees.

Rules 13, 14, and 15 define the three allowable relationships between two obliquely divided rectangles that form a larger rectangle. Although rule 5 can apply to produce any of the six possible relationships between two obliquely divided rectangles, the label ● that identifies the shared side of the two rectangles (see rules 3 and 4) can be erased only when one of the three relations specified by rules 13, 14, and 15 holds.

Rules 17, 18, and 25 of the grammar are color rules.

Rule 17 colors a wedge-shape with a color denoted by the variable label c_i. The color c_i is chosen from a palette of primaries, black, white, and grey tones. Rule 18 defines allowable color relationships between the two wedge-shapes in a rectangle. Although rule 17 can apply to produce a diversity of color relationships between the two wedge-shapes in a rectangle, the label | can be erased only when c_i = grey or white and c_j = a primary color, grey, white, or black. Rule 25 erases the black dividing lines of a composition only when $c_i \neq c_j$ or c_i and c_j are the same white or grey tone; it also erases the boundary lines of a composition whenever either a color c_i or a color c_j is not present.[8]

Wherever necessary, the angles of oblique divisions and the dimensions of rectangles and wedge-shapes in rules are allowed to vary.

A derivation of a design using the stage I grammar is given in figure 7.24. A black and white illustration of the design generated here, along with black and white illustrations of designs generated by grammars for following stages, is given in figure 7.31.

Stage II: Elaboration

In stage II, form and color relationships in paintings become more complex. Four paintings from stage II, which extends from 1949 to 1956, are shown in figure 7.25.

In a stage II painting, rectangular and oblique divisions partition the canvas into wedge-shapes as in stage I paintings. In some paintings, the rectangular divisions are very systematic but, in general, they appear to be arbitrary. The oblique divisions in these paintings usually divide rectangles into wedge-shapes of more equal areas than in stage I paintings. Each of these wedge-shapes is then subdivided by a cut parallel to and near the narrow end of the wedge. This new subdivision creates a thin, wedge-shaped band or border along the narrow end of each wedge. The width of the border is approximately the same for each wedge-shape.

The relationships between obliquely divided rectangles that form a larger rectangle (see figure 7.23) are basically the same as those in stage I paintings. Relation 1 is still the predominant, if not the only, relation in most paintings. Relation 2, however, is

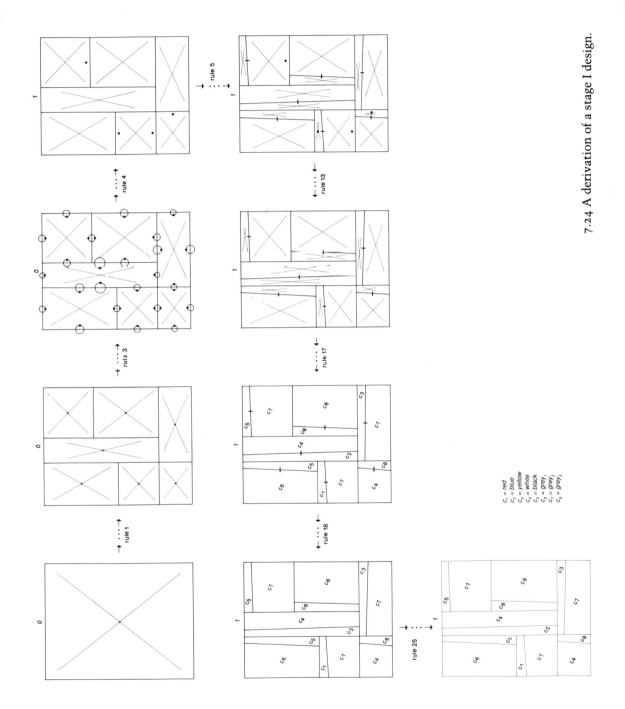

7.24 A derivation of a stage I design.

c_1 = red
c_2 = blue
c_3 = yellow
c_4 = white
c_5 = black
c_6 = grey$_1$
c_7 = grey$_2$
c_8 = grey$_3$

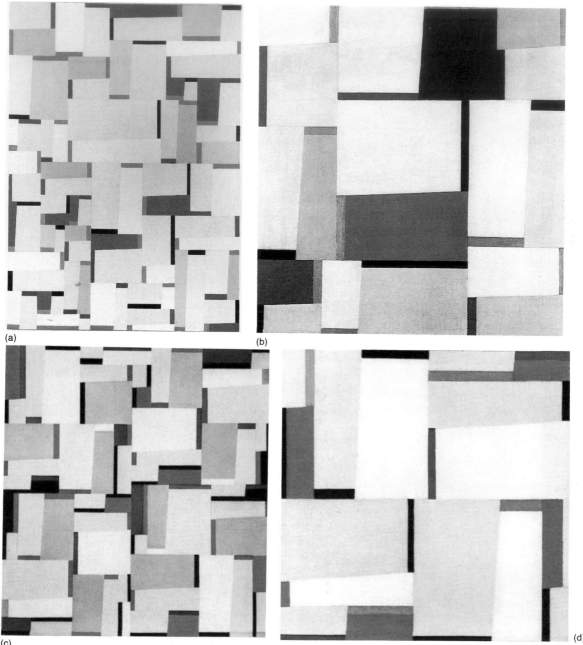

(a)

(b)

(c)

(d)

dropped. The border at the narrow end of each wedge articulates more clearly the relationship between wedges in adjacent rectangles and may have prompted the abandonment of this particular relation – with borders on wedge-shapes, relation 2 becomes noticeably different from relation 1. Relation 3 continues to be used infrequently, if at all, in most paintings. A new relation, relation 5, is introduced as the predominant relation in one painting, but does not appear in any other paintings.

7.25 (opposite)
Stage II Glarner
paintings.
a. Fritz Glarner,
*Relational Painting No.
60,* 1952, Oil on canvas,
149 × 108 cm.
Collection, The
Museum of Modern Art,
New York, The Riklis
Collection of McCrory
Corporation (fractional
gift).
b. Fritz Glarner,
*Relational Painting No.
65,* 1953, Oil on canvas,
77.5 × 72.5 cm.
(whereabouts of owner
unknown.)
c. Fritz Glarner,
*Relational Painting No.
74,* 1954, Oil on canvas,
116 × 108.5 cm.
(whereabouts of owner
unknown.)
d. Fritz Glarner,
*Relational Painting No.
80,* 1954–56, Oil on
canvas, 65 × 65 cm.
(whereabouts of owner
unknown.)

The relationships between the colors of wedge-shapes in a rectangle are complicated slightly by the new subdivisions of wedges. Excluding these new divisions, the relationships between the colors of wedge-shapes remain essentially the same as in stage I paintings. Usually, one wedge is grey or white; the other is a primary color, grey, or white. Black is no longer used. In some paintings, more specific constraints on color relationships between wedges are used. Color relationships between the new wedge-shaped bands and the wedge-shapes they border are not restricted in general. Instead, specific color relationships are defined for specific paintings. For example, in the painting shown in figure 7.25a, the border of one wedge-shape in a rectangle is always the same grey tone, and the border of the other wedge-shape is always either black or a primary color. Additionally, if one of the wedge-shapes in a rectangle is a primary color, its border is always the grey tone rather than the black or primary color.

A grammar for Glarner's stage II paintings is derived from the grammar for his stage I paintings by adding a rule for wedge subdivisions, deleting a rule for a relation between obliquely divided rectangles, adding a rule for a new relation between obliquely divided rectangles, and changing the rule for color relations.

Rule addition: Rule 8 is added. This rule applies to subdivide a wedge-shape into two wedge-shapes as discussed above.

Rule deletion: Rule 14, which defines a relation between obliquely divided rectangles, is deleted.

Rule change: Either rule 13, 14, or 15 in the stage I grammar – rules that define relations between obliquely divided rectangles – is changed into rule 16 in the stage II grammar – a rule that defines a new relation between obliquely divided rectangles. In figure 7.20, rule 15 in the stage I grammar is carried over into stage II and, at the same time, is changed into the new rule 16. Rule 16 is produced by repositioning shapes in the spatial relation underlying rule 15; in particular, by rotating the oblique dividing line in the rule.[9]

The variables in the oblique division rule 5, that allow the placement of the oblique to vary, are changed so that oblique divisions create wedge-shapes of approximately equal areas as described above. Minor labeling changes are also made in conjunction with the addition of rule 8: spatial labels are added to rule 5 to ensure application of rule 8 which erases them.

Finally, color rule 18 is changed as shown to define new color relationships between subdivided wedges. The spatial label | in the new rule 18 can be erased only when c_i = grey or white and c_j = a primary color, grey, or white. Constraints on c_k and c_l are specific to each painting.

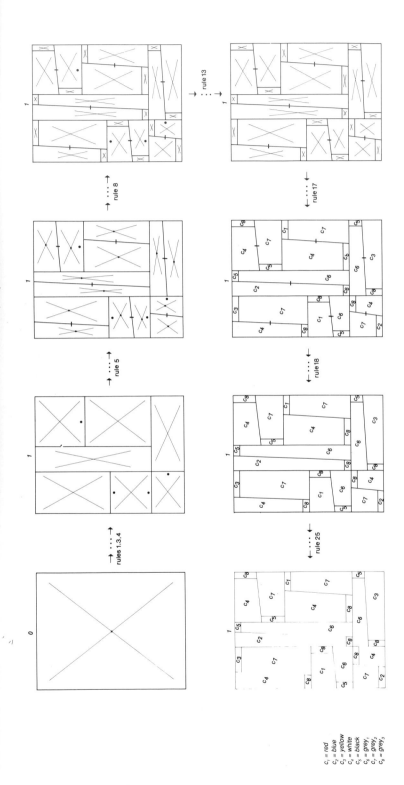

$c_1 = red$
$c_2 = blue$
$c_3 = yellow$
$c_4 = white$
$c_5 = black$
$c_6 = grey_1$
$c_7 = grey_2$
$c_8 = grey_3$

7.26 A derivation of a stage II design.

Figure 7.26 shows a derivation of a design using the stage II grammar. (See figure 7.31 for a black and white illustration.)

Stage III: Variation

Stage III is very brief, lasting from 1956 to 1957. In this stage, Glarner makes a small, almost unnoticeable change in the composition of his paintings by subdividing wedge-shapes at their wide ends rather than at their narrow ends. Color relationships between wedge-shapes and borders, however, remain the same. Relation 1 (figure 7.23) is the only relation between obliquely divided rectangles used in these paintings. Figure 7.27 shows two stage III paintings.

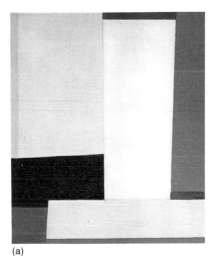

(a)

7.27
Stage III Glarner
paintings.
a. Fritz Glarner,
*Relational Painting No.
77*, 1956, Oil on canvas,
60 × 51 cm.
(whereabouts of owner
unknown.)
b. Fritz Glarner,
*Relational Painting No.
82*, 1957, Oil on canvas,
111.5 × 81 cm. Richard
S. Zeisler Collection,
New York.

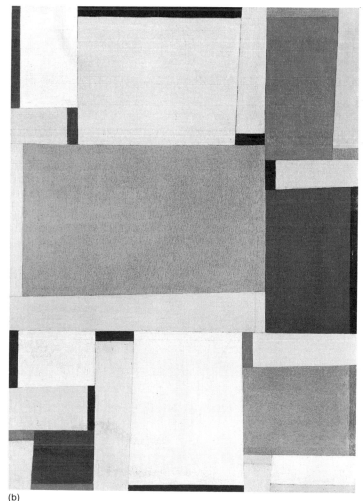

(b)

The grammar for stage II paintings is transformed into a grammar for stage III paintings essentially by changing the rule for subdividing wedge-shapes and deleting all but one rule for relationships between obliquely divided rectangles.

Rule addition: No rules are added.

Rule deletion: Rules 15 and 16, which define relationships between obliquely divided rectangles, are deleted.

Rule change: Rule 8, the rule for subdividing wedges, is changed as shown: by repositioning the dividing line in the rule. Because rule 8 is changed, rule 18, the rule for defining color relationships between subdivided wedges, is also changed as shown. Restrictions on the colors c_i, c_j, c_k, and c_l in subdivided wedges remain the same as those used in stage II.

A design generated by the stage III grammar is illustrated in black and white in figure 7.31. Derivations of designs using the stage III grammar are basically the same as derivations of designs using the stage II grammar.

Stage IV: Combination

In stage IV, which lasts from 1958 to 1962, Glarner combines the compositional systems used in stage II and stage III. The wedge subdivisions in stage II paintings and the wedge subdivisions in stage III paintings are both used but never in the same painting. Relation 3 between obliquely divided rectangles (figure 7.23) is reintroduced as the primary relation in one painting and as a subordinate relation in other paintings. Color relationships between subdivided wedges remain the same as those in stage II and III paintings.

The grammar for stage III paintings is transformed into a grammar for stage IV paintings in the following way.

Rule addition: Two rules for changing states, rules 6 and 7, are added. Application of one of these rules initiates the application of one of the two rules for subdividing wedge-shapes (rule 8 or 9), but not both.

Rule 15, which defines a relation between obliquely divided rectangles, is added back from stage II.

Rule deletion: No rules are deleted.

Rule change: The state labels in rule 8 (for subdividing wedges at their wide ends) and the final state are changed as shown.

Rule 8 in the stage III grammar is carried over into stage IV and, at the same time, is changed into rule 9 (for subdividing wedges at their narrow ends) in stage IV. (Note that this change is the inverse of the change that produces rule 8 in the stage III grammar from rule 8 in the stage II grammar.)

Rule 18 (for defining color relationships between wedges subdivided at their wide ends) in the stage III grammar is carried over into stage IV and, at the same time, is changed into rule 19 (for defining color relationships between wedges subdivided at their narrow ends) in stage IV. (Note that this change is the inverse of the change that produces rule 18 in the stage III grammar from rule 18 in the stage II grammar.)[10]

Designs in the language defined by the stage IV grammar are derived in a similar way as designs in the languages defined by the stage II and III grammars. A derivation of a design using the stage IV grammar has one extra step involving the application of either rule 6 or rule 7.

Stage V: Elaboration

Stage V begins in 1961. In this final stage of Relational Painting, Glarner introduces new, more complicated form and color relationships. New subdivisions of wedge-shapes and corresponding new color relations between new subdivided areas are added to those used in previous stages.

Two paintings produced during stage V are shown in figure 7.28. In each painting, the canvas is first divided in exactly the same way as in previous paintings – by rectangular divisions, oblique divisions, and by divisions of wedge-shapes at either their narrow or wide ends. Relation 1 between obliquely divided rectangles (figure 7.23) is the only relation used in these and all other stage V paintings. Further, new subdivisions of wedge-shapes are then made whenever two subdivided wedges have a particular spatial relationship. This relationship is different for wedge-shapes divided at their narrow ends than it is for wedge-shapes divided at their wide ends. Both of these relationships are depicted in figure 7.29a. In the relationship between wedges subdivided at their narrow ends, the border at the narrow end of one wedge meets at a right angle with the wide end of the other wedge. Similarly, in the relationship between wedges subdivided at their wide ends, the border at the wide end of one wedge meets at a right angle with the narrow end of the other wedge. Whenever two subdivided wedge-shapes have one of these relationships, then the wedge-shape whose border abuts the other wedge-shape is subdivided again by a cut parallel to the first subdivision. The exact placement of this second subdivision varies; in general, it is placed closer to the end where the first subdivision was made. Secondary subdivisions of wedge-shapes are illustrated in figure 7.29b.

The color relationships used for stage IV paintings are used for stage V paintings wherever they are still applicable. New color relationships are defined for those areas formed by the new secondary subdivisions of wedge-shapes. These color relationships

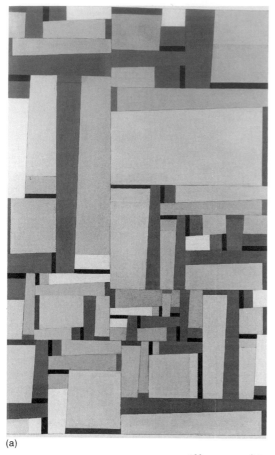

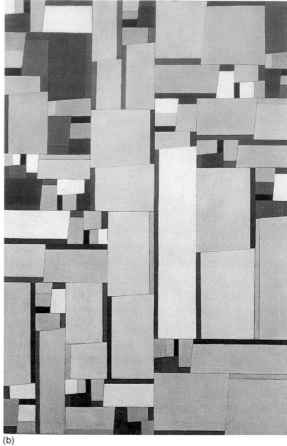

(a)

(b)

7.28
Stage V Glarner
paintings.
a. Fritz Glarner,
*Relational Painting No.
89,* 1961, Oil on canvas,
200.5 × 124.5 cm.
Courtesy, Sheldon
Memorial Art Gallery,
University of
Nebraska–Lincoln,
F. M. Hall Collection.
b. Fritz Glarner,
*Relational Painting No.
93,* 1962, Oil on canvas,
174.5 × 117 cm.
Courtesy,
Albright–Knox Gallery,
Buffalo, New York. Gift
of the Seymour H. Knox
Foundation, Inc., 1966.

are illustrated in figure 7.29c. The border that separates the two wedge-shapes in either of the relationships described above is painted black. The two areas separated by the black border are painted the same color. The remaining area formed by the secondary subdivision in one wedge-shape is painted any color. These restrictions on color relationships are used almost without exception in completed paintings. They are not used, however, in any of the preliminary color studies for paintings that were not completed. It is not clear whether Glarner intended to drop these restrictions in the final paintings or whether he intended to use them.

A grammar for stage V paintings is derived from the grammar for stage IV paintings by adding new rules for the new form and color relationships described above.

Rule addition: Rules 10, 11, and 12 for secondary subdivisions of wedge-shapes are added.

Rule 10 is a rule for changing states; it initiates application of either rule 11 or rule 12. Rule 11 applies to subdivide a wedge-shape previously subdivided at its wide end; rule 12 applies to subdivide a wedge-shape previously subdivided at its narrow end. The spatial label ● on the left-side of each rule identifies a wedge-

7.29
a. Relationships
between wedge-shapes
subdivided at their
narrow ends (left) and at
their wide ends (right). (a)
b. Secondary
subdivisions of
wedge-shapes that have
the spatial relationships
shown in a.
c. Color relationships
between areas formed
by the secondary (b)
subdivisions of
wedge-shapes shown
in b.

(c)

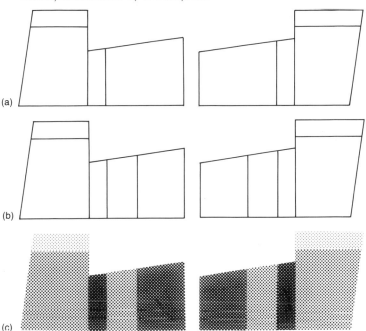

shape that, together with another wedge-shape, has one of the two
relationships shown in figure 7.29a. The spatial label | located on
the wide or narrow end of the wedge-shape on the right-side of
each rule identifies a wedge-shape with secondary subdivisions
and is used subsequently to define the color relationships shown
in figure 7.29c. The spatial label | located on the oblique side of
each wedge-shape is also used subsequently for coloring. This
label is located toward the narrow end of the wedge and not at the
midpoint of the oblique. If neither of the two wedge-shapes that
comprise a rectangle has secondary subdivisions, only one label |
(placed by rule 5) marks the oblique side shared by the wedge-
shapes; if one of the two wedge-shapes has secondary subdivi-
sions, two labels || mark the oblique; and, if both of the wedge-
shapes have secondary subdivisions, three labels ||| mark the
oblique. In both rules 11 and 12, subdivisions and dimensions of
wedge-shapes are allowed to vary as described above.

Color rules 20, 21, 22, 23, and 24 are also added.

Rules 20 and 21 define allowable color relationships between
the areas formed by secondary subdivisions. The label | may be
erased only when c_i = a primary color, grey, or white, c_j = black,
and c_k = a primary, color, grey, or white. (Restrictions on the color
c_i are not actually necessary in these rules; rule 25 prohibits c_i
from being black.)

Rules 22 and 23 define allowable colors for a wedge-shape that
forms a rectangle together with a wedge-shape with secondary
subdivisions. (If either of rules 11 or 12 applies to a wedge-shape,
rule 18 or 19 no longer defines colors for the adjacent wedge-
shape.) The labels || may be erased only if c_i = a primary color,

grey, or white. There are no restrictions on c_j. If both wedge-shapes that comprise a rectangle have secondary subdivisions, then rule 24 applies to erase the labels | | | that mark the oblique dividing the two wedge-shapes.

Rule deletion: Rule 15, which defines a relation between obliquely divided rectangles, is deleted.

Rule change: The state labels in rule 4 are changed to variable labels as shown. The final state is also changed as shown.

Rules 8 and 9 are changed by adding labeled circles to them. The labeled circles in these rules are used to find wedge-shapes that have the spatial relationships shown in figure 7.29a in the same way that they are used in rule 3 to find rectangles that form a larger rectangle. In rules 8 and 9, however, the sizes of circles are fixed. When either rule 8 or rule 9 is applied to subdivide a wedge-shape, two labeled circles are placed at fixed distances from two vertices of the wedge-shape. Whenever two subdivided wedge-shapes have one of the relationships in figure 7.29a, two circles coincide while the two labels associated with them remain separate. To erase labeled circles, rule 4 is applied as before, leaving a label ● to identify the wedge-shape that must be subdivided again by either rule 11 or rule 12.

A derivation of a design using the stage V grammar is given in figure 7.30. In this design, wedge-shapes are subdivided at their wide ends. A black and white illustration of the design is given in figure 7.31. Figure 7.31 also shows another design in the stage V language in which wedge-shapes are subdivided at their narrow ends.

Discussion

Although both Vantongerloo and Glarner worked within the *De Stijl* tradition and shared similar formal concerns with line and color relationships, the styles they developed and the ways they developed them are very different. Vantongerloo begins his abstract paintings in a style typical of early *De Stijl*. He breaks away slowly from the *De Stijl* rectangular format, first, with a special kind of rectangular division system, later, with the introduction of curved lines and, last, with the complete elimination of rectangular divisions. The composition of his paintings is progressively relaxed and less overtly structured. Each stage in this progression is marked by a very visible, pronounced transformation; the final break with *De Stijl* is decisive.

Glarner, on the other hand, begins his abstract paintings using styles derivative of early *De Stijl*. His first break with a rectangular format is made immediately with the introduction of oblique lines. Each stage in the progression away from this early style, however, is comprised of very modest and subtle

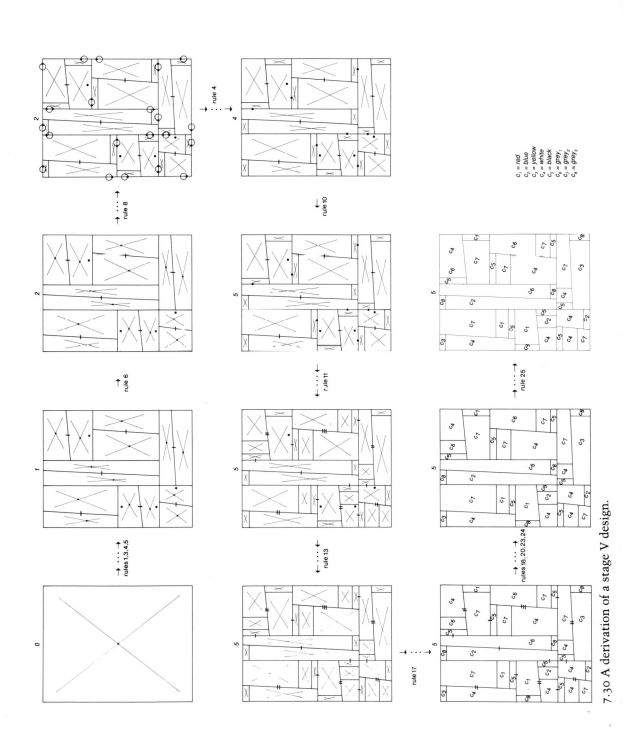

$c_1 = red$
$c_2 = blue$
$c_3 = yellow$
$c_4 = white$
$c_5 = black$
$c_6 = grey_1$
$c_7 = grey_2$
$c_8 = grey_3$

7.30 A derivation of a stage V design.

7.31
Stage I, II (or IV), III (or IV), and V designs. The derivations of the stage I, II, and V designs are shown in figures 7.24, 7.26, and 7.30, respectively.

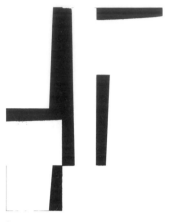

Stage I

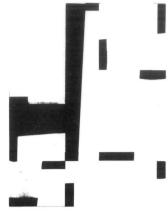

Stage II (IV)

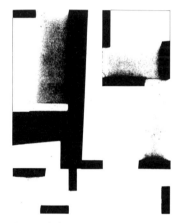

Stage III (IV)

Stage V

Stage V

transformations; the rectangular division system with which his early work began never disappears and is never changed. From the beginning, the composition of his paintings is more structured than the composition of Vantongerloo's paintings. And, instead of progressively loosening the format of paintings as Vantongerloo did, Glarner gradually gives more and more structure to them.

The differences between the development of Vantongerloo's paintings and the development of Glarner's paintings, as well as some general similarities, are most easily understood by simply observing the differences and similarities between the grammars and transformations used to characterize each artist's work. The very broad resemblances between Vantongerloo's paintings and Glarner's paintings that link the two artists to the same *De Stijl* origins are reflected in the similar kinds of rules in the Vantongerloo and Glarner grammars. During one stage or another, both the Vantongerloo grammars and Glarner grammars have rules for rectangular divisions, rules for other kinds of divisions (pinwheel divisions or oblique divisions), and rules for coloring divided areas (rectangular areas or wedge-shaped areas). The ways in which the Vantongerloo grammars and the Glarner grammars are transformed, however, are not alike. The Vantongerloo grammars are transformed, basically, by making substantial changes to existing rules and by deleting rules. Thus, the grammars for the later stages of Vantongerloo's paintings are simpler and have no rules in common with the grammars for earlier stages. The Glarner grammars, on the other hand, are transformed mostly by making small changes to existing rules and by adding new rules. The grammar for the final stage of Glarner's paintings is thus more complex but not totally unlike the grammars for earlier stages; it contains almost all of the same or similar rules of earlier grammars plus several new ones.

These contrasts between the evolution of Vantongerloo's paintings and the evolution of Glarner's paintings, both starting with roughly the same style, demonstrate very plainly how a single style can lead to a diversity of new and quite different ones.

8 The transformation of Frank Lloyd Wright's Prairie houses into his Usonian houses

Introduction

Frank Lloyd Wright is probably the best known American architect and certainly one of the most prolific architects of his time. Born in 1867, his architectural career spanned some seventy years – from 1889, when his first independent project was completed, to 1959, the year he died. Two of his most impressive series of works are the Prairie houses of his early career and the Usonian houses of his later career. While much has been written about these two very distinctive styles of architecture, formal studies of the designs of Prairie and Usonian houses are rare; analysis of composition is often subordinated to discussions of innovations in the use of materials and construction techniques.

Still less has been said about relationships between the design of Prairie houses and the design of Usonian houses. John Sergeant's spatial analysis of Usonian houses,[1] and his comparison of these houses with Prairie houses, draws on earlier analyses of Wright's work by Grant Manson[2] and by Richard MacCormac.[3] Manson was the first to look closely at the relationship between Wright's Froebel kindergarten education and his later architectural work. MacCormac carried the Froebel–Wright connection further by likening Wright's Prairie and other early houses to the disciplined play of Froebel blocks within rectilinear grids – an activity that Wright was instructed in as a child. Sergeant's subsequent analysis, like that of MacCormac, focuses on the role of the grid, not only in Wright's Prairie designs, but in his later Usonians as well. However, much is left unsaid about other, very basic aspects of composition, for example, the spatial relationships between the various building elements that occupy grids. Sergeant's exploration of relationships between Prairie and Usonian houses is insightful yet relatively informal; Usonian

houses are described as a simplification and loosening of the planning grids of Prairie houses.

In this study, Wright's Prairie architecture, his Usonian architecture, and relationships between these two styles are approached in a different and fundamental way. Prairie houses and Usonian houses are characterized in terms of shape grammars. Usonian houses are further characterized as transformations of Prairie houses by showing how a grammar for Prairie designs can be transformed straightforwardly into a grammar for Usonian designs. Basic, but largely unrecognized, continuities from the design of Prairie houses to the design of Usonian houses are discussed.

From butterflies to polliwogs: the language of the Prairie transformed

Wright's Prairie houses have often been described as cruciform or butterfly-shaped in plan. Figure 8.1 shows the main floor and the upper, bedroom floor plans of five of these houses: the Henderson (1901), Willets (1902), Roberts (1908), Baker (1909), and Robie (1909) houses. A shape grammar that defines a language of these and other Prairie-style houses has been given in a very elucidating and original study of the Prairie style by Hank Koning and Julie Eizenberg.[4] Based on Wright's compositional theories and produced works, Koning and Eizenberg's grammar generates Prairie houses in three dimensions. Only the most essential aspects of the designs of these houses are considered; many details considered superficial are ignored.

Prairie designs are generated by the Koning and Eizenberg grammar in two stages. First, basic compositional forms are defined with *basic composition rules*. Second, basic compositional forms are elaborated and ornamented in various ways with *ornamentation rules* to produce complete designs.

Basic compositional forms represent the main level of a house and are built up in terms of simple spatial relations between three-dimensional Froebel-type blocks. These blocks correspond to the basic volumetric spaces of Prairie houses. The dimensions of the blocks can vary to correspond to dimensional differences of spaces in different houses. Blocks are distinguished functionally as either living zones or service zones. Living zones include living rooms, dining rooms, libraries, and so on. Service zones include kitchens, servants' quarters, main floor bedrooms, and so on. The generation of a basic compositional form begins with basic composition rules for locating a fireplace, considered by Wright to be the focal point of a Prairie design. A living zone is then added in relation to the fireplace and a service zone added in relation to the living zone to form the rectangular *core unit* of a Prairie design. To complete a basic composition, the core unit is extended by adding

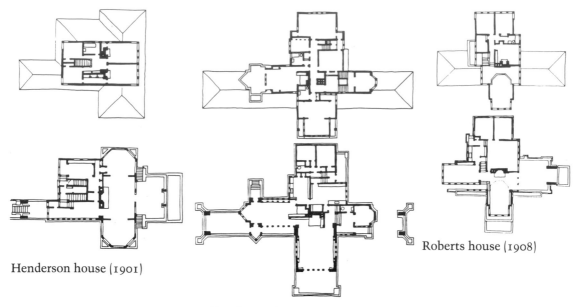

Henderson house (1901)

Willets house (1902)

Roberts house (1908)

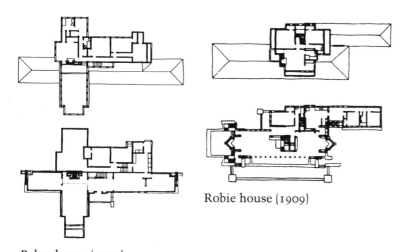

Robie house (1909)

Baker house (1909)

8.1

The plans of five Prairie houses designed by Wright. Both the main floor and the upper, bedroom floor plans are shown.

smaller living and service zones (the wings of the butterfly) to it. Ornamentation rules then apply to articulate and elaborate basic compositional forms by adding upper stories, basements, roofs, porches, terraces, and other interior and exterior details.

The Koning and Eizenberg grammar contains ninety-nine rules. Basic composition rules apply to produce eighty-nine different basic compositional forms; these can be ornamented in various ways to produce over two-hundred final designs. Figure 8.2 shows a simplified derivation of a Prairie house design using the

grammar. Only the main stages of the derivation are shown; labels have been omitted. Grey tones, however, are used informally here as labels; each different grey tone denotes a different function – dark grey corresponds to upper level bedrooms, medium grey to living areas, light grey to service areas, and very light grey to porches. In the first four steps of the derivation, a basic compositional form is generated. In the last four steps, the basic form is ornamented by adding porches, a basement, a second story, and a roof. The final design of the derivation – the "Stiny" house – is not an original Wright design, but a new design in the Prairie style. In figure 2.2 of chapter 2, the designs of three other houses generated by the grammar are illustrated. Two of the houses – the Little and the Robie houses – are Wright designs; one – the "March" house – is new. The upper level, main level, and exterior form of each house are shown. Detailed floor plans, not generated by the grammar, are also illustrated.

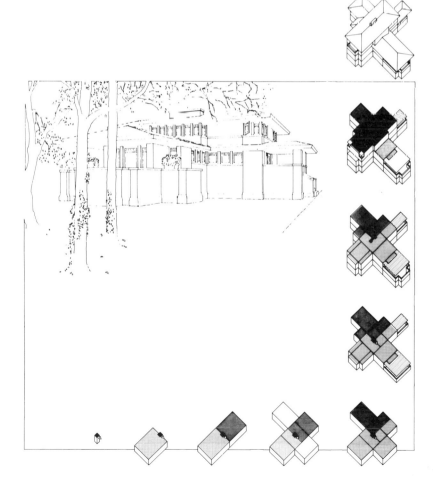

8.2

The main stages of the derivation of a new Prairie-style house (the "Stiny" house) using the Koning and Eizenberg shape grammar. A more detailed rendering of the exterior of the house is also shown. Drawing, courtesy of Hank Koning and Julie Eizenberg.

The basic compositions of Prairie houses provide the basis for the basic compositions of the later Usonian houses, in particular the L-shaped or, what Wright called *polliwog* (tadpole), designs typical of this style. Like the basic composition of a Prairie house, the basic composition of a polliwog Usonian consists of a two-zone core unit. One zone of the core unit is an open-plan living zone or *body* that incorporates living, kitchen, and dining areas; the other zone is a bedroom zone or *tail* that includes bedrooms and bathrooms. The core unit is sometimes extended by adding smaller living or bedroom zones to the body or tail. The logical center of a Usonian design is a small area located in the hinge of the L-plan which Wright termed the *work space*. Analogous to the central fireplace of a Prairie house, the work space is always contained within the living zone and consists of a kitchen area with an adjacent fireplace facing out toward the living room. Designs of Usonian houses are completed by ornamenting and articulating basic compositions in a variety of ways. Unlike the Prairie houses, however, many Usonians are only one level. In the words of Wright, Usonian designs are summarized thus:

A Usonian house if built for a young couple, can, without deformity, be expanded, later, for the needs of a growing family. As you can see from the plans, Usonian houses are shaped like polliwogs – a house with a shorter or longer tail. The body of the polliwog is the living room and the adjoining kitchen – or work space – and the whole Usonian concentration of conveniences. From there it starts out, with a tail: in the proper direction, say, one bedroom, two bedrooms, three, four, five, six bedrooms long ... The size of the polliwog's tail depends on the number of children and the size of the family budget.[5]

Figure 8.3 shows the plans of six, one-level polliwog Usonians: the Jacobs (1936), Lusk (1936), Rosenbaum (1939), Newman (1939), Garrison (1939), and Pope (1940) houses.

The differences between Prairie and Usonian houses are, to a certain extent, reflections of changes in living standards between the times in which they were built – Prairie houses during the early 1900s and Usonian houses during the years before and after World War II. The Usonian house was conceived partially in response to the urgent need for low-cost housing during the thirties. Hence, the core unit of a Prairie house which formed only a part of an expanded design became, in the case of many Usonians, the whole of a design. Extensions to the core unit of a Usonian house were the exception, for larger or more affluent families, rather than the rule. Since servants were no longer a common fixture of households, the kitchen, which was segregated from the living and social areas in a Prairie house, became integrated into the living area of a Usonian. A host or hostess could cook as well as entertain and socialize from this new, centralized work space. The adjacent fireplace, however, remained a focal point of a design.

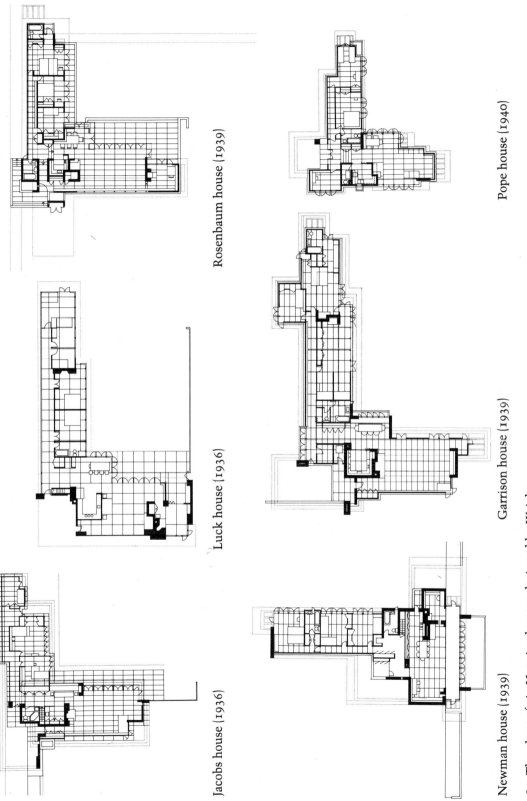

Rosenbaum house (1939)

Pope house (1940)

Luck house (1936)

Garrison house (1939)

Jacobs house (1936)

Newman house (1939)

8.3 The plans of six Usonian houses designed by Wright.

The design of Wright's Usonian houses and the design of his earlier Prairie houses can be described with the two shape grammars illustrated in figure 8.4. The Prairie grammar is taken from Koning and Eizenberg's grammar. The Usonian grammar is new. The initial shape, rules, and final state of each grammar are separated into basic composition rules and ornamentation rules. Basic composition rules and ornamentation rules are further subdivided into categories of rules with more specific compositional functions. Rules in the Prairie grammar and rules in the Usonian grammar that are identical or have corresponding compositional functions are shown in the same row. When a rule in the Prairie grammar corresponds to more than one rule in the Usonian grammar, they are connected by lines as shown.

The Prairie grammar

The Prairie grammar is a simplified version of Koning and Eizenberg's earlier grammar. Rules from the Koning and Eizenberg grammar have been translated into the standard format for shape grammars described in chapter 3. Only those rules that have counterparts in the Usonian grammar are given. These include translations of most of the basic composition rules from Koning and Eizenberg's grammar but none of the ornamentation rules. Readers may refer to Koning and Eizenberg's grammar for omitted basic composition rules (these include, for example, rules for beginning a design with a double-hearth fireplace and rules that allow different zones in a design to interpenetrate one another) and for ornamentation rules. The basic composition rules that are included here generate a few new possibilities for basic compositions not generated by Koning and Eizenberg's rules. These new basic compositions are allowed since they appear to satisfy the same stylistic criteria satisfied by other basic compositions.

The Prairie grammar shown here, like Koning and Eizenberg's grammar, is a parametric shape grammar. The lengths and widths of blocks in the rules are allowed to vary so that designs of different dimensions can be generated. For example, the length of the longer side of a living or service zone block that forms a part of the core unit in a basic composition can vary between one to four times the length of the adjacent side. The height of a core unit block, however, is fixed. The living and service zone blocks added to a core unit to extend a basic composition must each be smaller than the core unit but not less than one-quarter of its size.

The functions of different zones in a Prairie design are indicated by different grey tones as in the Koning and Eizenberg grammar. A light grey tone indicates a living zone; a medium grey tone indicates a service zone.

The initial shape of the Prairie grammar consists of a fireplace in a state 0. Rules 1 through 8 depict all possible ways of placing a

8.4

A shape grammar that generates Prairie houses and a shape grammar that generates Usonian houses.

Transformations in design

BASIC COMPOSITION RULES

9:

10:

11:

12:

completing the
core unit: adding
a service zone
(Prairie rules) or
a bedroom zone
(Usonian rules) 13:

14:

obligatory
extensions 15:
(Prairie rules) or
optional extensions
(Usonian rules)
to the core unit 16:

8.4 continued



BASIC COMPOSITION RULES

PRAIRIE GRAMMAR USONIAN GRAMMAR

17:

18:

19:

20:

21:

22:

23:

extensions (con't) 24:

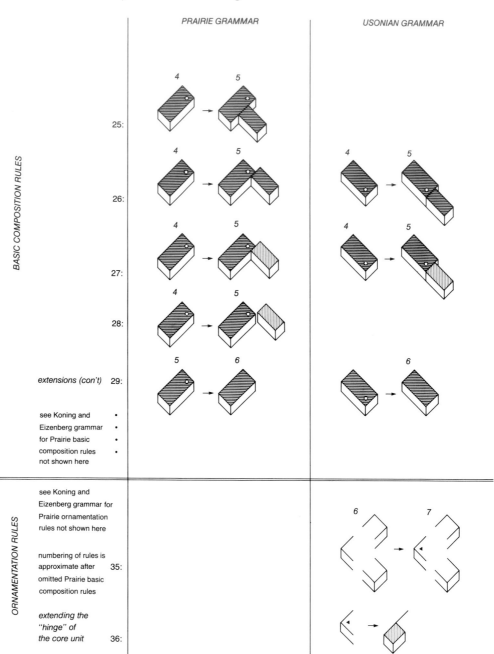

PRAIRIE GRAMMAR

USONIAN GRAMMAR

BASIC COMPOSITION RULES

25:

26:

27:

28:

extensions (con't) 29:

see Koning and •
Eizenberg grammar •
for Prairie basic •
composition rules •
not shown here

ORNAMENTATION RULES

see Koning and
Eizenberg grammar for
Prairie ornamentation
rules not shown here

numbering of rules is
approximate after 35:
omitted Prairie basic
composition rules

extending the
"hinge" of
the core unit 36:

8.4 continued

ORNAMENTATION RULES

37:

38:

39:

40:

41:

42:

43:

*interpenetrating
zones* 44:

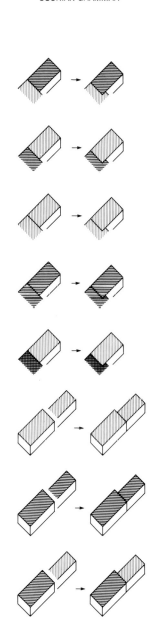

PRAIRIE GRAMMAR *USONIAN GRAMMAR*

ORNAMENTATION RULES

more extensions

adding secondary fireplaces

8.4 continued · living zone in relation to the fireplace. The spatial labels ● and ○ marking the corners of living zones are used subsequently to distinguish different ways of adding other zones to a living zone.

Rules 9 and 10 specify the two ways that a service zone can be added to a living zone to form the rectangular core unit of a Prairie

		PRAIRIE GRAMMAR	USONIAN GRAMMAR
ORNAMENTATION RULES	56:		
	57:		
inflecting exterior corners	58:		
final state	F:	$q \geq 6$	$q \geq 6$

design. In rule 9, a service zone is added to the longer side of a living zone; in rule 10, a service zone is added to the shorter side of a living zone. The labels ● and ○ distinguish these two different relationships between the living and service zone of a core unit.

Extensions to the core unit are obligatory. These are determined by rules 14 through 29. Rules in this group add smaller living and service zones to the living and service zones of the core unit. Rules 14, 15, 22, and 23, define all possible ways of adding a smaller living zone to the living zone of a core unit; rules 17 through 20 and rules 25 through 28 define all possible ways of adding either a smaller service zone or a smaller living zone to the service zone of a core unit. The labels ● and ○ control the placements of extensions to the two possible configurations of living and service zones forming a core unit. Rules 16, 21, 24, and 29 erase the labels ● and ○ associated with living and service zones after these zones have been extended. Applications of extension rules are ordered by state labels so that extensions to both the living and service zones of the core unit are obligatory.

The final state of the grammar is variable; it may be any state greater than or equal to 6.[6]

Figure 8.5a shows how the basic composition rules of the Prairie grammar apply to derive the basic compositional form of Wright's Robie house. Figure 8.5b shows two other basic compositions generated by these rules. One is the basic compositional form of the Roberts house; the other is the basic compositional form of the Henderson, Willets, and Baker houses.

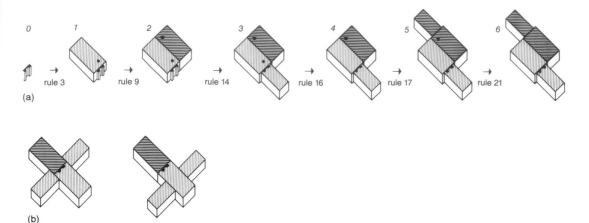

(a)

(b)

The transformation of the Prairie grammar

8.5
a. A derivation of the basic composition of the Robie house.
b. The basic composition of the Roberts house (left) and the basic composition of the Henderson, Willets, and Baker houses (right).

The shape grammar for Prairie houses can be transformed into a shape grammar for polliwog Usonians, as well as other new grammars, by deleting, changing, and adding rules. In the transformation, all of the Prairie ornamentation rules and some of the Prairie basic composition rules are deleted, the remaining Prairie basic composition rules are changed, and new, Usonian ornamentation rules are added. Of the three grammatical transformations, rule change illustrates most strikingly the close relationship between Prairie and Usonian designs.

Rule deletion: Prairie basic composition rules 1, 3, 4, 6, 8, 14, 17, 20, 22, 25, 28, and all other basic composition and ornamentation rules from the Koning and Eizenberg grammar, not given here, are deleted.

Rule change: The remaining Prairie basic composition rules are changed by changing the spatial relations and labels that define these rules. Changes to spatial relations and labels are as follows:

Spatial relations

Between a fireplace and a living zone (rules 2, 5, 7): These spatial relations are changed by both repositioning shapes and introducing new shapes. The fireplace is moved from the border of a living zone into the interior of a living zone and, at the same time, is changed into a fireplace/kitchen or work space.

Between a living zone and a service zone in a core unit (rules 9, 10): These rectangular, core unit spatial relations are changed into L-shaped and other new kinds of core units by repositioning shapes. New core units are produced by rotating 90° either a living or service zone in either of the two types of rectangular Prairie core units. This change is the most prominent compositional change in the transformation of Prairie designs into Usonian

designs and is closely related to the change in state labels described below. Changing the rectangular core unit of a Prairie house into an L-shape allows extensions to be added to it optionally, that is, to one, both, or neither of the zones in it, without disturbing the integrity of the plan ("without deformity," as Wright said). Any extension to an L-shaped core unit simply elongates either the body or the tail of the polliwog. Optional extensions to a rectangular core unit, on the other hand, would produce a lopsided, unbalanced plan whenever only one zone is extended – a plan analogous in form to a butterfly with only one wing.

In addition to the change in location, the service zone in a Prairie core unit, which may include bedrooms and bathrooms, changes functionally to become a bedroom zone in a Usonian core unit, which includes only bedrooms and bathrooms.

Between a zone in a core unit and an extension (rules 15, 18, 19, 23, 26, 27): These spatial relations are changed by repositioning shapes. Extensions are repositioned so that core unit zones and extensions are always aligned along their longer sides.[7]

The spatial relation changes outlined above are illustrated in figure 8.6. Spatial relations are numbered to correspond to the basic composition rules they define. The change rules that transform Prairie spatial relations into Usonian spatial relations are also shown. The new Usonian spatial relations are used to define the new Usonian basic composition rules depicted in figure 8.4. The change rules shown can also apply to Prairie spatial relations to produce new spatial relations other than the Usonian spatial relations illustrated. These other spatial relations define other new rules, leading to other new grammars. Other spatial relations are discussed in the following section.

Spatial labels: In conjunction with the spatial relation changes described above, the spatial labels ● and ○ marking the corners of core unit zones are changed as shown in the new Usonian basic composition rules illustrated in figure 8.4. As in the Prairie grammar, these labels distinguish different ways that zones may be added to core unit zones.

State labels: The state labels associated with extension rules 16, 21, 24, and 29 of the Prairie grammar are changed as shown in the new Usonian grammar. These changes make the application of extension rules optional rather than obligatory.

Rule addition: New ornamentation rules (rules 35 through 58 in figure 8.4) are added. These rules are described in the next section.

Rule deletion, rule change, and rule addition apply to the Prairie grammar to produce a family of new grammars. Included in the family is a grammar that defines a language of polliwog Usonian houses. This is the grammar shown in figure 8.4.

2:

5:

7:

changing the spatial relation between a fireplace and a living zone

9:

10:

11:

12:

13:

changing the spatial relation between a living zone and a service zone in a core unit

Prairie spatial relations *change rules* *Usonian spatial relations*

8.6 Changing Prairie spatial relations into Usonian spatial relations.

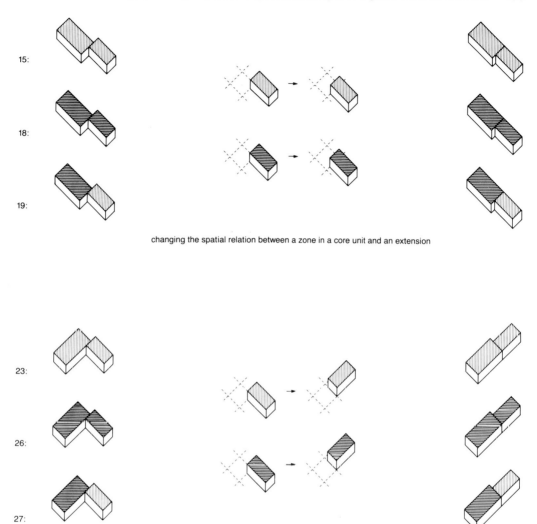

changing the spatial relation between a zone in a core unit and an extension

changing the spatial relation between a zone in a core unit and an extension

Prairie spatial relations

change rules

Usonian spatial relations

The Usonian grammar

Although the outward appearance and spatial organization of Usonian houses seems substantially different from that of the Prairie houses, the underlying composition of Usonian designs is closely related to that of Prairie designs. Parallels between these two styles are reflected in analogous rules of composition in the Usonian and Prairie grammars.

In the Usonian grammar, as in the Prairie grammar, designs are generated by first defining basic compositional forms and then ornamenting these forms to produce complete designs. The generation of a Usonian basic composition begins with a fireplace/kitchen or work space – the initial shape of the grammar. A living zone is then placed in relation to the work space in any one of the three ways specified by rules 2, 5, and 7. The work space is always located in the upper half of a living zone; the fireplace is always parallel to a side of the living zone. The spatial labels ● and ○ marking the corners of living zones are used subsequently to distinguish different ways of adding other zones to a living zone. The core unit of a Usonian design is completed by adding a bedroom zone, containing from one to three bedrooms and all bathrooms, to the living zone. Rules 9 through 13 specify the five different ways an L-shaped Usonian core unit can be formed.

Optional extensions to the core unit are determined by rules 15, 16, 18, 19, 21, 23, 24, 26, 27, and 29. Application of either rule 15 or 23 adds a smaller living zone to the living zone of a core unit. This small living zone extension is used as either a workshop or a study. Application of one of rules 18, 19, 26, or 27 adds a smaller bedroom zone or a smaller living zone to the bedroom zone of a core unit. The small bedroom zone extension includes one or two additional bedrooms and possibly a bathroom. The small living zone extension is used as a workshop or a study and is sometimes converted into a bedroom. The labels ● and ○ in rules 15, 18, 19, 23, 26, and 27 control the placement of extensions. Rules 16, 21, 24, and 29 apply to erase the labels ● and ○. Because the left-sides of these rules have no state labels, the rules can be applied to a design in any state; that is, to designs with core unit extensions (in states 3 or 5) or without core unit extensions (in states 2 or 4). Applications of extension rules are thus ordered by state labels so that extensions to a Usonian core unit are optional rather than obligatory as they are for Prairie core units.

The basic composition rules of the Usonian grammar apply to derive basic compositional forms in much the same way that the basic composition rules of the Prairie grammar apply to derive basic compositional forms. In particular, the recursive structure of the Usonian basic composition rules is isomorphic to the

recursive structure of the Prairie rules from which they are derived. Thus, despite differences in the spatial relations and the labels that define Prairie and Usonian basic composition rules, the ways Prairie basic compositions and Usonian basic compositions are generated are equivalent.

Figure 8.7 gives a catalogue of all the different basic compositional forms that can be generated by the Usonian basic composition rules. The dimensions of each of these forms can be varied to determine forms with different proportions in the same ways that the dimensions of Prairie basic compositional forms can be varied (see p. 224). Included in the catalogue are the basic compositions of the Usonian houses illustrated in figure 8.3. These are identified by name. All other basic compositions are new.

A line between a living zone and a bedroom zone in a basic composition as illustrated in figure 8.7 approximates either a real or implied boundary between spaces used for different purposes; in other words, it does not necessarily correspond to an actual wall or partition. A line between a living or bedroom zone and its extension frequently does correspond to a physical boundary such as a wall, partition, or secondary fireplace.

When the living zone and bedroom zone in a core unit overlap, as in basic compositions 1 through 6, then a part of the living zone and a part of the bedroom zone are contained within the same space in the hinge of the plan. In the Rosenbaum house, for example, both the kitchen and master bathroom are contained in this area. When the living zone and bedroom zone are separated as in basic compositions 13 through 18, 25 through 30, 37 through 42, and 49 through 54, then the intervening space could be either a courtyard, terrace, or other open or semi-enclosed space. For example, in Wright's Adelman house of 1953 – a Usonian house close in plan to Wright's L-shaped Usonians shown here – two separate areas of the house are linked by an outdoor terrace.

Usonian basic compositional forms are developed further with ornamentation rules 35 through 58 in the Usonian grammar. All of these rules are optional and are analogous in purpose, but not in form, to ornamentation rules in the Prairie grammar. Although Prairie houses and Usonian houses are closely related in basic compositional form, their designs rapidly diverge with further embellishments.[8]

Rules 35 and 36 apply to add a living zone, used as either a workshop or a study, to the hinge of an L-plan. Because the state of a design changes when rule 35 is applied, the rule can be applied only once. The area of the space added by rule 36 may vary between one-quarter to one-half the area of the living or bedroom zone in the core unit. The length of any side of this space may vary between one to two times that of the adjacent side.

Rules 37 through 41 each apply to interpenetrate one zone in a

Transformations in design

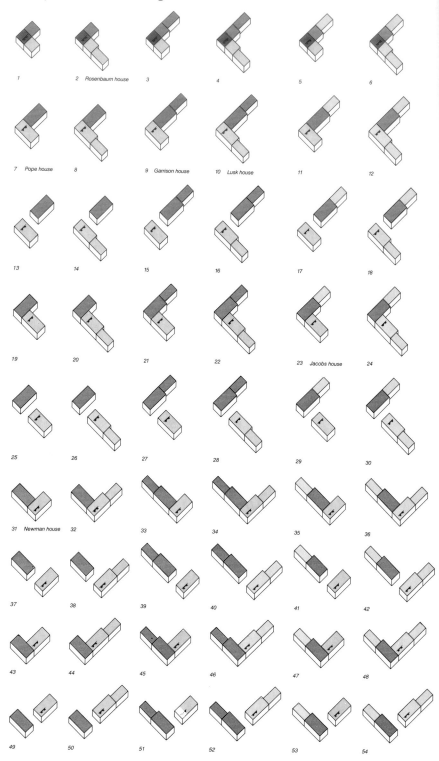

1

2　Rosenbaum house

3

4

5

6

7　Pope house

8

9　Garrison house

10　Lusk house

11

12

13

14

15

16

17

18

19

20

21

22

23　Jacobs house

24

25

26

27

28

29

30

31　Newman house

32

33

34

35

36

37

38

39

40

41

42

43

44

45

46

47

48

49

50

51

52

53

54

8.7 Usonian basic compositions.

design with another zone. The depth of interpenetration is always less than one-third the length of the interpenetrating zone. If any one of these rules is applied to interpenetrate a zone of a core unit with another zone of the core unit, then one of rules 42, 43, or 44 can be applied to reattach an extension to the interpenetrating zone.

Rules 45 through 48 add spaces to extensions. In rule 45, the larger space is a zone of a core unit and the smaller space is an extension. The label ▼ marks a side of an extension as shown. Because the state of a design changes when rule 45 is applied, the rule can be applied only once. In rules 46, 47, and 48, the area of the added space may vary between one to one-half the area of the extension it adjoins. The length of any one of its sides may vary between one to two times that of the adjacent side. Notice that a bedroom zone can never be added to a living zone.

Secondary fireplaces may be added to designs with extensions by applying rules 49 through 55. In rule 49, the larger space is a zone of a core unit and the smaller space is an extension. The label ◆ can be placed anywhere along the line that separates a core unit zone and its extension, but not at its endpoints. The extension may or may not interpenetrate the adjoining zone. Rule 50 replaces the label ◆ with a single-hearth fireplace; rule 51 replaces the label ◆ with a single-hearth fireplace in a corner of a zone. Rules 52 through 55 create different double-hearth fireplaces from single-hearth fireplaces. Whenever a fireplace is added, the line or lines it overlaps are erased thus preventing fireplace rules from being reapplied in the same place.

Finally, rules 56, 57, and 58 each apply to cut off or inflect an exterior corner of any zone in a design. The dimensions of the inflection can vary. The total area of inflections to a zone cannot be greater than one third the original area of the zone. These rules apply recursively to produce the interior alcoves and niches and undulating exterior facades characteristic of polliwog Usonians.

The final state of the Usonian grammar is variable; it may be any state greater than or equal to 6.

A design is in the language generated by the Usonian grammar whenever it meets the usual provisos and whenever all areas in a design distinguished by grey tones are completely bounded by lines. This latter, supplementary proviso ensures that designs generated by inappropriate applications of some of the ornamentation rules are not included in the language.

In figure 8.8, a derivation of Wright's Garrison house is illustrated. Basic composition rules apply in the first five steps to generate a basic compositional form. Ornamentation rules are then applied to produce the final design. The final designs for the Jacobs, Lusk, Newman, Rosenbaum, and Pope houses, produced by applying ornamentation rules to appropriately dimensioned basic compositions, are illustrated in figure 8.9.

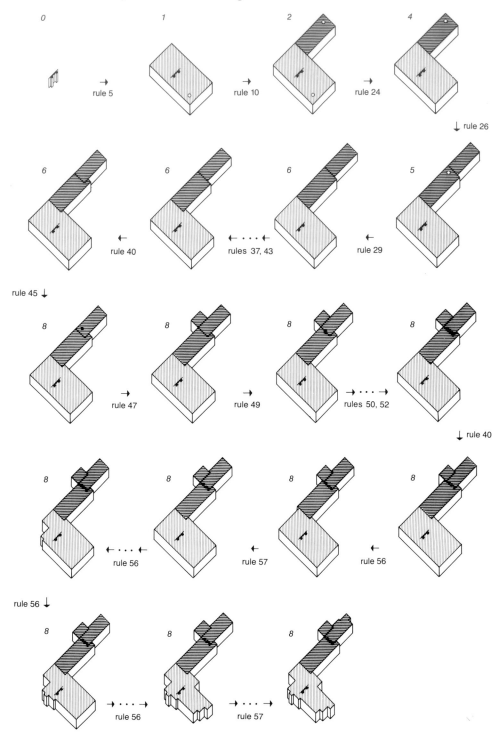

8.8 A derivation of the Garrison house.

8.9

The final designs of the
Jacobs, Lusk, Newman,
Rosenbaum, and Pope
houses.

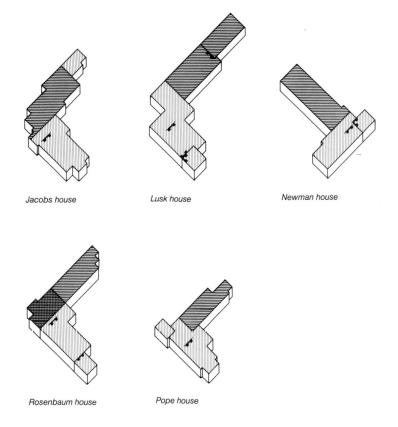

Jacobs house Lusk house Newman house

Rosenbaum house Pope house

The Usonian grammar is only one of several grammars pro-
duced in the transformation of the Prairie grammar. Because the
change rules illustrated in figure 8.6 determine new spatial rela-
tions other than the ones shown, other new rules can be defined
for other new grammars. For example, the two change rules that
apply to the rectangular core unit of a Prairie design can apply to
produce new spatial relations other than the L-shaped relations
shown in figure 8.6. Figure 8.10 shows some of the other possible
spatial relations that result from different applications of these
two change rules. Each spatial relation is produced by rotating
both the living and service zone in a Prairie core unit, rather than
just one of these zones as in figure 8.6. Spatial relation 1 corres-
ponds to some of Wright's early one-zone Usonians; spatial rela-
tion 2 corresponds roughly to what Sergeant calls an "in-line
Usonian."[9] Other spatial relations can be considered the bases for
completely new Usonian or other style compositions.

8.10

Other spatial relations
between living and
bedroom zones in a core
unit that result from
different applications of
the change rules shown
in figure 8.6

Discussion

This study illustrates again how the formal model described in Part II can be used to elucidate changes in styles. Wright's Prairie style is described very easily in terms of rules based on spatial relations between block-like shapes. His later Usonian style is described as a transformation of Prairie rules. Central to this transformation are the changes in the spatial relations and the ordering of rules for the basic composition of Prairie designs. These changes are unexpectedly simple yet they have very sophisticated consequences – they are the basis for rules for a distinctly different style.

The way that the spatial relations for Prairie designs are changed into spatial relations for Usonian designs illustrates one of the ways for changing spatial relations discussed in chapter 5. The shapes in each spatial relation for a Prairie basic composition are simply rearranged to produce a Usonian spatial relation; no new shapes (except for the work space) are introduced. Recall however, that Wright's stylistic innovations also included the introduction of new shapes. (See figure 5.8a and pp. 88, 91). The plans of three houses Wright designed around the same time as the Usonians discussed here – the "Life," Jester, and Sundt houses – have distinct stylistic characters. The stylistic differences between these houses, though, are essentially the result of introducing new shapes into a fixed arrangement of shapes.

Descriptions of styles and stylistic changes are always interest relative, and are biased in the way some aspects of styles are highlighted while others are ignored. Certainly, Koning and Eizenberg's characterization of Wright's Prairie houses as arrangements of blocks around a central fireplace is very unique. Nonetheless, it is compelling. This characterization is perhaps even more plausible now since it can be shown how block arrangements for Prairie houses are easily transformed into block arrangements for Usonian houses. It would be interesting to see if the very different, earlier analyses of Prairie houses as projections of two-dimensional planning grids could be placed as firmly and explicitly in the tradition of Wright's other work.

Postscript

The three case studies of Part III bring up important, but not often discussed, issues regarding the limitations and potentials of shape grammars and grammatical transformations in studying individual styles and stylistic change.

Any analysis of a style with a shape grammar is a theory – a particular, retrospective view – of the designs in that style. That view may or may not have anything to do with the way those designs were originally conceived or with the process by which they were made. When dealing with historical material and limited supporting information, it is often impossible to know whether a shape grammar corresponds to historical fact. Even with contemporary material and a living designer, it may still be difficult to know definitively whether a grammar corresponds to the designer's own conception of his or her designs. Designers are not always willing or able to recount the true origins and methods of their work. Any analysis of a stylistic change using grammatical transformations has the same kind of uncertainties.

Yet, the purpose of most grammars developed thus far has not been to describe or even to conjecture about the historical genesis and actual making of designs, but simply to describe the designs themselves. The more compelling the grammar, the more it would seem likely that the grammar corresponds to historical reality, but there is usually no presumption and certainly no guarantee that it does. Without a definite historical or cognitive basis, however, the relevance of shape grammars to historians and designers is no less significant. A convincing description of a style with a shape grammar points to the existence of some sort and some degree of structure (including, possibly, a lack of structure) underlying designs in that style. Similarly, the description of a change in style with grammatical transformations points to the existence of some kind of structure underlying that change.

Whether or not a shape grammar matches the original thoughts or activities of a designer, the grammar demonstrates, at the very least, that those thoughts or activities (whatever they may have been) led to designs with the particular properties described by the grammar. At the very most, the grammar may suggest, by its simplicity or intuitiveness, that the designer's original thoughts or activities were the same or equivalent in structure to the structure manifested by the grammar. For example, ancient Greek potters may not have worked by the rules exactly as defined in chapter 6, but may have used a similar or equally systematic approach in order to produce designs with the simple regularities revealed by the grammars. Any claim stronger than this suggestion, however, could probably not be proven.

Nonetheless, even if a grammar is completely "false" from an historical point of view, the grammar may be just as accurate in the classification of works chronologically or geographically and the prediction of unknown, missing, or new works – and, in this sense, of equivalent value – as a grammar that is historically "true." For designers, the historical truth of a grammar or grammatical transformations may be irrelevant. The knowledge gained about designs with a grammar or transformations can suggest many new creative strategies and ideas that can be employed in future design work, regardless of historical facts.

Another issue concerning the limits of shape grammars is raised by this study. Here, the examination of style and stylistic change is restricted to the study of form and, within the framework of grammars, to the study of one particular aspect of form and one particular representation of form. To what extent can other dimensions of form, and more generally, of style and change, be explored with the kind of formal rigor applied in the work here? Recent and ongoing research suggests that the bounds on what is possible to represent, describe, and know formally – in particular, with grammars – are broader than might be supposed.

For example, shape grammars as originally conceived represent form in only one way, that is, with lines. Although line representations of form are common and traditional, other ways of representing form are equally valid, even cultivated within various movements in the history of art and architecture. Whereas lines enjoyed a special status during the Renaissance, planes were promoted by *De Stijl* artists and architects, and solid volumes by the modern movement in architecture. In a 1991 paper, George Stiny described an important generalization of shape grammars in which designs can be described using any of these different representations.[1] The representations that can be encoded in the rules of a shape grammar are chosen from a hierarchy of spatial elements used alone or in combination with one another: *points* in two or three dimensions, *lines* in two or three dimensions, *planes* in two or three dimensions, and *solids* in three dimensions.

Related to this work is an earlier, 1989 paper in which the representation of aspects of form, other than purely spatial ones, is addressed. In this paper by the author, the shape grammar formalism is extended to include the representation of *qualities* of form such as color, texture, material, function, and so on.[2] With this extended formalism, designs are described with rules made up of different pictorial elements used alone or in combination with one another: lines in two or three dimensions (as in standard shape grammars), colored (or other quality-defined) planes in two or three dimensions, and colored (or other quality-defined) solids in three dimensions.

A still broader generalization of shape grammars was discussed in chapter 2. Description grammars or schemes allow designs to be described in nonpictorial, verbal ways as well as pictorial ways. With description schemes, meanings and determinants of style and stylistic change that may be addressed more appropriately with words, can be treated with the same formal clarity used here to treat spatial form.

The study of style and stylistic change is undeniably complex and difficult. More work is needed to realize the full promise of the formal systems proposed in this book and in the research described above. Yet, even in the work done so far, many of the varying concerns and ideas about style and change are beginning to be brought together more clearly; new and exciting ways of thinking about these ideas are being made possible.

Notes

Preface

1 G. Stiny and W. J. Mitchell, "The Palladian grammar," *'Environment and Planning B* 5 (1978): p. 17.

1 Style and stylistic change: the tradition

1 A. L. Kroeber, *Style and Civilizations* (Los Angeles and Berkeley, 1963).
2 T. Kuhn, *The Structure of Scientific Revolutions*, 2nd edn (Chicago, 1970).
3 N. Goodman, "The Status of Style," *Critical Inquiry* 1 (1975): 807.
4 H. Wölfflin, *Principles of Art History*, trans. M. D. Hottinger (New York, 1940), p. 11. First published in 1915.
5 B. Croce, "Pure Intuition and the Lyrical Character of Art," lecture, Third International Congress of Philosophy, Heidelberg, 1908; translated by D. Ainslie in B. Croce, *Aesthetic* (London, 1909), p. 394. See also B. Croce, *Aesthetic*, trans. D. Ainslie (Boston, 1978), pp. 12–21.
6 Croce, *Aesthetic* (1978), pp. 35–38.
7 A. Huxley, "A Night in Pietramala," in A. Huxley, *Along the Road* (New York, 1925), p. 230. Quoted in T. Munro, "Do the Arts Progress?" *Journal of Aesthetics and Art Criticism* 14, 2 (1955): 186.
8 Much of the discussion in this section follows E. Gombrich's etymology of the term *style* (p. 354) in his authoritative essay "Style," in the *International Encyclopedia of the Social Sciences*, vol. 15 (New York, 1968), pp. 352–361.
9 G. Vasari, *Lives of Seventy of the Most Eminent Painters, Sculptors, and Architects*, edited and annotated by E. H. and E. W. Blashfield and A. A. Hopkins, 4 vols. (New York, 1927). First published in 1550.
10 J. J. Winckelmann, *History of Ancient Art*, 4 vols. (Boston, 1880). First published in 1755.
11 The following discussion of theories of style and stylistic change is based in parts on a number of important works on this topic including

J. S. Ackerman, "Style," in J. S. Ackerman and R. Carpenter, *Art and Archaeology* (New Jersey, 1963), pp. 164–186; Gombrich, "Style"; E. Gombrich, *The Sense of Order* (Oxford, 1979), pp. 180–286; W. E. Kleinbauer, "Determinants of Art Historical Investigation," in W. E. Kleinbauer, *Modern Perspectives in Western Art History* (New York, 1971), pp. 13–36; T. Munro, *Evolution in the Arts* (Cleveland, 1963); M. Podro, *The Critical Historians of Art* (New Haven and London, 1982); and M. Schapiro, "Style," in M. Philipson and P. J. Gudel, eds., *Aesthetics Today* (New York and Scarborough, Ontario, 1980), pp. 137–171 (first published in 1953).

12 Vasari, *Lives.*

13 Winckelmann, *History.*

14 Hegel's ideas on art history can be found in G. W. F. Hegel, *Aesthetik* (1835), translated by F. P. B. Osmaston as *Philosophy of Fine Art* (London, 1920) and in G. W. F. Hegel, *The Philosophy of History*, trans. J. Silbree (London, 1900). For a short discussion of Hegel's contribution to art history, see E. Gombrich, "Hegel and Art History," *Architectural Design* 51, no. 6/7 (1981): 3–9.

15 G. Semper, "The Attributes of Formal Beauty," introduction to "Theory of Formal Beauty" (ca. 1856/1859), MS 179, fol. 40–44, Semper-Archiv, Zurich; translated by W. Herrmann in W. Herrmann, *Gottfried Semper: In Search of Architecture* (Cambridge, 1984), pp. 241–243. This formula appears to be a revision of an earlier formula for style, $Y = F(x,y,z \ldots)$ (G. Semper, *Kleine Schriften*, edited by M. and H. Semper (Berlin and Stuttgart, 1884), pp. 267–268). Semper uses the mathematical notation in this earlier formula in an ambiguous way leading to interpretations that conflate the mathematical function F in the formula with the utilitarian function of the object whose style is determined by F.

16 G. Semper, *Der Stil in den Technischen und Tektonischen Künsten oder Praktische Aesthetik*, vol. 1 (Munich, 1860–1863), p. 1. Quoted in Podro, *Critical Historians of Art*. Portions of *Der Stil* and other writings by Semper are translated by H. F. Mallgrave and W. Herrmann in G. Semper, *The Four Elements of Architecture and Other Writings* (Cambridge, 1989). A discussion of Semper's life, work, and theories, together with some translated manuscripts, is presented in Herrmann, *Semper*.

17 A. Riegl, *Stilfragen* (Berlin, 1893).

18 A. Riegl, *Die Spätrömische Kunstindustrie* (Vienna, 1901).

19 For a discussion of Riegl's theories, see O. Pächt, "Art Historians and Art Critics – vi: Alois Riegl," *Burlington Magazine* 105, part 1 (1963): 188–193.

20 H. Wölfflin, *Renaissance and Baroque* (Ithaca, NY, 1968). First published in 1888.

21 A. Göller, *Zur Aesthetik der Architektur* (Stuttgart, 1887).

22 Wölfflin, *Renaissance and Baroque*, pp. 77–78.

23 Wölfflin, *Principles.*

24 Ibid., p. 227.

25 Ibid., p. 229.

26 Ibid., p. 232.

27 Ibid., pp. 231–232.

28 P. Frankl, *Principles of Architectural History*, trans. J. F. O'Gorman (Cambridge, MA and London, 1968). First published in 1914.

29 Ibid., p. 3.

30 Ibid., p. 190.

31 Ibid., p. xv.

32 Ibid., p. 29.

33 Ibid., p. 57.

34 Ibid., p. 6.

35 P. Frankl, *Gothic Architecture* (Baltimore, 1962).

36 For example, "addition" and "division" are used to distinguish between Romanesque and Gothic architecture in O. von Simson, *The Gothic Cathedral* (Princeton, 1974) and in H. E. Kubach, *Romanesque Architecture* (New York, 1972). C. Alexander distinguishes between opposite ways of designing – by "differentation" (division) and by "addition" – in C. Alexander, *The Timeless Way of Building* (New York, 1979), pp. 365–384.

37 For a review of the work of this school, see M. Schapiro, "The New Viennese School," *Art Bulletin* 18 (1936): 258–266.

38 H. Sedlmayr, "Towards a Rigorous Science of Art," in O. Pächt, ed., *Kunstwissenschaftliche Forschungen* I (Berlin and Frankfurter, 1933).

39 H. Focillon, *The Life of Forms*, trans. C. B. Hogan and G. Kubler (New York, 1948), pp. 7–8. First published in 1934.

40 Ibid., p. 10.

41 Ibid., p. 14.

42 Ibid., p. 8.

43 G. Kubler, *The Shape of Time* (New Haven and London, 1962).

44 Ibid., p. 36.

45 For a discussion of *character* and *type* in architecture, see D. D. Egbert, *The Beaux-Arts Tradition in French Architecture* (Princeton, 1980), pp. 121–138.

46 M. Vitruvius, *The Ten Books on Architecture*, trans. M. H. Morgan (New York, 1960).

47 M. Laugier, *An Essay on Architecture*, trans. W. and A. Herrmann (Los Angeles, 1977), pp. 11–12. First published in 1753.

48 A. Quatremère de Quincy, *Encyclopédie Méthodique d'Architecture*, vol. 1 (Paris, 1788), article *"Cabane."*

49 For a more complete discussion of the term *type* as used in architectural theory, see A. Vidler, "The Idea of Type," *Oppositions* 8 (Spring 1977): 93–115.

50 C. Linnaeus, *Systema Naturae* (1735); G. L. LeClerc, Comte de Buffon, *Histoire Naturelle, Générale et Particulière* (Paris, 1749–67).

51 Ibid. Quoted in Vidler, "Type," p. 101.

52 J.-F. Blondel, *Cours d'Architecture* (Paris, 1771–77).

53 J. W. von Goethe, *Versuch die Metamorphose der Pflanzen zu Erklären* (Gotha, 1790).

54 For a more comprehensive study of the relationships between biological, archaeological, and architectural classification systems, see P. Steadman, *The Evolution of Designs* (Cambridge, 1979), pp. 23–32.

55 J. H. Woodger, "On Biological Transformations," in W. E. Le Gros Clark and P. B. Medawar, eds., *Essays on Growth and Form Presented to D'Arcy Wentworth Thompson* (Oxford, 1945).

56 J. N. L. Durand, *Précis des Leçons d'Architecture*, 2 vols. (Paris, 1819).

57 J. N. L. Durand, *Recueil et Parallèle des Edifices* (Paris, 1801).

58 Semper, *Four Elements of Architecture*, pp. 74–129. First published in 1851.

59 See Steadman, *Evolution of Designs*, p. 73.

60 For various interpretations of Semper's often dense writings, see R. H. Bletter, "Semper, Gottfried" in the *MacMillan Encyclopedia of Architects*, vol. 4 (New York, 1982), pp, 25–33; L. D. Ettlinger, "On Science, Industry and Art: Some Theories of Gottfried Semper," *Architectural Review* 136, part 1 (1964): 58; Herrmann, *Semper*; H. F. Mallgrave, "Introduction," in Mallgrave and Herrmann, *Four Elements of Architecture*, pp. 1–44; N. Pevsner, *Some Architectural Writers of the Nineteenth Century* (Oxford, 1972), pp. 252–268; Podro, *Critical Historians*, pp. 44–58; Steadman, *Evolution of Designs*, pp. 64–68, 72–73.

61 G. Cuvier, *Leçon d'Anatomie*, 5 vols. (Paris, 1800–1805).

62 Quoted in Ettlinger, "On Science, Industry and Art," p. 58. Originally given in English, the entire lecture is translated into German in Semper, *Kleine Schriften*, pp. 259–291.

63 C. Darwin, *The Origin of Species* (London, 1859).

64 Semper refers to Darwin in Semper, "Über Baustile," in Semper, *Kleine Schriften*, pp. 395–426, translated by J. Root and F. Wagner as "Development of Architectural Style," *The Inland Architect and News Record* 14 (1889): 76–78, 92–94; and 15: (1890): 5–6, 32–33. See pp. 76–77 for Semper's remarks regarding Darwin's theory of evolution. Semper's position with respect to Darwin is also discussed in Bletter, "Semper," pp. 28–29.

65 Semper, "Development of Architectural Style," p. 77.

66 Viollet-le-Duc distinguishes between these two uses of *style* in E. E. Viollet-le-Duc, *Dictionnaire Raisonné de l'Architecture Française du XI au XVI Siècle*, vol. 8 (Paris, 1854–1868), entry "Style". The two uses are also discussed in E. E. Viollet-le-Duc, *Lectures on Architecture*, vol. 1, trans. B. Bucknall (New York, 1987), p. 177. (This edition is a republication of the work first published in London, 1877 (vol. 1) and 1881 (vol. 2). The original French edition was published in Paris, 1863–1872.)

67 Viollet-le-Duc, *Lectures*, vol. 1, p. 179.

68 Ibid., pp. 173–176.

69 Ibid., p. 426.

70 Viollet-le-Duc, *Dictionnaire*, vol. 9, entry "Unité," p. 341.

71 Viollet-le-Duc, *Lectures*, vol. 1, pp. 172–173.

72 A. Choisy, *Histoire de l'Architecture* (Paris, 1899). For discussions of Choisy's theory of architecture, see R. Banham, *Theory and Design in the First Machine Age* (New York, 1960) and J. Posener, "Choisy," *Architectural Review* 120 (October 1956): 235–236.

73 Ibid. Quoted in Banham, *Theory and Design*, p. 24.

74 Le Corbusier, *Towards a New Architecture*, trans. F. Etchells (New York, 1960), p. 27. First published in 1923.

75 Ibid., p. 9.

76 *Objet-types* and the "Law of Mechanical Selection" are described in A. Ozenfant and Ch.-E. Jeanneret [Le Corbusier], *La Peinture Moderne* (Paris, 1925). These ideas are reviewed in Banham, *Theory and Design*, p. 211.

77 Schapiro, "Style," pp. 137, 139–140.
78 Ibid., p. 140.
79 Ibid., p. 140.
80 Ackerman, "Style," pp. 167–168.
81 Ibid., p. 168.
82 J. S. Ackerman, "The Historian as Critic," in Ackerman and Carpenter, *Art and Archaeology*, p. 152.
83 Schapiro, "Style," p. 140.
84 Ibid., p. 140.
85 Ackerman, "Style," p. 168.
86 Ibid., p. 168.
87 S. Ullmann, *Style in the French Novel* (Cambridge, 1957).
88 Ibid., p. 6.
89 Gombrich, "Style," p. 353.
90 Goodman, "Status of Style," pp. 799–811.
91 Ibid., p. 808.
92 Ackerman, "The Historian as Critic," p. 152.
93 Kubler, *Shape of Time*, pp. vii–viii.
94 Ibid., p. vii.
95 J. S. Ackerman, "Genres and Scholars," in Ackerman and Carpenter, *Art and Archaeology*, p. 199.
96 See, for example, A. Ellegäord, *A Statistical Method for Determining Authorship: The Junius Letters, 1769–1772* (Goteborg, Sweden, 1962); L. Hillier and L. Isaacson, *Experimental Music* (New York, 1959); and J. E. Cohen, "Information Theory and Music," *Behavioral Science* 7 (1962): 137–163.
97 H. Simon, "Style in Design," in C. M. Eastman, ed., *Spatial Synthesis in Computer-Aided Building Design* (New York, 1975), p. 302.
98 Gombrich, "Style," p. 360.
99 Goodman, "Status of Style," pp. 807–809.
100 K. Walton, "Style and the Products and Processes of Art," in B. Lang, ed., *The Concept of Style* (U. of Penn. Press, 1979), p. 46.
101 R. Wollheim, "Pictorial Style: Two Views," in Lang, ed., *The Concept of Style*, p. 135.
102 Simon, "Style in Design" and H. Simon, *The Sciences of the Artificial*, 2nd edn (Cambridge and London, 1981), pp. 150–151.
103 Simon, "Style in Design," p. 287.
104 Wollheim, "Pictorial Style," p. 134.
105 Simon, "Style in Design," p. 301.
106 For a critique of signature theories, see J. Genova, "The Significance of Style," *Journal of Aesthetics and Art Criticism* 37, 3 (1979): 315–324.
107 For a discussion of this view, see Ackerman, "Style," pp. 166–167 and Gombrich, "Style," pp. 354–356.
108 See E. Gombrich, "The Logic of Vanity Fair," in P. A. Schilpp, ed., *The Philosophy of Karl Popper*, Book II (La Salle, IL, 1974), pp. 925–957; Gombrich, *Sense of Order*, pp. 209–213; Gombrich, "Style," p. 355.
109 K. R. Popper, *The Poverty of Historicism* (London, 1961), p. 149.
110 See especially, Gombrich, *Sense of Order*, p. 209–213; Gombrich, "Logic of Vanity Fair"; and Steadman, *Evolution of Designs*, pp. 230–231.
111 Ackerman, "Style," pp. 183 and 174.

2 Languages and transformations: a new approach

1 Viollet-le-Duc, *Lectures*, vol. 1, p. 335.
2 N. Chomsky, *Syntactic Structures* (The Hague, Paris, 1957).
3 For a survey of the field of pattern recognition, see K. S. Fu, *Syntactic Methods in Pattern Recognition* (New York and London, 1974). The first true two-dimensional grammar was defined by Russell Kirsch in R. A. Kirsch, "Computer Interpretation of English Text and Picture Patterns," *I.E.E.E. Transactions on Electronic Computers* EC-13 (1964): 363–376.
4 See C. Alexander, *The Timeless Way of Building* (New York, 1979) for his theory of pattern languages; and C. Alexander, *A Pattern Language* (New York, 1977) for an example of a pattern language.
5 In particular, Alexander's "morphological law" or rule for generating a pattern, $X \rightarrow r(A,B, \ldots)$, is practically identical to K. S. Fu's definition of a pattern as an n-ary relation, $r(X_1, \ldots, X_n)$. (See Alexander, *Timeless Way*, p. 90 and Fu, *Syntactic Methods*, p. 68). Both formulations define a pattern as a mathematical relation of subpatterns. Both apply recursively to generate a hierarchical or tree-like description of a pattern composed of one or more levels of subpatterns.
6 G. Stiny and J. Gips, "Shape Grammars and the Generative Specification of Painting and Sculpture," in C. V. Freiman, ed., *Information Processing 71* (Amsterdam, 1972). For a complete formalization of shape grammars, see G. Stiny, *Pictorial and Formal Aspects of Shape and Shape Grammars* (Basel, 1975). For more recent definitions, see G. Stiny, *Shape: Algebra, Grammar, and Description* (forthcoming).
7 G. Stiny, "Ice-ray: a note on the generation of Chinese lattice designs," *Environment and Planning B* 4 (1977): 89–98; Stiny and Mitchell, "The Palladian grammar"; G. Stiny and W. J. Mitchell, "The grammar of paradise: on the generation of Mughul gardens," *Environment and Planning B* 7 (1980): 209–226; T. Weissman Knight, "The generation of Hepplewhite-style chair-back designs," *Environment and Planning B* 7 (1980): 227–238; T. Weissman Knight, "The forty-one steps," *Environment and Planning B* 8 (1981): 97–114; H. Koning and J. Eizenberg, "The language of the prairie: Frank Lloyd Wright's prairie houses," *Environment and Planning B* 8 (1981): 295–323; U. Flemming, "More than the sum of its parts: the grammar of Queen Anne houses," *Environment and Planning B: Planning and Design* 14 (1987): 323–350. See also F. Downing and U. Flemming, "The bungalows of Buffalo," *Environment and Planning B* 8 (1981): 269–293 and U. Flemming, "The Secret of the Casa Giuliani Frigerio," *Environment and Planning B* 8 (1981): 87–96.
8 G. Stiny, "Kindergarten grammars: designing with Froebel's building gifts," *Environment and Planning B* 7 (1980): 409–462.
9 Description schemes (originally called "description functions") are defined by G. Stiny in "A note on the description of designs," *Environment and Planning B* 8 (1981): 257–267 and in Stiny, *Shape: Algebra, Grammar, and Description*.
10 Schapiro, "Style," p. 140.
11 E. Gombrich, "Norm and Form," in E. Gombrich, *Norm and Form* (London and New York, 1966), p. 82.

12　L. March and G. Stiny, "Spatial systems in architectural design: some history and logic," *Environment and Planning B: Planning and Design* 12 (1985), p. 52.

13　E. Kaufmann, *Architecture in the Age of Reason* (New York, 1968), p. 91.

14　Frankl, *Principles*, p. 1.

4　Recursive structures of shape grammars

1　G. Stiny and W. Mitchell, "Counting Palladian plans," *Environment and Planning B* (1978): 189–198.

5　Transformations of shape grammars

1　Technically, only two mechanisms – rule addition and rule deletion – are necessary to transform any shape grammar into any other shape grammar. The third mechanism introduced here – rule change – is equivalent in its results to performing both rule addition and rule deletion. As already noted, however, rule change is very different from rule addition and deletion in the way it elucidates relationships between different grammars.

2　T. Weissman Knight, *Transformations of Languages of Designs*, Ph.D. Thesis, Graduate School of Architecture and Urban Planning, University of California, Los Angeles, CA (1986).

3　Stiny, "Kindergarten grammars."

4　The distinction made here between changing a shape (by introducing a new shape) and changing an arrangement of shapes (by repositioning a shape) assumes that shapes are the "same" if they are geometrically similar and "different" if they are not similar. If shapes are understood to be the same only if they are congruent, then the definitions for replacing shapes can be changed accordingly. However, if shapes are understood to be the same only if they are equal, then changing shapes in a spatial relation and changing an arrangement of shapes in a spatial relation are the same.

5　The relationships between the "Life," Jester, and Sundt houses were suggested by L. March and P. Steadman's topological analysis of these houses in *The Geometry of Environment* (Cambridge, MA, 1974), pp. 27–28.

6　Transformations of the meander motif on Greek Geometric pottery

1　J. M. Davison, *Attic Geometric Workshops* (Rome, 1968), p. 5.

2　Attributions of vases given here follow attributions given in the most recent comprehensive survey of Geometric pottery: J. N. Coldstream, *Greek Geometric Pottery* (London, 1968).

3　Davison, *Workshops*, p. 67.

4　The attribution to the Birdseed Workshop was made in N. Himmelmann-Wildschütz, "Review of Davison, *Workshops*," *Gnomon*, vol. 34, part 1 (1962): 76. It was corroborated in Coldstream, *Pottery*, p. 67.

5　E. L. Smithson, "The Tomb of a Rich Athenian Lady," *Hesperia*, vol. 37, no. 1 (1968): 77–116.

6 The term *step meander* is taken from B. Schweitzer, *Greek Geometric Art* (New York, 1971) and Coldstream, *Pottery*.

7 The term *meander tree* is taken from Schweitzer, *Geometric Art*.

8 Schweitzer, *Geometric Art*, p. 193.

9 To control the proportions of S-shapes that change with successive applications of rule 2, the rule must technically be a rule schema. The rule schema would include variables that are assigned different values to define differently proportioned S-shapes. Variables are assumed here.

10 As with the rules of the Early and Middle Geometric grammar to which they are added, stacking rules and erasing rules apply in parallel to generate designs. However, the parallel application of stacking rules is restricted to those parts of a design that are identical under the euclidean transformation of translation.

7 Transformations of *De Stijl* art: the paintings of Georges Vantongerloo and Fritz Glarner

1 Formally, the initial shape of a grammar cannot have variables. Labeled rectangles of differing dimensions must be generated from some other, nonparameterized initial shape. Also, the label should technically be a shape with a label associated with it.

2 Some sources give the date of this painting as 1918, placing it earlier than stage I paintings. If the 1918 date is correct, then this painting could not be classified as stage II in a chronological sequence of transformations but could, just as importantly, be classified as stage II in a strictly logical sequence of transformations.

3 Technically, only lines of one thickness may be used in a shape grammar. Different thicknesses of lines can, however, be indicated with labels.

4 Stiny, "A note on the description of designs"; *Shape: Algebra, Grammar, and Description*.

5 Mondrian's remark is noted in J. Elderfield, "The Paris–New York Axis: Geometric Abstract Painting in the Thirties," *Geometric Abstraction: 1926–1942*, section IV (Dallas Museum of Fine Arts, Dallas, 1972).

6 In some paintings produced during stage I and subsequent stages, the relationships between oblique divisions in three rectangles that form a larger rectangle and in rectangles that form other configurations also appear to be restricted. Since these restrictions are not common to all paintings, they are not considered here.

7 The relationships between colors in paintings produced during stage I and later stages were determined by a limited survey of available color reproductions of paintings. The color relationships in these paintings are assumed to hold for most other paintings.

8 In this and the following Glarner grammars, a special proviso is added to the usual requirement for a design to be in the language generated by a grammar. Here, a design is in a language whenever all lines, as well as all spatial labels, are erased. This is the simplest way of ensuring that final designs have no dividing or boundary lines. If the usual requirement for membership in a language is used, lines in designs would need to have separate labels associated with them to ensure that they are erased.

9 Vantongerloo's parallel division rule is derived from his perpendicular division rule, and Glarner's oblique division rule is derived from his rectangular division rule in essentially the same way – by rotating dividing lines. See pages 182 and 203.

10 Rules 9 and 19 could be reintroduced in stage IV by rule addition rather than by rule change. However, rule addition would not point out the relationship between rules 8 and 9 and the relationship between rules 18 and 19.

8 The transformation of Frank Lloyd Wright's Prairie houses into his Usonian houses

1 J. Sergeant, *Frank Lloyd Wright's Usonian Houses* (New York, 1976).

2 G. Manson, "Wright in the Nursery," *Architectural Review* 113 (1953): 143–146.

3 R. C. MacCormac, "Froebel's kindergarten gifts and the early work of Frank Lloyd Wright," *Environment and Planning B* 1 (1974): 29–50.

4 Koning and Eizenberg, "Language of the prairie."

5 F. L. Wright, *The Natural House* (New York, 1954), pp. 167–168.

6 A variable state of 6 or more makes all ornamentation rules not shown in figure 8.4 optional. In the Koning and Eizenberg grammar, some ornamentation rules, such as those for adding roofs, are obligatory. However, since these rules are not specified in the grammar given here, a more exact range of final states is not specified. Rather than leaving the variable final state undefined, it is defined here as 6 or more. Unornamented basic compositions are thus included in the language defined by the Prairie grammar.

7 Determining which Prairie spatial relations or rules are changed into Usonian rules is arbitrary to a certain extent. For example, any one of the Prairie spatial relations between a core unit zone and an extension could be changed into a comparable Usonian spatial relation by repositioning shapes in the appropriate way. The rule changes defined here are generally the simplest ones for transforming Prairie rules into analogous Usonian rules.

8 The Usonian ornamentation rules given here are not as detailed as the Prairie ornamentation rules given in the Koning and Eizenberg grammar. Basically, only those ornamentations observable in plan are included; variations in ceiling heights, roofs, and so on are not described.

9 Sergeant, *Usonian Houses*, pp. 52–58.

Postscript

1 G. Stiny, "The Algebras of Design," *Research and Engineering Design* 2 (1991): 171–180.

2 T. W. Knight, "Color grammars: designing with lines and colors," *Environment and Planning B: Planning and Design* 16 (1989): 417–449.

Index

Page numbers rendered in bold type indicate references to illustrations.

Abraham, Pol, 16
Ackerman, James, 18–19, 20, 22, 24, 26, 33, 34, 247 n. 11, 250 n. 107
addition rule(s), 49–50, **50**, 52, **53**, 106–107, **106**. *See also* shape rule(s)
Alexander, Christopher, 25, 248 n. 36
Anavysos Painter, 120, **121**, **136–137**
Archaic style, 111
archetype, 12, 13
Argos C201 Workshop, 125–127, **127**
Aristotle, 5, 19
Athens 894 Workshop, 124, **124**, **134–135**
Athens 897 Painter, Workshop, 121–122, **122**, **136–137**

Banham, R., 249 n. 72, n. 73, n. 76
battlement meander, 114. *See also* meander motif
Bauplan, 13, 37
Birdseed Workshop, 118–120, **119**, **136–137**
Black-Figure style, 112
Bletter, R. H., 249 n. 60, n. 64
Blondel, J.-F., 13
biological classification systems, 13
Bosanquet Painter, **131**
Buffon, 13

Carpenter, R., 247 n. 11, 250 n. 82
change rule(s), 95–104, **97**, **98**, **101**, 102, **103**, 110, 233, **234–235**, 241. *See also* rule change
character, 12
Chinese ice-ray shape grammar, 28, **29**
Choisy, Auguste, 16–17, 22

Chomsky, Noam, 25
Clark, W. E. Le Gros, 248 n. 55
Cohen, J. E., 250 n. 96
Coldstream, J. N., 252 n. 2, n. 4, 253 n. 6
complex (double, triple, quadruple, etc.) meander, 116. *See also* meander motif
composition(s) of transformations, 45, **47**
computer-aided design, xv–xvi
Corbusier, Le, 17, 165
Croce, Benedetto, 4
Cuvier, Georges, 14

Darwin, Charles, 6, 15
Davison, Jean M., 113, 252 n. 3
derivation, 27, 50–51. *See also* shape grammar(s)
description scheme(s), 32–34, 35, 36, 39, 183, 245
De Stijl art, 110–217. *See also* Glarner, Fritz; Vantongerloo, Georges
Dipylon Master, Workshop, 116–118, **116**, **117**, 118, 120, 122, **134–135**, **136–137**, 155. *See also* meander motif
Downing, F., 251 n. 7
Durand, J. N. L., xiii, 14, 15, 34, 35

Early Geometric style, 112. *See also* meander motif
Early and Middle Geometric meander shape grammar, 133, 139, **139**, **140**
Eastman, C. M., 250 n. 97
Egbert, D. D., 248 n. 45
Eizenberg, Julie, 219, 220, 221, 224, 232, 242, 251 n. 7, 254 n. 6, n. 8. *See also* Frank Lloyd Wright Prairie house shape grammar

Elderfield, J., 253 n. 5
Ellegård, A., 250 n. 96
emergent shape, 71
empty shape, 43
equality relation, 44, **45**
erasing rule(s), 58, **59**, 71
Ettlinger, L. D., 249 n. 60, n. 62
euclidean transformation(s), 44–47, **46**, **47**, 87, 91
in rule applications, 51, 52, 54, 55, **55**, 56, 58, 95, 96

Fence Workshop, **126**
final state(s), 62–63. *See also* shape grammar(s)
changing state labels in, 83–85, **84**
Fischer von Erlach, J. B., **90**, 91
Flemming, U., 251 n. 7
Focillon, Henri, 11, 18, 20, 24, 26, 36, 39
form and content (meaning), 19–20, 24, 34, 39
Frankl, Paul, 9–10, 19, 33, 35, 36
Froebel, Frederick, 28, 32, 218, 219
Froebel block shape grammar, 32, **33**
Fu, K. S., 251 n. 2, n. 5

generative grammar, 25
Genova, J., 250 n. 106
Geometric style, 111–112. *See also* meander motif
Gips, James, xiii, 25
Glarner, Fritz, 168–170, 191–217, **200–201**, 202, **206**, **209**, **212**. *See also* De Stijl art; Vantongerloo, Georges
shape grammars for paintings of, 170, **196–199**, 200–214, 217
Göller, Adolph, 8
Goethe, 13, 14, 38, 165, **166**

Gombrich, Ernst, 19, 21, 22, 34, 246 n. 8, 247 n. 11, n. 14, 250 n. 107, n. 110
Goodman, Nelson, 3, 19–20, 21, 34
grammar(s), 24–25. *See also* shape grammar(s)
Greek cross (spatial relation, rule), 26–28, **26**, 27, 52, **53**, 53–58, **54**, 55, **56**, 57, **58**, 62, **63**, **64**, **65**, **66**, 76, **77**, **78**, 86–87, **86**
Guarini, Guarino, **89**, 91, 93, **93**
Gudel, P. J., 247 n. 11

Hegel, G. W. F., 6, 8
Hellenistic style, 112
Hepplewhite chair shape grammar, 28, **30**
Herrmann, W., 247 n. 15, n. 16, 249 n. 60
Hillier, L., 250 n. 96
Himmelmann-Wildschütz, N., 252 n. 4
Hirschfeld Painter, Workshop, 118, **119**, **136–137**. *See also* meander motif
Huxley, Aldous, 4

identity transformation, 46
initial shape(s), 26, 62, **63**. *See also* shape grammar(s)
 changing state labels in, 83–85, **84**
 changing spatial labels in, 86–87, **87**
 change rules applied to, 96
Isaacson, L., 250 n. 96
isomorphic recursive structures. *See* recursive structure(s), isomorphisms between

Japanese tearoom shape grammar, 28, **31**

Kaufmann, Emil, 11, 35
Kirsch, Russell A., 251 n. 3
Kleinbauer, N. E., 247 n. 11
Knight, T. W., 75, 245, 251 n. 7
Kroeber, A. L., 3
Koning, Hank, 219, 220, 221, 224, 232, 242, 251 n. 7, 254 n. 6, n. 8. *See also* Frank Lloyd Wright Prairie house shape grammar
Kubach, H. E., 248 n. 36
Kubler, George, 11, 20, 24, 36
Kunstwissenschaft school, 10–11
Kunstwollen, 7–8
Kuhn, Thomas, 3

label(s), 52
 erasing, 58, **59**
 final state, 62–63
 schema(ta), 68
 spatial, 52, 53–58, **54**, **55**, **56**, 57,

58, 69. *See also* rule change, spatial label changes
 state, 52, 53, 59–62, **60**, **61**, 69. *See also* rule change, state label changes
 variable state, 60–62, **61**, 68, 231
Lang, B., 250 n. 100, n. 101
language(s), xiii, 25, 26, 63, 76, 78. *See also* shape grammar(s), grammar(s)
language(s) of descriptions, 32–33, 36. *See also* description schemes
language(s) of designs, xiii. *See also* language(s), shape grammar(s)
Late Geometric meander shape grammars
 Argive, left-running, 147–151, **150**
 Argive, right-running, 161, **164**
 Attic, 147–151, **148–149**
 Birdseed, 161, **163**
 Hirschfeld, 161, **162**
 new, 147–151, 154–155, **154**
 Rhodian, 147–151, 154, **152–153**
Late Geometric style, 112. *See also* meander motif
Laugier, 12–13, 17
Lebensgefühl, 8
line(s), 25, 35, 43, 244
Linnaeus, 13

MacCormac, Richard, 218
Mallgrave, H. F., 249 n. 60
manner, 4–5, 19
Manson, Grant, 218
March, Lionel, 34, 252 n. 5
meander motif, 111–167
 analysis of, 132–164
 Argive, 125–127, **126**, **127**, **134–135**, **138**
 Attic, 112, 115, 116–125, **116**, **117**, **119**, **120**, **121**, **122**, **123**, **124**, **134–135**, **136–137**
 Cycladic, 128, **128**, **134–135**
 development of, 113–131
 Early and Middle Geometric, 113–115, **114**, **115**, **125**, **133–139**, **134–135**
 eastern Greek (Rhodian and Samian), 128–130, **129**, **130**, **134–135**
 Late Geometric, 116–130, **116**, **117**, **119**, **120**, **121**, **122**, **123**, **124**, **126**, **127**, **128**, **129**, **130**, **139–161**, **134–135**, **136–137**, **138**, **141**, **160**
 shape grammars for. *See* Early and Middle Geometric meander shape grammar; Late Geometric meander shape grammars
 Post-Geometric, 131, **131**, **134–135**, 161–163

see also names of individual workshops and painters
meander tree, 128. *See also* meander motif
Medawar, P. B., 248 n. 55
metathesis, 93–95, **95**
Middle Geometric style, 112. *See also* meander motif
Mitchell, William, xiv, 251 n. 7, 252 n. 1
Mondrian, Piet, 168, **169**, 171, 186, 191, 198, 199
Mughul garden shape grammar, xiv, 28, **30**
Munro, T., 247 n. 11
Mycenaean style, 111, 114

nondeterminism, 51, 96

Orientalizing style, 111

Pächt, O., 247 n. 19, 248 n. 38
Palladian villa shape grammar, 28, **29**, 71
parallel shape grammar(s), 133, 253 n. 10
parametric shape grammar(s), 66–69, 170, 224
part relation, 44, **45**
Pevsner, N., 249 n. 60
Philipson, M., 247 n. 11
Pliny, 4
Podro, M., 247 n. 11, 249 n. 60
Popper, Karl, 22
Posener, J., 249 n. 72
Post-Geometric. *See* meander motif
Post-Geometric meander shape grammar, 162–163, **165**
Prairie house shape grammar, xiv, 28, **31**, 37, 219–221, 224, 230–231, **225–230**. *See also* transformations of shape grammars, for Frank Lloyd Wright houses
Protogeometric style, 111, 113, 114, 115

Quatremère de Quincy, 12–13
Queen Anne house shape grammar, 28, **32**

Radiant City, 165, **167**
Rattle Workshop, 120, **120**, **136–137**
recursive structure(s), 37, 41, 70–74, **72**, **73**
 isomorphisms between, 73–74, 76, 78, 85–86, **85**, 87, 102–104, **103**, **104**, 105–106, 147, 161, 163, 170, 236–237
redent, 165–166
Red-Figure style, 112
reflection, 44, **46**, 88

Relational Painting, 198–199. *See also* Glarner, Fritz
Rhodian meanders, 128–130, **129**
Riegl, Alois, 7–8, 18, 19, 20, 33, 35, 36
Rossi, Aldo, 91, **92**
rotation, 44, **46**, 88
Rottiers Painter, **128**
rule addition, 37, 41, 75–76, **77**, **78**, 105. *See also* transformations of shape grammars, for *De Stijl* art, for Frank Lloyd Wright houses, for the meander motif
rule change, 37, 41, 78–104, 105. *See also* transformations of shape grammars, for *De Stijl* art, for Frank Lloyd Wright houses, for the meander motif
state label changes, 79–86, **80**, **81**, **82**, **83**, **84**, 105
spatial label changes, 86–87, **87**, 105
spatial relation changes, 88–104, 105
introducing a new shape, 88 91, **89**, **90**, 96–97, **97**, 102, **103**, 105
resizing or repositioning a shape, 88, 91–93, **92**, **93**, 98–100, **98–99**, 102, **103**, 105
transposing shapes, 88, 93–95, **94**, 100–102, **101**, 105
rule deletion, 37, 41, 76–78, **77**, **78**, 105. *See also* transformations of shape grammars, for *De Stijl* art, for Frank Lloyd Wright houses, for the meander motif
rule(s). *See* shape rule(s)
running (single) meander, 114. *See also* meander motif

Samian meanders, 130, **130**
Sangallo, Guiliano da, **26**
San Salvatore, Venice, **89**, 91
Santa Maria della Divina Providenza, Lisbon, **89**, 91
Santa Maria delle Carceri, Prato, **26**
scale, 45, **47**, 88
Schapiro, Meyer, 17–19, 20, 24, 26, 33, 247 n. 11, 248 n. 37
Schilpp, P. A., 250 n. 108
Schweitzer, B., 253 n. 6, n. 7, n. 8
Sergeant, John, 218–219, 241
Sedlmayer, Hans, 10
Semper, Gottfried, 6–7, 14–15, 20, 36
shape addition (sum), 44, **45**
shape grammar(s), xiii, 25. *See also* final state(s), initial shape(s), shape rule(s)
for Chinese ice-ray lattice designs, 28, **29**
and computer-aided design, xv–xvi

for Early and Middle Geometric meanders, 133, 139, **139–140**
with Froebel blocks, 32, **33**
for Glarner paintings, 170, **196–199**, 200–214, 217
for Greek cross designs, 26–28, **26**, **27**. *See also* Greek cross
for Hepplewhite chairs, 28, **30**
for Japanese tearooms, 28, **31**
for Late Geometric meanders. *See* Late Geometric meander shape grammars
for Mughul gardens, xiv, 28, **30**
for Palladian villas, 28, **29**, 71
parallel, 133, 253 n. 10
parametric, 66–69, 170, 224
for Post-Geometric meanders, 162–163, **165**
for Prairie houses, xiv, 28, **31**, 37, 219–221, 224, 230–231, **225–230**. *See also* transformations of shape grammars, for Frank Lloyd Wright houses
for Queen Anne houses, 28, **32**
standard format, 37, 41, 43–69, **64**, **65**, **66**, 106
simple example of, 26–28, **26**, **27**
and style, xiii–xiv, 25–35
transformations of. *See* transformations of shape grammars
for Usonian houses, 37, **225–230**, **236–242**. *See also* transformations of shape grammars, for Frank Lloyd Wright houses
for Vantongerloo paintings, 170, **172–174**, 171–191, 217
shape rule(s), 26, 49–62. *See also* shape grammar(s)
application of, 50–51, 53, 59, 60, 68
addition rules, 49–50, **50**, 52, **53**, 106–107, **106**
changing, 78–104. *See also* rule change
combining addition and subtraction rules, 106–107, **106**, 110
defining in terms of a spatial relation, 50, **50**, 52, **53**
for erasing labels, 58, **59**, 71
labeling of, 52–62. *See also* label(s)
nondeterminism of, 51
schema(ta), 67–68, **69**, 253 n. 9
subtraction rules, 49–50, **50**, 52, **53**, 106–107, **106**
shape rule schema(ta), 67–68, **69**, 253 n. 9
shape(s), 25, 43, **45**
emergent, 71

empty, 43
initial. *See* initial shape(s)
introducing new, 88
operations on (addition, subtraction, euclidean transformations), 44–47, **45**, **46**, **47**
relations between (part, equality), 44, **45**
resizing or repositioning, 88
schema(ta), 67, **67**
symmetry properties of, 87
transposing, 88
shape schema(ta), 67, **67**
shape subtraction (difference), 44, **45**
Simon, Herbert, i, 21, 22, 34
Simson, O. von, 248 n. 36
situational logic theory, 22–23
Smithson, E. L., 252 n. 5
Soane, John, 93, **94**, 95
spatial label(s). *See* label(s)
spatial relation(s), 26, 48–49, **48**, **49**, 69. *See also* rule change, spatial relation changes; shape rule(s)
schema(ta), 67, **68**
spatial relation schema(ta), 67, **68**
Spavento, Giorgio, **89**, 91
spiraling meander, 117. *See also* meander motif
standard format shape grammar(s), 37, 41, 43–69, **64**, **65**, **66**, 106
state label(s). *See* label(s)
Steadman, P., 248 n. 54, 249 n. 59, n. 60, 250 n. 110, 252 n. 5
step meander, 125. *See also* meander motif
stilus, 4, 5, 12, 19
Stiny, George, xiii, xiv, 25, 28, 32, 34, 39, 43, 87, 183, 244, 251 n. 7, n. 9, 252 n. 1
style, 3–39. *See also* stylistic change
architectural, xiv
concept of, 3–4
etymology of, 4–5, 12
form and content (meaning) in, 19–20, 24, 34, 39
language analogy with, 24
and manner, 4–5, 19
process theories of, 21
rationalist theories of, 16, 18
and shape grammars, xiii–xiv, 25–35
signature theories of, 21–22
situational logic theory of, 22–23
synonymy theory of, 19, 21
stylistic change, 3–39. *See also* style
architectural theories of, 12–17
art historical theories of, 5–11, 246–247 n. 11

cyclical theories of, 6. *See also*
Focillon, Henri; Hegel,
G. W. F.; Kubler, George;
Winckelmann, J. J.; Wölfflin,
Heinrich
evolutionary theories of, 5–6. *See
also* Choisy, Auguste; Hegel,
G. W. F.; Semper, Gottfried;
Viollet-le-Duc
external theories of, 6–7
generative principles for, 13–14.
See also Durand, J. N. L.;
Goethe; Semper, Gottfried;
Viollet-le-Duc
internal theories of, 7–11
language analogy with, 36
recent theories of, 17–23
and transformations of languages
of designs, xiv–xv, 36–39
types of (external vs. internal,
evolutionary vs. cyclical), 5
Sub-Dipylon Workshop, 118–120
subtraction rule(s), 49–50, **50**, 52,
53, 106–107, **106**. *See also*
shape rule(s)
symmetry, 87
synonymy theory, 19, 21
syntactic pattern recognition, 25

Telephos Painter, **131**
transformations of languages of
designs, 36, 41. *See also*
transformations of shape
grammars
transformations of shape grammars
for *De Stijl* art, 110–217
formal model for, 75–107
for Frank Lloyd Wright houses,
37–38, 218–242
for the meander motif, 111–167
operations for, xv, 37, 41, 43, 75,
104–107, 110. *See also* rule
addition, rule deletion, rule
change
and stylistic change, xiv–xv,
36–39

translation, 44, **46**, 88
transposition. *See* rule change,
spatial relation changes,
transposing shapes
type(s), 12, 13, 14, 17

Ullmann, Stephen, 19, 21
Urhutte, 14
Urpflanze, 13, 14, 38
Usonian house shape grammar, 37,
225–230, 236–242. *See also*
transformations of shape
grammars, for Frank Lloyd
Wright houses

Van Doesburg, Theo, 168, **169**, 171,
191
Vantongerloo, Georges, 168–170,
171–195, **175**, **178**, **180–181**,
185–187, **189**, **192–193**, **194**,
200, 201, 214–217. *See also De
Stijl* art; Glarner, Fritz
shape grammars for paintings of,
170, **172–174**, 171–191, 203,
217
variable state(s), 60–62, **61**, 68, 231
Vasari, Giorgio, 5, 6
Vidler, A., 248 n. 49, n. 51
Villa Angarano, **29**
Villa Badoer, **29**
Villa Hollywood, **29**
Villa Santa Monica, **29**
Villa Sarraceno, **29**
Villa Sepulveda, **29**
Villa Vine, **29**
Villa Zeno, **29**
Viollet-le-Duc, 15–17, 36, 251 n. 1
Vitruvius, 4, 12
vocabulary, 25–26, **27**, 43–47. *See
also* shape grammar(s)

Walton, Kendall, 21
Winckelmann, J. J., 5, 6
Wölfflin, Heinrich, i, xiii, 4, 8–9,
10, 19, 20, 33, 35, 36
Wollheim, Richard, 21, 250 n. 104

Woodger, J. H., 13, 37
Wright, Frank Lloyd
Adelman house, 237
Baker house, 219, **220**, 231, **232**
and Froebel, 32
Garrison house, 222, **223**, 238,
239, **240**
Henderson house, 219, **220**, 231,
232
Jacobs house, 222, **223**, 238, 239,
241
Jester house, 89, 91, 242
"Life" house, 88, **89**, 242
Little house, **31** 221
Lusk house, 222, **223**, 238, 239,
241
"March" house, **31**, 221
Newman house, 222, **223**, 238,
239, **241**
Pope house, 222, **223**, 238, 239,
241
Prairie houses, xiv, 37, 110. *See
also names of individual
houses*; Wright, Frank Lloyd,
transformation of Prairie
houses into Usonian houses;
Prairie house shape grammar
Roberts house, 219, **220**, 231, **232**
Robie house, **31**, 219, **220**, 231,
232
Rosenbaum house, 222, **223**, 237,
238, 239, **241**
"Stiny" house, 221, **221**
Sundt house, **89**, 91, 242
transformation of Prairie houses
into Usonian houses, 218–242
Usonian houses, 37, 110. *See also
names of individual houses*;
Wright, Frank Lloyd,
transformation of Prairie
houses into Usonian houses;
Usonian house shape grammar
Willets house, 219, **220**, 231, **232**

Zeitgeist, 6